Praise for Nancy Baker Jacobs

"Nancy Baker Jacobs's promising mystery debut [*The Turquoise Tattoo*]...packs enough excitement and provocative questions to be well worth the reader's time."
—*Publishers Weekly*

"Original plotting...a heroine who's gutsy but no superwoman... a welcome addition to the genre."
—*Kirkus Reviews*

"A colorful and surprising mystery...featuring gutsy, down-to-earth private investigator Devon MacDonald... Closely plotted and fast-paced, *A Slash of Scarlet* carries the reader along nicely."
—*Mystery News*

"As is becoming her trademark, all Jacobs's characters, even the minor ones, leave an imprint.... [*The Silver Scalpel*] is an important, well-written novel that deserves to be read by anyone with an open mind."
—*Cleveland Plain Dealer*

"This tale keeps the reader guessing until the fiery climax, a sure sign of a good mystery."
—United Press International

"A complex, action-packed plot coupled with a high powered ending makes *Double or Nothing* a novel thriller fans should find quite engrossing."
—*Monterey Herald*

FLASH POINT

ALSO BY NANCY BAKER JACOBS

MYSTERIES AND SUSPENSE NOVELS
 Deadly Companion
 See Mommy Run
 Cradle and All
 Daddy's Gone A-Hunting
 Rocking the Cradle
 Double or Nothing
 Star Struck

THE DEVON MACDONALD, P.I., SERIES
 The Turquoise Tattoo
 A Slash of Scarlet
 The Silver Scalpel

FLASH POINT

A SUSAN KIM DELANCEY MYSTERY

Nancy Baker Jacobs

2002 · PERSEVERANCE PRESS / JOHN DANIEL & COMPANY

A Perseverance Press Book
Published by John Daniel & Company
A division of Daniel & Daniel, Publishers, Inc.
Post Office Box 21922
Santa Barbara, California 93121
www.danielpublishing.com/perseverance

Book design by Eric Larson, Studio E Books, Santa Barbara
www.studio-e-books.com

Cover photo: Billowing Flames from House ©Craig Aurness/CORBIS

10 9 8 7 6 5 4 3 2 1

LIBRARY OF CONGRESS CATALOGING-IN-PUBLICATION DATA
Jacobs, Nancy Baker, (date)
 Flash point : a Susan Kim Delancey mystery / by Nancy Baker Jacobs.
 p. cm.
 ISBN 1-880284-56-1 (alk. paper)
 1. San Francisco Bay Area (Calif.)—Fiction. 2. Mother and infant—Crimes against—Fiction.
3. Kidnapping—Fiction. 4. Arson—Fiction. I. Title.
 PS3560.A2554 F58 2002
 813'.54—dc21
 2002001330

For the firefighters,

the bravest and best among us.

Acknowledgments

MANY people generously shared their time and expertise to help me research the art and science of arson investigation for this book. I particularly want to thank Natalie Rodda, Coordinator for the California Fire Academy in Pacific Grove; Robert J. Sherman, Fire Inspector for the Naval Postgraduate School in Monterey; Joe Konefal, Supervising Arson and Bomb Investigator for the California Department of Forestry and Fire Protection in Sacramento; Captain Marty Huegenin of the Costa Mesa Fire Department; and Detective Sylvia Faris and Sergeant Heidi Clark, both of the Los Angeles County Sheriff's Department Arson/Explosives Detail.

Any factual errors in this book are, of course, entirely my own and in no way the result of the information these experts supplied.

In addition, as always, I want to thank my husband and frontline editor, Jerry Jacobs, for his help and constant support.

FLASH POINT

Chapter One

FLASHES of vivid red and blue and yellow from the emergency vehicles pulsed against the black sky like strobe lights at a rock concert. But there was no music in the cacophony of chatter from competing two-way radios, and the smoke that lingered in the night air wasn't from marijuana or tobacco. The odor was one I'd recognized since childhood, the acrid stench of death and destruction, the residue of somebody's torched dreams, somebody's burned life.

Sloshing through the rivulets of ash-laden water crisscrossing the street, I made my way between the fire chief's car and the pumper truck toward the burned building. It was a one-story tract house in the middle of a block of similar dwellings, typical of San Vicente, a middle-class suburb twenty-five miles south of San Francisco. The fire was essentially out now, except for two sections under the eaves that still smoldered. Two firefighters, their somber faces blackened with soot, aimed hand lines on the

trouble spots while their coworkers rolled unused hoses back onto the waiting trucks.

I elbowed my way through the milling throng of onlookers, hoping that somebody from the local police or fire department had thought to take photos, or better yet, a videotape of the crowd for future reference. They were the usual motley crew of neighbors and passersby, curious about someone else's tragedy, thankful it wasn't theirs. I spotted a woman wearing a bathrobe and curlers; a family of five eating ice cream cones in the warm April air; three or four stubble-faced youths about my son Max's age, telling cremation jokes; an elderly woman with tears streaming down her face; males of various ages standing alone, at least three of them taking pictures, the rest simply gawking; and a small crowd of reporters interviewing anybody they could manage to corner.

"Hey, lady!" a uniformed cop shouted, starting toward me. "Nobody's allowed inside."

"Delancey. Arson Investigation. Governor's Special Assistant," I replied, pulling my credentials from the pocket of my old trench coat.

In the dim nighttime light, the cop's wary gaze darted back and forth between me and my photo ID half a dozen times before he handed it back to me. I'd had that kind of reaction from people all my life; they didn't expect someone named Susan Delancey to be Asian. On the other hand, I realized I was still wearing the faux-ruby mini-chandelier earrings that matched the skimpy red cocktail dress hidden under my coat. I'd exchanged my strappy red shoes for the knee-high black rubber boots I carried in the Volvo's trunk for emergencies, along with my hard hat and the bag holding my tape recorder, notebook, cell phone, and flashlight, but had forgotten the earrings. My big Saturday night date with Dr. Todd Hampshire obviously was now down the toilet.

"Guess it's okay," the cop mumbled. "See Detective Berry inside."

I mashed my hard hat onto the French twist hairdo it had taken me half an hour to pin up and picked my way through puddles and over charred boards and piles of sodden ashes toward the house. The front door had been reduced to little more than splinters by a firefighter's ax. As I peered inside to gauge the condition of the still-smoking structure, a drop of water from a hole in the mangled ceiling slid off the rim of my hard hat and slithered down the back of my neck.

My breath caught in my throat as I stepped farther into the house, and I had to fight hard not to gag. Here in the foyer the stench was nearly overwhelming, a rancid mixture of soot and smoke and steam. I caught whiffs of burned wood, along with the sharp chemical smell of scorched carpets and synthetic fabrics. Underlying it all was an odor like meat left too long on a charcoal grill. Holding a handkerchief over my nose and mouth to filter out the worst, I carefully picked my way around sections of collapsed plasterboard toward three men who stood in the center of what looked like the remains of the living room. Luckily, the air here was significantly better, freshened through a gaping hole in the ceiling and the cedar shake roof above it.

"Susan Delancey," I announced, stuffing the handkerchief back in my pocket. "Governor's Special Assistant for—"

"Bill Hoffman, San Vicente Fire." A burly fire chief in a black slicker, boots, and hard hat thrust out his hand. I tried not to wince at his crushing handshake. "Made pretty good time," he told me.

"Ducked out of a hospital fund-raiser in Palo Alto," I replied, remembering my earrings. I pulled them off and slipped them into my coat pocket. "Thanks for calling so fast."

"Clyde O'Laughlin, DA's office," Hoffman said, gesturing toward the others, "and Detective Hank Berry, San Vicente PD."

I shook hands with both men, sizing them up quickly. Detective Berry was a dour-faced, middle-aged man with a graying red mustache. He wore a rumpled gray suit, striped tie, and the requisite hard hat, and he didn't seem particularly pleased to see me.

O'Laughlin was younger than the other men, probably no more than thirty. Nearly as tall as Hoffman, he was spare where the fire chief was thick, and like the detective, he was dressed in a gray suit, but his tie was dark red and his suit was still crisply pressed, except for the hems of his pants, which were soaked and streaked with black.

It didn't take long to figure out why O'Laughlin looked like he was about to lose his dinner. He glanced at me only briefly, then returned his gaze as though hypnotized to the reason I'd been called—the badly burned corpse lying on the floor only a few feet away. Some of the fire debris had been cleared away from the body, which lay on its side, curled into a pugilistic position. The deceased was now framed by an oval perimeter of wet ashes. My guess was that this was the first fire death young O'Laughlin had witnessed. It was not a pretty sight.

I'm not sure anybody ever gets used to seeing what fire can do to the human body, and I've never been able to develop the sort of hard shell around my feelings that some cops and firefighters do, the kind of emotional armor that lets them joke about the horrors they encounter. Calling burned bodies "crispy critters" is simply their way of coping with extreme violence, a method of distancing themselves from the tragedy that often seems a routine part of their daily lives. Yet no matter how many fire victims I've seen, I've never been able to forget, even for a moment, that they were somebody's parents, somebody's children, somebody's best friends.

"We're going to need more light in here," I said, steeling myself for the part of my job I liked least.

"My guys are rounding up some portable floods," Berry replied. He sounded like a petulant child, obviously displeased about something, perhaps having to turn over some of his authority to an investigator from the governor's office, and an almond-eyed female investigator at that. My presence at an arson site often elicited a negative reaction from local authorities who saw me as an invader of their turf, but after six months in the new position created by the state's first female governor, I was getting used to it.

Ignoring Berry's tone, I turned on my flashlight, and taking care not to destroy any potential evidence beneath my thick rubber boots, I crossed over to the corpse and crouched down beside it.

Along with whatever clothes it might have been wearing before the fire, and any hair it might have had, much of the corpse's flesh had been burned away. What remained was blackened and blistered, with white bone clearly visible in at least two places on the skull.

I played my light across the head. A fragment of brain matter protruded from a narrow crack in the skull. I swallowed hard and breathed through my mouth to mitigate the odors of burned flesh and scorched hair. At least this corpse was fresh. Had it been discovered a day or two later, I knew the stench would have been unbearable.

The corpse was small, thus more likely a woman's than a man's, but I'd learned that a body can shrink by several inches in length and as much as sixty percent in weight when burned, because its fat becomes additional fuel for the fire. I couldn't tell the sex of this corpse from what I could see.

"Female?" I directed my question to Hoffman, who seemed the friendliest and most forthcoming of the three men.

"Probably a gal name of Ginger Smith," Hoffman replied. "Rented the house last fall from the owner, who lives in Sunny-

vale. Medical examiner's on his way, so we oughta know the sex, at least, pretty soon."

"How about X ray and a tech? ME's bringing that, right?" I hoped I wasn't insulting the locals' professionalism, but San Vicente was a small town, unused to violent deaths except for an occasional gang shooting and its share of domestic abuse cases.

Hoffman rubbed his jawline. "Usually decides about calling in the tech after he takes a look at the body."

"I'm going to need X rays, both skull and full body," I said. "If the ME doesn't request it, please see that it's fully x-rayed before it's moved out." As badly burned as this corpse was, I was concerned that it could easily fall apart the minute we tried to move it, destroying important clues to both the deceased's identity and the killer's.

"Will do," Hoffman said. "Clyde, how about making the call now?"

Obviously relieved to have an excuse to leave the death scene, O'Laughlin fairly bolted for the doorway.

"Body where you found it?" I asked.

"Right," Hoffman said. "She was obviously dead, so my men never touched her. Just cleared a bit of space around her so the ME can do his thing."

I nodded my approval. The protocol was that all fire deaths were to be treated as homicides until proven otherwise. If we determined later that the death was accidental, all we'd have wasted was some extra effort. But I sure didn't want to find out it was murder later on, after all our clues had disappeared.

Arson sites are considered among the most difficult crime scenes to process. Most of the evidence has been destroyed, either by the fire itself or by the firefighters' efforts to put it out. Often fingerprints, body fluids for DNA typing, fiber evidence, footprints—the sort of evidence most useful in making a case—can't be recovered from a crime scene. I'd had to get used to

working with clues soaked with water or fire retardant chemicals and buried under hunks of burned ceilings and walls, after which a herd of two-hundred-plus-pound men in size-twelve boots had tramped through them. Not exactly ideal for crime solving.

From the few things I'd already observed here, I had a strong feeling that this was a homicide. "Burn pattern on the body looks like whatever the victim was sitting or lying on burst into flame around her," I said, speaking into my small tape recorder. I coughed to clear the rancid taste from my throat.

Trying to breathe shallowly, I flashed my light away from the corpse along the floor to the nearest wall and then upward from baseboard to ceiling. There was a clear narrow black V-shape on the wall, the typical char pattern of a rapid-burning fire. It brought to mind three others I'd been investigating in recent weeks. Like the other fires, in Sausalito, San Francisco, and Daly City, this one had burned hot and fast, probably achieving flash-over—in which the room becomes so hot that everything in it bursts into flame—within at most four or five minutes. Also like the others, this one had been called in early on a Saturday night.

This corpse, like the other three, was lying some distance from the walls of the room, approximately four or five feet from the closest one. I couldn't help wondering about the positions of the bodies. Most fire victims are found either huddled in a closet, attempting to hide from the flames and smoke, or near a door or window, killed while trying to escape. Of course, this particular woman—assuming it was a woman—could have been dead before the fire started. Maybe the killer started the fire in hopes of concealing murder.

Yet, in the previous three fires in what could be a series of arson–murders, the medical examiners had found soot in the victims' windpipes and stomachs. They'd all been alive when the fires began.

The autopsies had determined all of the deaths to be completely fire-related—no gunshots, knife wounds, strangulations, or fatal beatings. All three women had died because they were burned alive. I figured they were probably unconscious when fire erupted and quickly engulfed them; otherwise, they would have made some attempt, however futile, to escape the flames. Being burned alive must be one of the most painful and terrifying ways to die, one that's haunted my dreams ever since I was a child. It's been nearly thirty years now, but I still sometimes wake in the middle of the night, drenched in sweat, visions of flames hovering before my eyes and the odor of burning flesh filling my nostrils.

"Any more bodies?" I asked, pushing myself back to a standing position.

"Just the one, thank God." Hoffman removed his hard hat and scratched his balding head.

"No Mr. Smith, no roommates?"

"Isn't any Mr." It was Detective Berry who spoke this time. "Wasn't married, and the owner says the lease doesn't allow roommates without approval."

"Kids? Pets?" I stiffened, waiting for confirmation of what was now a strong hunch.

Berry offered it. "Neighbors say Ginger Smith gave birth a couple weeks ago, to a girl. We've been all through this place, though. There's some baby gear survived the fire in the back bedroom, but no sign of any infant. Whoever killed the mom must've snatched the baby." The detective squared his jaw and glared, letting me know he was far ahead of me. "Got men out searching for the baby's daddy. Old gal across the street says his name is Steve, doesn't know his last name. We'll turn up somebody knows more. Daddy's suspect number one."

"Fine," I said. When it came to violence in the home, the victim's spouse or lover often turned out to be the culprit. But I

doubted such would be the case here. The pattern already was too consistent.

We now had four dead women, all of them young mothers of newborn daughters. If tonight's victim fit the pattern, all of them were burned alive. All of them died on Saturday nights. All lived within a twenty-five-mile radius of San Francisco. All lived alone; only the victim from Sausalito was married, and her Navy husband was stationed aboard a carrier in the Persian Gulf.

Most importantly, all four of the dead women's babies were missing after the fires, and within days, the fire departments involved—at least in the first three—had received taunting notes, possibly from the killer, about "liberating" the babies from their "whore" mothers. It looked like we were dealing with a kidnapper as well as a murderer.

My money was on a single warped killer, somebody who for some reason used fire as his or her weapon of choice and who wanted female babies. Had the murderer taken these women's newborns as some sort of souvenir of the deaths? Or for use in some kind of bizarre occult ceremony? Or maybe to sell for thousands of dollars each? Or simply to keep? If the babies had been "liberated," where were they now?

"Who've you talked to in the neighborhood?" I asked.

Pulling a list from his inside pocket, Berry gave me a brief rundown.

"Anybody I should see?"

He bristled. "My men have things covered."

"No doubt, Detective, but sometimes we arson investigators come up with different questions."

Berry rolled his eyes and mumbled something under his breath that sounded like, "a regular Charlie Chan."

"What was that?" I snapped.

He backed up half a step and tossed me a crumb. "S'pose you could follow up with that old gal directly across the street—Mrs.

Roswell, the one called in the fire. Maybe she'll open up more to a woman."

Right, I thought. Just a couple of "gals" chatting. No threat to the detective's masculinity there. Let the Oriental broad play detective if she wants to. I wanted to tell Detective Berry where to stuff his bigoted opinions, but I kept my mouth shut. "Fine," I said after a while. "I'll see what she has to say."

"Suit yourself."

As I emerged into the cool, fresh air outside, I saw there were now three remote rigs from TV stations parked in the street. As soon as they spotted me, more than a dozen reporters—from radio stations and newspapers as well as television—began shouting questions at me.

The cops guarding the crime scene kept them from surging through the police line and trampling potential evidence, but couldn't keep them quiet. I would never make it across the street to interview the woman who'd called in the fire without answering at least a few of the media's inquiries.

"How many bodies inside?" KBA radio reporter Bruce Link shoved his microphone toward me as I approached the group.

"One." I wanted to keep my answers short, to avoid volunteering anything that could come back to haunt the investigation later.

"Who is it?"

"Victim hasn't been identified yet. We'll issue a news release as soon as we make the ID and notify the family." I tried to push my way past the group, but they shifted and encircled me.

"Ms. Delancey." I recognized a loud female voice as that of Channel 3's Lauren Meyers, a tall, attractive brunette known for her aggressive, tabloid-style reporting. "I need a sound bite for the ten o'clock news."

Meyers gestured to her cameraman, who switched on a blazing

light and aimed it directly into my face. I blinked, temporarily blinded.

"Is this another Baby Snatcher Murder?" she asked.

"It's too early to say whether this is murder at all." I resented the media's labeling crimes with catchy names. So far there'd been no leak about the killer's notes to the fire departments or the coverage would have been even more lurid.

"Neighbors tell Channel Three this house was rented to a young, single woman with a new baby. You say you found only one body, so—"

"Let me repeat—we don't know who the victim is yet." I felt like slapping her microphone away. "When we do, you'll know."

As I tried to shoulder my way past, Meyers followed me. "Isn't this why the governor hired you, Ms. Delancey, to stop mayhem like this?"

I whipped off my hard hat and held it in front of me like a shield. "My mandate is to help coordinate the efforts of fire and police departments in serial arsons, particularly those in which human life is lost," I said, paraphrasing my official job description. "Governor Bennett has been very concerned that local agencies sometimes don't communicate with each other all that well. As you reporters all know, that can make it a lot harder to catch and prosecute serial arsonists, especially those who move among jurisdictions." I tried to keep my answers vague and safe, balancing my words so I wouldn't either say something that might give the killer some kind of advantage or come across as so tight-lipped that I pissed off the media.

Meyers took a card out of her pocket and referred to it as she spoke. "The fire deaths of Betsy Cavendish in San Francisco, Isabel Morrisey in Daly City, and Heidi Weill in Sausalito are exactly like this one, aren't they? Their babies are missing, too."

"We don't know yet if the same person is responsible for all of these women's deaths. Or the missing babies."

Lenny Palmer of the San Francisco *Bay Crime Journal* roughly elbowed Meyers aside. She angrily shoved him back, but he held his ground. "When *will* you know?" he demanded. Palmer was every bit as aggressive as Meyers, and he'd already written one unflattering article about me. While his newspaper didn't have the large circulation of the *San Francisco Courier* or *Inquirer*, its subscribers were highly influential people—legislators, local government officials, and the legal community—along with the "paranoids" convinced that they lived under siege by hordes of criminals.

"As quickly as possible. The proper authorities in all the communities involved are working day and night to solve these crimes," I said. "And my office is coordinating their efforts. If tonight's tragedy turns out to be an arson–murder, the San Vicente police and fire departments won't rest until the guilty party is caught. Neither will I."

"What happened to the babies?" The question came from a young newspaper reporter, whom I recognized as a student in a criminology class I'd taught three or four years earlier.

"Too early to comment on that, Jeff. Sorry, folks, that's all I've got for now."

The reporters shouted more questions at me as I turned away from the TV lights.

"But you—"

"—about the violence in—"

"—true she lived alone?"

"—find the baby?"

"We'll issue a statement as soon as possible." I kept walking, talking over my shoulder. "Until then, I have no further comment." I sprinted across the street just as the reporters' attention was distracted by the arrival of the medical examiner's van.

Chapter Two

"*THEY'RE* dead, aren't they?" Deborah Roswell asked. She was a hefty sixtyish matron wearing a blue flowered tent dress. Her gray hair was pulled into a messy bun held at the nape of her neck with a large mother-of-pearl clip. "I feel terrible I wasn't home when it started. Maybe I could've saved 'em." The woman lowered herself into a sturdy oak rocking chair with pink-and-white striped chair pads that were held on with little bows. She rocked back and forth nervously as she talked.

"Don't blame yourself. It's not your fault." I perched on the edge of a wooden chair, having refused the sofa—a mass of pale pink-and-white flowers with ruffles rimming the bottom edge. I'd slipped out of my boots and left them at the bungalow's door to avoid leaving a trail of soot across the rose-colored carpeting, but I kept my soiled coat on, despite the warmth of the room. Doing the interview in my stocking feet was one thing; doing it in a red cocktail dress was something else.

I clicked on my tape recorder and propped it up on the coffee

table between us. "We're not absolutely positive that the victim is Ginger Smith," I told her. "But the fire moved very fast. Whoever died in that house died very quickly."

Mrs. Roswell's rocking slowed a bit and she leaned forward, gripping the hard arms of the chair. Her unpolished fingernails were ragged and bitten, and I wondered whether that was their usual condition or something brought on by the stress of tonight's tragedy. She'd been at the nearest shopping mall, she told me, arriving home a little after seven o'clock. "Always go for Saturday supper with a girlfriend, ever since my Bud died— September tenth, 'eighty-nine. Cancer. Early Bird special, you gotta order before six. How'd the fire start?"

"Not sure yet. Maybe you can help us figure it out." I wondered whether the room had been pink when the late Bud was alive. Nearly every surface was covered with knickknacks—glass cats and birds, Hummel figures, china ballerinas, miniature Victorian houses. If there was supposed to be a theme to the vast collection, I couldn't tell what it was. "Did Ginger smoke?" I asked.

"Don't know." She shrugged. "Maybe not, with the baby. Could she have left something on the stove?"

"It'll take a while to determine the fire's cause. Notice anybody hanging around Ginger Smith's house tonight?"

Her expression froze. "You mean somebody burned up that girl on purpose?"

"That's always a possibility. We'll know more after we take a closer look at the place and complete some chemical tests."

The woman caught her breath and bit down on her lower lip. Her knuckles grew whiter on the arms of the chair as she shook her head. "You can see where somebody might have it in for Ginger, I s'pose, but who'd want to hurt an innocent little baby like that?"

"We didn't find the baby, Mrs. Roswell. Know if there's a baby-sitter Ginger might've taken it to?"

She shook her head again, loosening another strand of alumi-num-colored hair from her bun. "Baby's awful little to be shoved off on a sitter, but who knows? You ask me, these girls nowadays, no sense of responsibility. But I shouldn't speak ill of the dead. Nope, don't know about any baby-sitter."

"We'll find the baby," I said, with more confidence than I felt at the moment. "When did you first notice the fire?"

"Terrible thing, just terrible." She began to chew her right thumbnail, caught herself, and stopped, shoving both hands into her lap, where she gripped her fingers tightly together. "Smelled smoke as soon as I got to my driveway." She'd spotted flames through the living room windows of Ginger Smith's small house, she told me, then called 911 as fast as she could make it to the telephone. "Firemen were here real quick. Five or six minutes, I'd say, seven tops. But I guess…" Her eyes welled up and she blinked rapidly.

"Notice anybody on the street when you got home?"

"Uh-uh."

"What about strange cars or trucks parked on the block?"

"Nope, street was real quiet. Sorta eerie, now I think about it, but it's mostly young people around here lately, work in the com-puter industry. Go out Saturday nights, unless they're having one of their loud parties. Say, can I get you a cup of coffee or something?" She squinted at me. "Lord, what's wrong with me? You probably drink tea. Haven't got any of that fancy green stuff, but I can make you a cup of good old-fashioned Lipton's."

"No, thanks, that's not necessary. Did you know Ginger well?"

"No bother. I can put a kettle—"

I held up a palm in protest. "No, no, Mrs. Roswell, really, I don't need anything. I have to go back across the street in a few minutes and see the medical examiner. Now, about Ginger Smith—"

She admitted that she knew Ginger Smith barely well enough

to say hello to. "Neighborhood's not what it used to be when my Bud was alive. That man knew everybody, all their kids. Now it's all these young renters—new ones every few months. Can't keep track." She said she'd seen Ginger's new baby only once, the day after Smith brought her home from the hospital. "Named her Tiffany, like that fancy jewelry store. Tiffany Jo Smith, I think it was, or maybe Tiffany Ann, something like that. Can you imagine?"

"I understand Ginger Smith wasn't married."

Roswell raised an eyebrow. "Guess it's not required nowadays. They go right ahead and have these babies no matter what. White girls sleeping with Mexicans, coloreds, popping out all these mulatto babies." She picked up a yellow glass cat from the lamp table and began to stroke it in her lap as if it were real.

"Is Ginger's baby of mixed race?"

"Nope. Just meant, in general there's too much of that sort of thing going on." She jutted out her plump chin and her voice took on a defensive tone. "I mean, your people don't believe in mixing bloodlines, either, right?"

I didn't bother telling her that my people were an unknown Korean woman and some Caucasian GI Joe, or that I'd been adopted and raised by white Americans. Caucasians tended to see me as Asian, while Asians categorized me as white. My own bloodline was already well mixed, a fact that had taught me long ago that bigots come in every color. "Ever meet the boyfriend?" I asked, careful not to let my indignation show on my face.

She shook her head. "But I saw him coming and going plenty—used to hang around that girl all hours of the day and night." Mrs. Roswell leaned forward in the rocker, as though to confide a secret. The glass cat disappeared among the folds of her dress. "Till she told him she was going to have a baby, and that was the end of him."

"Know his name?"

"Steve's all I ever heard. Myra Potter might know, though—she's the brown house next to Ginger. Myra says Ginger told her Steve didn't like the idea of being a father. He was pushing her to get an abortion, but she wouldn't." Her voice took on a confidential tone. "Jerk should've kept his pants zipped, you ask me. Dumped her fast when she wouldn't get rid of that baby. Heard she planned to haul him into court for child support." She straightened her spine and the yellow cat reappeared. She stroked it harder and harder now, like a worry stone.

I made a mental note to take a look at the family court files. Was being sued for child support reason enough to kill the mother of your baby? Surely it had happened more than once before. But why would a man who didn't want to be a father steal his own infant and then murder its mother?

"Ginger have any other frequent guests?" I asked.

Her eyes widened. "You mean, maybe this Steve wasn't the father?"

"I don't mean anything. I'm simply asking if you noticed if Ginger had other visitors."

My voice must have been too sharp because Mrs. Roswell flinched and her round face stiffened. "Can't expect me keep track of everybody comes to see people on this block. I'm no snoop, you know; got better things to do with my time." She reached over and dropped the glass cat back down on the table. It landed with a thud. "Got this big house to keep up all by myself, and my own friends, plus I volunteer for the seniors Wednesdays and Fridays."

"I know it's hard to remember," I said, turning off the recorder and getting to my feet, "especially at a stressful time like this. But if you think of anything else that could help us, anything at all, please give me a call." I took a card from my pocket and handed it to her. "Anytime, day or night. The answering service can always reach me."

✿ ✿ ✿

As I came out of the Roswell house, I saw the Channel 3 van pull away from the curb and head down the street. At least I wouldn't have to parry with Lauren Meyers again tonight. I ducked into my car for a moment of privacy and used my cell phone to call Todd.

"Missed a really scintillating speech by the chairman of the board," he told me. "Seventy-three full minutes of budgets and bricks—I timed it. More than you'll ever want to know about the hospital's new wing and how we're going to pay for it."

"All that and rubber chicken, too! I feel deprived."

"Me, too." He sounded wistful. "Very."

I apologized again for deserting Todd. A doctor on the burn ward at Bay Community Hospital, he had no choice but to attend the fund-raiser. And I'd had no choice but to leave him to answer my summons.

"Hey, last time it was me," he reminded me. "Have to live with it, I guess."

We'd been having a romantic dinner in Tiburon the previous Sunday, admiring the view of the San Francisco lights across the water, when one of his burn patients went into crisis. Todd literally ran out the door of the restaurant, leaving me with my half-eaten dinner and a wad of bills to pay the check. We'd learned to take separate cars on our infrequent dates so neither of us was ever left stranded.

With our demanding careers, his two children living with him on alternate weekends, and my son, Max, with me half of each week, Todd and I sometimes wondered if we were ever destined to spend a full evening together. Until I got the call about the San Vicente fire, I'd been hoping tonight would be the night. Max was staying with his dad half a mile from my San Francisco condo, Todd's kids were with their mother in Hillsborough, I'd

dressed to kill, and the bed sheets were clean. Then the damn beeper...

"Afraid I'm here for at least a few more hours," I told Todd. "Maybe later in the week?"

"Count on it."

We rang off with words of mutual regret that were quickly becoming our mantra. I sat in the car for a moment, wondering about the fickleness of fate. I'd been divorced from Max's father for five years now, and while I'd dated several men, all of them the tall, fair-skinned types that always got my juices flowing, Dr. Todd Hampshire was the first one I'd felt any potentially lasting passion for. It seemed unfair that I'd met him right after I'd given up my faculty position with its predictable schedule and plunged into the most challenging and time-consuming job I'd ever had.

I'd had a few sleepless nights deciding whether to leave the university. Teaching in the Criminal Justice Studies department, where I'd taught classes in arson investigation, had given me stability plus a good salary and benefits. For the most part I'd enjoyed it, particularly working with the brighter, more motivated students. Sure, the endless, boring faculty meetings and the long-winded articles I'd had to publish to get tenure were a pain. And I couldn't wait to see the last of that handful of students each semester who didn't do their class work, then whined about their failing grades afterward. Still, the university was the right place for me to be while Max was growing up.

But now Max was sixteen and he didn't need me around so much anymore. And the truth was, I'd been aching to get back into the real world for years. I'd missed dirtying my hands instead of simply teaching others to do the job.

In the six months since I'd become the California governor's first arson czar, I'd solved three serial arson cases that crossed

county lines, and I'd learned to feel fully alive again. Right now, I wouldn't give up that high for anything. Or anyone.

I slid the cell phone into my bag, plopped my hard hat on my head, and headed back toward Ginger Smith's demolished home.

When I got back to the burned house, I was relieved to find that Detective Berry was gone for the night, as was the assistant DA. The portable floodlights were in place now and the bright illumination threw into eerie relief the scene inside the structure, including the charred body, which drew everyone's attention. The ME was examining it, and the X-ray technician had finished and was putting his equipment back into his van. I was told the body could be moved out soon.

Chief Hoffman introduced me to the ME. Dr. Gene Gleason was a short, thin man, with a full mane of white hair and a friendly, open face. "Female all right," he said in response to my query. After taking the body's temperature and certain other measurements he rolled it on its side. Underneath was a sliver of bright blue cotton, its edges well charred.

"The shirt she was wearing?" I asked him.

"Seems thick for a shirt." Gleason grasped the scrap of fabric with a tweezers and held it up for me to see.

"More like upholstery. Maybe part of whatever she was lying on when the fire started," I suggested. "From the burn pattern on the body, I'd guess it was some kind of polyurethane mattress or cushion that burst into flame."

"Not a bad theory."

Dr. Gleason placed the scrap in an evidence bag and marked it, then gestured to the aides to bring the body bag and gurney. Within a few minutes the corpse had been removed to the coroner's van. It would be refrigerated at the morgue until tomorrow,

or more likely Monday morning, when the ME would do a thorough autopsy. Not until then would we have an official cause of death. Identification of the deceased would have to wait for records from Ginger Smith's dentist, which would be compared with tonight's X rays of the head.

Without stepping on the spot where the body had lain, I bent down and inspected it more closely in the bright light. The burn pattern here was distinctive. I could see that the body had partially protected a portion of the flooring, even while whatever it had been lying on burned almost completely.

There was a thick layer of ash all around and I noticed a strong odor of burned plastic—further evidence of flaming polyurethane—but no smell of gasoline or kerosene, two favorites of arsonists. With luck, lab tests would tell us whether an accelerant had been used.

I was beginning to feel frustrated. Other than the unusual speed and intensity of the fire and the fact that the victim apparently hadn't made any attempt to escape, there really was nothing here that was positive proof of arson.

Yet I believed that's what it was. Arson and murder and probably kidnapping as well.

A burned-out sofa and chair stood in a corner at right angles to each other, their springs and frames partially surviving the overwhelming heat of the blaze. The remains of a metal TV stand was opposite at the other side of the room. Shards of curved glass from the TV screen littered the floor just beneath the layer of ash. Nearby were a few charred bricks, maybe the remains of an economical bricks-and-boards bookcase. There was also a rectangular metal frame with wire straps strung across it. Judging by its shape and size, I guessed it was the mattress supporter from a baby crib.

While the portable light was still available I surveyed the rest

of the one-story house, moving from the spot where the body was found outward to the periphery in all directions. As I moved, I drew a diagram of each room on a pad of paper, indicating where everything was located and making notes to myself in the margins.

The area of greatest burn was in the living room, right around the body, which I found curious. Often, if someone other than the owner wants to torch a house, it will be done from the outside. A Molotov cocktail or firebomb is thrown through a window, instantly setting furnishings on fire and spreading quickly. That wasn't the case here.

I saw no evidence of a bomb, nor did Deborah Roswell's eyewitness account support this theory. Nor was there anything to indicate that the fire had started simultaneously in more than one spot, another firm indication of arson.

This fire appeared to have started at the place where we'd found the corpse, then fanned outward.

Could this be some kind of bizarre accident? I wondered. Could Ginger Smith have taken drugs or been drunk, then passed out while holding a lighted cigarette and lying atop some kind of flammable mattress she kept on her floor? A number of unlikely factors had to coincide before that could happen. That theory also didn't answer a key question: Where was Ginger's baby?

In view of the similarities to the other Bay Area crimes I was investigating—plus my gut feeling, woman's intuition, whatever you want to call it—my vote remained with arson and murder.

I checked the front door. Although most of it was now in splinters from the firefighters' entry, I could tell from the portion still hanging on the hinges that it had been closed during the fire. There was no charring along the hinged portion of the door's frame. I also detected no sign of forced entry from a quick

examination of the deadbolt lock, which lay on the floor, still attached to chunks of the door and its frame.

The back door, which opened off the kitchen, remained locked with a deadbolt. No intruder had entered here, unless he'd had a key to the house and used it to get in, then relocked the door after leaving. Perhaps Ginger Smith's elusive boyfriend required a closer look after all. He certainly would have had access to her house keys.

The fire had traveled along the hallway toward the back of the building, probably in search of oxygen. A bedroom window was cracked open about an inch. It was a crank-out window, nothing an intruder could have squeezed through to gain entry, but it would have provided fresh air to keep the fire burning longer. All of the other windows in the house were closed and locked, except for one in the living room that had exploded from the heat of the fire. Every shard of glass I found was well blackened by the smoke—a clear sign that this window had remained intact until the fire was well underway.

It was in the tiny back bedroom, where the flames had barely licked through the doorway before the fire crew put them down, that I felt my heart wrench. An old oak crib stood against the wall facing the doorway, a mobile of angels in soaking wet white gowns fastened to one side. The little bed looked remarkably like the one my ex-husband, Doug, and I had bought for Max before he was born. As I sketched its position in the room onto my pad of paper, I couldn't help remembering my own chubby baby lying on his back, his tiny hands and feet flailing against the air as he delighted in the musical mobile circling above his head.

As a teenager, Max still loved music. I wondered what Baby Tiffany would learn to love? Whatever it was, her mother wouldn't be around to appreciate it. Or her.

Before I left for the night, I checked back with Chief Hoffman. "If he sticks to his pattern," I told him, "you can expect a note from the killer in the mail early in the week—in a plain white business-size envelope addressed to you personally. Always seems to know which chief is in charge."

"Should I open it?" Hoffman's eyes were bloodshot and he looked as dog-tired as I felt.

I thought for a moment. "Have to, I guess, to be sure. There's been no return address on any of the envelopes so far, nothing to distinguish them from routine mail." I reminded the chief to avoid leaving his fingerprints on any suspicious mail he received, although we hadn't yet found the killer's prints on any of his notes.

He or she was very smart. All the notes and envelopes had been printed on a standard laser printer. Even with my department's paltry budget, we have one in the office. The envelopes were sealed with plain water and the stamps were the self-adhesive kind, so we'd been unable to recover saliva for DNA tests. And it had been determined that all three of the messages had been deposited in different drop boxes around San Francisco, so the killer had deliberately avoided a post office, where a sharp clerk might remember a face to go with the evil little notes.

Hoffman promised to keep two of his firefighters at the house to handle any remaining hot spots that might flare up. And a uniformed cop would stay to keep the site secure. At first light, fire department workers would be on site to section off the house before beginning the important debris-sifting process. I informed him I would return shortly after that.

It was two-thirty before I climbed back into the Volvo and started the drive back home to San Francisco. If I was lucky, I'd manage to catch a few hours of sleep before I had to be back on the job.

My drive home was as free of traffic as it ever gets in the Bay Area. Except for a few drunks and a handful of night-shift workers, there aren't many people on the freeways after two on a Sunday morning. I made good time from San Vicente, pulling into the underground garage of my Nob Hill high-rise condominium a little past three. I stuffed my coat and boots back into the Volvo's trunk. Bone-weary now, I used my security key to summon one of the elevators and rode it alone to the sixteenth floor.

I sensed something was wrong as soon as I unlocked the door of my unit.

Chapter Three

LIGHTS were blazing inside my condo, and I was sure I'd turned them all off when I left for my date with Todd Hampshire. I froze in the open doorway, but heard nothing more than distant traffic noises and the whine of the elevator descending to the first floor. I crept into the foyer.

An erratic snore came from the direction of the living room. A sleeping burglar? I'd heard stories of vagrants breaking into vacant houses only to use the shower and perhaps grill a steak stolen from the owners' freezer. But on the sixteenth floor of a condominium on the peak of Nob Hill? Not too likely. Besides, the building's security was excellent: a doorman on duty until midnight and security locks on the front and rear doors as well as in the garage. This wasn't an easy place to break into.

Slipping off my shoes, I tiptoed across the oak hardwood floor of the foyer and peeked around the corner. Sprawled across the living room floor were three sleeping youths, one of whom had his arms wrapped around an electric guitar. In the bay window

that looked out over the sparkling city lights and the Golden Gate Bridge stood a set of drums and an electronic keyboard, humming low. My son, Max, lay spread-eagled on the cream-colored sofa, a skinny, jeans-clad leg thrown over its back. The glass-topped coffee table was littered with an open pizza box holding only crumbs, a trio of empty Pepsi cans, and some greasy paper napkins. The room stank of garlic and sweat.

I wasn't sure which was the stronger urge—to cuss the boys out thoroughly or to laugh hysterically.

Gripping Max's shoulder, I shook him awake. "What's going on here?"

"Huh? Oh, Mom, hi." His boyish face was thick with sleep.

"Why aren't you at your dad's? And what's the band doing here?"

As Max pushed himself to a sitting position, his knee hit the pizza box and it slid onto the floor, scattering crumbs across the ivory carpet. The other boys stirred and the snoring ceased abruptly.

"Answer me, Max. What's going on here?"

He yawned and stretched his legs, revealing a hole in the toe of one of his sweat socks. "You know how Dad is. He knows we gotta practice, but we don't get through two numbers before he goes, 'Can't hear myself think over that racket.'"

I suppressed a smile; Max's imitation of his father's familiar complaining tone was right on target.

He raised his hands in a gesture of supplication. "Hey, we had to go *somewhere*."

"So you've been making your racket here all night." I could see it coming, another complaint letter from the condo association's board of directors, another threat of a stiff fine if the "disturbance" coming from my unit didn't "cease immediately." If this place were a rental, Max and Pacific Rim, his band of rock 'n' roll wannabes, would have gotten us evicted long ago.

He swept a shock of brownish-black hair off his forehead. "Don't call it a racket, it's— 'Sides, we kept the amps turned way down and Bri was, like, hardly touching the drums. We packed it in around midnight and ordered a pizza. Guess we sorta crashed after—"

"Hi, Mrs. Macalester." The smallest of the band members rubbed his eyes. "How ya doin'?" Bucky Chong grinned at me sheepishly.

I chose to ignore the boy's penchant for calling me by Max's father's surname instead of my own. I suspected his calling me Mrs. Macalester was his way of needling me, in a pseudo-polite way.

"Max," I said, my temper rising. "It's after three o'clock in the morning. I spent the last six hours at a fire and I'm exhausted. I want you to get your friends and their gear out of here—*quietly*. Now. And then you can go to your room and sleep until tomorrow morning, which is precisely what I plan to do. *Undisturbed*. Understand?"

Max nodded almost imperceptibly, his mouth tightening. I was committing one of the worst sins the mother of a teenager possibly could—reprimanding him in front of his friends—but I figured he'd earned it.

"We'll talk in the morning." I turned on my heel and strode down the hall to my bedroom, my red evening shoes still foolishly dangling from my fingers.

By the time I'd closed the door firmly behind me, I was already feeling the familiar pangs of divorced-and-working-mother's guilt. Like most moms I know, I'm adept at flogging myself with it.

Truth was, my life wasn't really so bad and neither was Max's. All I had to do was remind myself of tonight's victim and the other three murdered women to realize that. Divorce or no, career or no, I'd been there to see Max grow from a chubby, brown-

haired, hazel-eyed infant to a fine young man. Most important, I loved my son and he loved me. Even when we rubbed each other's nerves raw, which seemed to be happening more and more during his teenage years.

I went into the bathroom, brushed my teeth, and took a quick shower to wash off the smoky stench that clung to my hair and skin like cheap perfume. After setting the alarm clock, I slid between my nice, clean sheets, feeling a momentary pang of sadness that I was there alone.

The inevitable crashing and banging as the members of Max's band packed up their instruments and headed toward the elevator lasted for another five minutes after I got into bed. Then I heard the door shut and there was nothing but blessed quiet.

My last thought was the hope that the boys had remembered to call a cab before they left the building. Otherwise, heaven forbid, they would be back.

The smoke in the narrow hallway was so thick I couldn't see anything. It quickly filled my lungs, gagging and choking me. I dropped to my knees, desperate to find a breath of oxygen in the rapidly increasing heat.

My heart pounding wildly, I finally managed to draw a lungful of air near floor level.

"Come back!" I screamed, squandering my precious breath. "Don't leave me!"

I could no longer find the big firefighter in the rubbery yellow coat and surreal black mask. He'd disappeared somewhere ahead of me in the dense, smoky cloud.

I crawled in the direction I'd seen him go a moment ago, but the heat was almost unbearable now, coming at me in undulating waves, and all I had to protect myself from it was a flimsy nightgown. My skin grew hot and dry, far more painful than any sunburn I'd ever had.

"The kids here need me," a familiar voice called back to me. "Have to get 'em out."

What about me? I cried silently, alone in the circling smoke. What about me? I need you.

My eyes streaming, blinded by the inferno spreading around me, I felt my way along the floor, moving as quickly as I could on hands and knees. A fat rat skittered across my hand, searching for its own escape route. Oblivious to the splinters piercing them, my fingertips slid across the rough wooden surface of the filthy tenement floor, searching frantically for some way out, a path to survival.

I felt the slight rise of a doorsill. Drawing a quick, shallow breath at floor level before pushing myself upward on one knee, I ran my hand up the surface of the door, searching for a doorknob. My fingers found a sharp-edged glass globe, closed around it, and twisted hard.

The door jerked open and I fell through, landing squarely on one elbow. I found myself on the floor of a large, shabby room. There was less smoke here, so I could see better, but the heat was still intense. I spotted two or three broken chairs, an old green sofa with its springs exposed, a pair of badly torn and stained mattresses lying on the floor on the other side of the room. The shabby furnishings smoldered in the murky darkness.

The tall firefighter in the yellow coat appeared before me, moving slowly and determinedly across the room. Still he paid me no mind.

"Here I am, here I am! Help me!" I called, but he didn't turn around. He didn't hear me.

I was only a foot or two inside the room when everything in it erupted in flames—as though the smoky cloud hovering near the ceiling had burst, raining gasoline. Crimson flames leapt high into the air, blackening the chair beside me in an instant, consuming it in less than a minute.

As the flames licked at his boots and slithered up his legs, the fireman finally turned toward me. I could see his eyes above his oxygen mask looking at me with regret and sorrow, and despite the deafening roar of the blaze, I clearly heard him whisper, "Good-bye, sweet Susan. Good-bye."

With a sharp crack, the floor opened up and the big firefighter sank. In a flash, the flaming bowels of the building swallowed him.

In shock, I crawled to the edge of the abyss and peered downward. As he fell, the fireman's mask flew off and I saw the terrified face of my father for the very last time.

I became invincible now; smoke and heat could not stop me. I stood up and sped out of the room, back into the hallway. My heart pounding, now I could see clearly through the thickening smoke. I ran straight through the flames, my gown and skin no longer touched by the searing heat.

I found the back stairs and hurried downward, taking them two at a time. But when I reached the basement three floors below, I found that most of the building had collapsed into it.

"Daddy! Daddy!" I cried.

Sobbing, I dug through the burning rubble with my bare hands, tossing aside flaming floor joists like toothpicks. Burning coals and hot ashes scattered everywhere as I plunged in up to my armpits.

Finally my fingers touched the back of the thick yellow coat. I grabbed hold of it and pulled, lifting the firefighter as much as I could. But he was dead weight and my strength was quickly draining. I tugged and yanked and pulled, trying to turn the firefighter's face upward. My heart thudded to a halt and my breath caught in my throat as I looked down. I gazed in horror upon the dead face of my only child.

Throwing myself across Max's burning body, I screamed and sobbed as though my heart would never mend.

✿ ✿ ✿

Waking with a start, I felt my heart beating as fast as a hummingbird's wings. Tears streamed down my face, and my nightgown and bedsheets were soaked with sweat.

Much of the terrifying dream was familiar, the nightmare that had haunted me since my early teens.

I was thirteen when my adoptive father, Michael Maxwell Delancey—known as Mickey—died in a fire in a Los Angeles tenement that drug addicts used as a shooting gallery.

There are some things I know for certain about his death. One is that my father went into that building to try to rescue some children. When his fire crew arrived on the scene, bystanders on the sidewalk said they thought there were kids trapped inside. Dad was the first one to go into the tenement.

I never found out whether he'd followed proper departmental procedure, whether he'd gone in alone or with a partner in his shadow, whether he'd been pulling a hose, whether he'd been wearing his oxygen mask.

What I do know is that drug sellers had booby-trapped that building, chopping a hole in the floor of the shooting gallery and covering it loosely with a thin scrap of linoleum. It was their effort to ambush any narcs who might try to raid the place during a drug deal.

In the smoke and flame and confusion, my father stepped on the booby-trapped section of the floor and plunged three stories to his death. They didn't find his body until the next day, after the fire had already been put out. He was buried in the basement under three feet of charred fire debris, his body burned beyond recognition.

One other thing I know for sure about my father's death is that the fire that killed him was started by an arsonist. Mickey Delancey died on that hot summer night more than twenty-five years ago because somebody murdered him… just as certainly as if he'd been shot in the heart.

The difference was that my father's murderer hadn't had the guts to look him in the eye while he stole his life. This killer had done the job in the arsonist's cowardly manner. He'd simply lit a match, tossed it into a river of gasoline, and stood back to watch it consume anyone who blundered into the hungry fire's path.

They never found any children's bodies in that burned tenement. And they never caught the arsonist who murdered my father.

I sat up in bed, hugging myself for warmth in the damp nighttime air. There was something disturbingly different about my dream tonight, a new element that chilled me to the marrow.

This was the first time I'd ever become an adult in the dream. Until now, I'd always remained that thirteen-year-old girl, a child in the process of metamorphosing into a young woman, an adolescent who still desperately needed her dad. But worse, tonight's dream was the first time the dead man I found in the basement wasn't my father.

Shivering with fear and cold, I climbed out of the bed and shed my damp nightgown, tossing it into the hamper. I took a clean, dry one from the drawer, a cozy, well-worn blue-and-yellow-flowered flannel number, and pulled it over my head.

Barefoot, I padded down the hall toward the kitchen, stopping at the closed door of Max's bedroom. I pressed my ear against the door but heard nothing. Slowly, I twisted the knob and pushed the door open a crack, indulging my primal desire for reassurance that my son was alive and well. I peered into the dusky room and froze in place. Max was nowhere in sight. Logic told me he wasn't burned to death in a collapsing tenement. But where was he?

My heart racing, I hurried through the place, searching. I found the answer in the kitchen. Propped against the coffeepot was a note in Max's round scrawl: "Dear Mom, I went back to

Dad's to crash so I wouldn't bother you. Remember you promised to take me practice driving on Sunday. Love, Max."

Gripping the note tightly, I felt myself seesawing between relief and annoyance. Max was okay, that was the important thing. Obviously he'd taken the cab with his friends. Still, he'd left in the middle of the night without letting me know, scaring me half to death.

Realizing I would need something to help me get back to sleep, I poured a mug of milk and placed it into the microwave to heat for hot chocolate. When I was a bit younger than Max and I awoke like this after one of my nightmares, my mother used to make me a mug of hot chocolate. The two of us would sit at the kitchen table for half an hour or so while Mom listened to me describe my fears. She never dismissed my night terrors as childish fantasies, and over time, they grew less and less frequent. Now the nightmares came only once or twice a year, usually as the climax of a particularly exhausting or frustrating day.

Tonight, however, the old terror was back, with a horrifying new twist.

I mixed cocoa and sugar into the hot milk, then sipped it slowly, sitting alone at the round oak table. When my stomach was warm and full, I climbed back into bed and lay still for another hour, gazing out of the window at the beautiful, dazzling diamonds of San Francisco's nighttime lights. As my eyelids once more grew heavy, I couldn't help thinking how much the glowing white lights reminded me of tiny sparks waiting only for a quick burst of oxygen or a splash of gasoline to ignite into full-fledged, life-extinguishing fire.

Chapter Four

IT WAS much warmer in San Vicente than in San Francisco, not unusual for an April morning. San Francisco is almost always air-conditioned by an ocean breeze and frequently socked in by fog, while the Peninsula and East Bay enjoy far more sunshine and warm weather. I peeled off the jacket of my navy denim pantsuit and tossed it into the Volvo's backseat.

It felt good to get out of the car and stretch my legs after what had proved to be a most adventurous ride.

"Pretty good for my first time on the freeway, huh, Mom?" Max asked. He grinned with pride that he'd managed to drive all the way from his dad's townhouse to San Vicente without getting us killed. Apparently nearly sideswiping a delivery van on the freeway entrance ramp and parking with one wheel teetering over the curb when we finally came to a screeching halt less than two feet behind the fire chief's car didn't count as demerits in his book.

I took my time, carefully phrasing my answer, wanting neither to discourage nor falsely praise my budding Mario Andretti.

"For your first time, not too bad," I replied, finally. "We'll have to practice merging, though. And parking." Max had sounded so devastated when I tried to cancel our Sunday driving date that I agreed to let him come with me to the burn site. I promised he could drive us there and back, but while I worked he had to find a quiet spot to do his homework and stay out of the way.

By the time I arrived at the fire scene, the hand search was well underway and the sifting station was being set up on the muddy lawn.

The crew from the local fire department was assembling the sifting apparatus, a high rack holding three parallel screens of varying fineness: the top one a one-inch mesh, the second a half-inch, and the bottom a quarter-inch. One at a time, bags of ashes and fire debris carried from inside the burned house would be dumped onto the top screen, then washed down with a booster line from the fire engine. Everything in the house was already soaked from last night's efforts to extinguish the fire, so more water wouldn't really damage it any further. Whatever ended up captured by any of the three screens became potential evidence, yielding possibly important clues to the fire's origin and cause.

This was just the start. A thorough arson investigation of the entire burned property could easily take many days. My role was to make sure it was being done correctly, then compare the results with those from similar fires to see if I could find any common pattern.

As I crossed the lawn to check the crew's progress, I heard the squeak of sneakers on the wet grass behind me. I halted and spun around abruptly. Max barely avoided running me over.

"Hey, kiddo, we have a deal."

"Just want to see what's going on."

"I can't let you get any closer. You might contaminate the evidence."

"I won't touch anything, honest."

Obviously logic wasn't going to work on my stubborn son. I changed tactics. "Tell you what, Max. You take one more step toward my fire scene and I drive us home. *Now*."

"Hey!"

I stood my ground, staring Max down as I watched him mentally figuring his odds of winning this battle. Finally, grumbling under his breath, he turned around and headed back toward the car.

I waited until he'd settled down on the curb with a book, then went inside what remained of the house.

"Looks like it originated here in the living room," Chief Hoffman said as I approached him. "Char depth and burn patterns all point that way." Standing at the edge of the living room while his crew used colored string to section off the area into two-foot squares, the tall man looked tired, drawn—roughly the way I felt. Portable floodlights cast the scene of destruction in a bright glow.

"That's what I guessed from what I could see last night. Any thoughts on the cause?"

"Nothing definite yet. But it sure wasn't a gas leak or a short in the wiring. We'll send ash samples in to the lab, see what they can turn up."

Lab tests can uncover traces of flammable agents like gasoline, kerosene, napalm, virtually anything that can be used to start or accelerate a fire. If we found traces of an accelerant here in the living room, it would almost certainly serve as solid proof of arson. It wasn't likely Ginger Smith kept gasoline or the like in her living room, where it could catch fire accidentally.

Still, that kind of logic doesn't always deter arsonists from some bizarre explanations when we get them into court. Like one case where a homeowner who was behind in his mortgage payments tried to torch his own house for the insurance money. When the lab found traces of flammable paint thinner on what

remained of his living room carpeting, he claimed he'd spilled it months earlier, when painting the walls. Only trouble was that the paint on the walls was water-based, not oil-based.

"Any word from the ME?" I asked.

"Nope." Hoffman glanced at his watch. "Said he'd probably be done with the autopsy around noon."

"He's doing it this morning?" I was impressed. Most medical examiners I knew would simply have refrigerated the body until Monday morning and done the autopsy during their regular working hours.

"Doc Gleason's pretty conscientious, 'specially where homicide's suspected."

Hoffman's inside team finished sectioning off the living room and began to number each square of the grid. If any evidence of arson were discovered in this room, the grid number corresponding to the spot where it was found would later pinpoint its original location. That kind of precise documentation is essential to proving how and where an arson fire started, especially when that proof later has to be offered in court.

When the numbering was finished, each of the men knelt next to a grid square and began running his gloved hands through the fire debris, searching for clues.

I watched for a time while the team poked around in the soggy ashes, recovering charred shingles from the roof, burned and splintered remains of furniture, some round metal rods, broken glass from a light fixture, melted hunks of carpeting. It was a filthy, backbreaking job.

One of the men searching near where the body had been found held up a tarnished piece of metal. Carefully, I moved close enough for him to hand it to me.

It was blackened and misshapen. "Looks like a hair clip," I guessed. I scratched off a little of the black with my thumbnail, uncovering a faint sheen of copper underneath. Sadness washed

over me as the personal nature of the find returned Ginger Smith to my thoughts. The fire victim had almost certainly been wearing this barrette when her hair caught fire. Had she dressed up specially to meet a visitor, or was this an ornament she routinely wore while home alone? The fire, its heat intense enough to deform this clip, had completely consumed the woman's hair.

I made a mental note to look up the melting temperature of copper. This probably wasn't pure copper, though; it was probably some sort of alloy. It wasn't really melted, either, just bent and reshaped. Still, its condition was clear proof that this fire had burned very, very hot, particularly at the spot where the victim had been found.

I handed back the hair ornament and watched while the fireman photographed it, then placed it in a paper bag and marked the bag with his name, the time, the date, and the grid number where he'd found it. I jotted down its existence in my own notebook, along with a crude drawing of it.

A few minutes later, the same searcher found a smaller piece of metal in the same grid. "Looks a little like a fishhook," he said, handing it over.

I held it in the palm of my hand and examined it carefully. The shape was familiar. I removed one of my earrings—the ones I'd chosen for today were long, narrow twists of hammered gold that hung nearly to my shoulders—and laid it alongside the hook for the chief and the others to see.

"Earring hook," I said. "Wonder whether the victim's ears were pierced." We would have to ask a friend or neighbor; the ears had been burned off the charred corpse I'd seen last night.

If Ginger Smith's ears weren't pierced, I realized with a small surge of excitement, this could be our first clue that her murderer was female. The kind of earrings men wear are usually either hoops or studs, not the dangling, feminine kind that require hooks to attach them to the ears.

Whatever had once hung from this particular hook was no longer attached. Perhaps wooden beads, I thought, or something made of a metal thin enough to be completely melted by the intense heat. Or maybe we would find the rest of the earring during the sifting operation.

The tiny hook looked to me like surgical steel, not gold, silver, or copper. It was tarnished but neither melted nor misshapen. That made sense; I recalled that steel's melting point is higher than copper's. With luck, the discovery of the barrette and the earring hook would help determine the hottest temperature the fire had reached, which in turn would give us some clues about how it started and what fueled it.

No, this was definitely not a fish hook. I handed it back and watched it go into the paper bag with the barrette.

When the team had finished hand-searching the entire living room, they began shoveling the remaining ash into carefully marked bags and carrying them outside, where the sifting operation was now fully set up.

I followed one of the men out. It was after noon now, and the sun was blazing high in the sky as my black sneakers squished across the lawn. With relief, I spotted Max sitting on the curb in the shade of the Volvo, his back against the door. He was engrossed in a paperback book. Apparently he'd kept his promise to stay away from the action, and for a brief moment, I actually let myself hope that one of his high school English class assignments had finally captured his hungry imagination. Then I noticed the image of a fire-breathing dragon on the book's cover.

A small crowd of bystanders gathered to watch now that there was something going on outside the house. The neighborhood probably had never seen this much excitement and obviously nobody wanted to miss anything. A uniformed cop kept them all peacefully behind the police line. I recognized some of the faces from last night.

"Chief, phone for you!" somebody shouted.

Chief Hoffman sauntered over to the fire truck and grabbed the cell phone. As soon as he was finished talking, three men and a woman split away from the onlookers and approached him. The woman was a reporter named Joy Something from the *San Jose Messenger* and one of the men was Lenny Palmer of the *Bay Crime Journal*. I'd never met the other two men, although I thought I'd seen at least one of them in last night's media barrage.

Hoffman quickly shrugged off the reporters and walked back over to me, leaving them standing behind the police line looking unhappy. He spoke in a low voice, careful not to be overheard. "Doc Gleason on the phone. Says our victim was definitely alive when the fire started—he got ash from the lungs, esophagus, and stomach."

I sighed. "Was he able to ID her?"

Hoffman nodded. "Got lucky there. Neighbor lady remembered the dentist Ginger Smith went to, and we got him to send over her dental records right away. It's her, all right." No surprises there, simply a necessary confirmation of the details we'd already suspected.

"What'd you say to those reporters?"

"Just that your people would call a news conference when you had something to tell them."

"Thanks." I appreciated the chief's deference to the state's authority. My worst nightmare was trying to do my job while half a dozen other jurisdictions were all giving different stories to the news media. "Did the ME say whether the victim had any injuries that weren't from the fire?" I asked. If she'd had a concussion, been knocked out, that would explain why she'd made no attempt to escape.

"Nope. He'll do a tox screen, of course."

I knew that would take a while. "I'll need a copy of the autopsy report."

Hoffman nodded. "Doc said he'd be sure to fax you a copy of the prelim tomorrow, soon as he gets it typed up."

I glanced back at the crowd. The woman from the *Messenger* was walking across the street, where she climbed into a late model Jeep minivan. "You get some good crowd pictures at the fire?" I asked Chief Hoffman.

"A few. But our video guy didn't get here any too fast. Had another fire across the county. Might want to see if any of these media people got anything we didn't. 'Specially the ones got here early on."

"We can try, but usually they protect their outtakes with their lives. Claim it's a journalism-ethics thing." I made a note to myself to check with the news crews anyway. There was always the off chance that somebody would be willing to help us out.

Video would probably be better than still shots, but the only shooters I saw with video cameras were the TV guys, and I certainly wasn't about to ask Lauren Meyers for a favor. She'd get far too much satisfaction out of turning me down.

There'd been several still photographers here last night, in addition to the video crews. This morning's *San Jose Messenger* ran a photo of the fire on an inside page. Too bad that Joy woman had already left, I thought. I remembered seeing a photographer from the *San Francisco Courier* in the crowd, too, but he wasn't here today.

Lenny Palmer always took the photos for his stories; the *Bay Crime Journal* was too chintzy to pay two employees' salaries to cover a story, so if he wanted a photo Palmer had to take it himself. Even KBA radio's Bruce Link occasionally took a snapshot or two. He sometimes freelanced articles for national crime magazines, which required him to supply the accompanying art.

At the scene of any big fire, a handful of freelancers with cameras always show up, eager to sell their stuff to the highest bidder.

There'd been several faces I didn't recognize in last night's media group, at least three or four men and a couple of women. Some of them had to have been taking pictures. Trouble was that the news media sought dramatic shots of the fire and rescue efforts, not the footage of gawkers that we needed. The best we could hope for was that somebody had inadvertently caught a few onlookers in the background of a newsworthy shot, and that he or she would be willing to give us a copy.

Still, it was worth asking. "I'll go check with Palmer. He was here." I turned and saw Palmer and a man in a gray plaid shirt crouched down in the street facing Max, while a couple of young men I took to be neighbors looked on.

I walked over to the little group.

"—read the one where this fiend from the Abyss tries to kill Drizzi?" Max was asking. "Drizzi's this elf, see, and—"

"Guess I missed that one," Palmer said. "Who wrote it?"

"Dude named Sal-something—Salvadore, Salvatore or something."

"How's this different from the kind of stuff Stephen King writes?" the man in the plaid shirt asked.

Apparently my son had roped a couple of reporters into a discussion of his favorite novels. I laughed, wishing Max would show half as much enthusiasm for his school work. "What's this, a meeting of the Book of the Month Club?"

"Just waiting for you," Palmer said, pushing himself to his feet. A stocky, muscular man an inch or two taller than I, he was wearing jeans, sneakers, and a long-sleeved blue turtleneck shirt, but he still managed to look cool, even in the noontime heat.

As I joined the reporters, the two neighborhood men slipped away and returned to watching the sifting operation.

The man in the gray plaid shirt thrust out his hand and I shook it. "Hi. I'm Dusty Horowitz, *San Mateo Herald*, Ms.

Delancey." He was about the same height as Palmer, but chubbier, sporting a noticeable beer belly. "Like to talk to you if you've got a minute."

"Nice to meet you, Dusty, but I'm afraid I haven't got anything more to tell you guys," I said.

"ID the victim?" Palmer asked.

"I'll hold a news conference as soon as the next of kin is notified, Lenny. You'll know as fast as anybody. I promise."

Horowitz chimed in, "What'd you find out about the baby?"

I held up a palm in protest and glanced down at Max. He was listening attentively. If I wasn't careful, I'd be holding an impromptu news conference right here.

I tried changing the subject. "You were taking pictures here last night, right, Lenny?"

"Yeah, a few."

"How about you, Dusty?"

"The *Herald* had a photographer here, sure."

"Get any crowd shots I could look at?"

"For what?" Lenny asked.

"See if I recognize any familiar faces."

He laughed. "I mean *in exchange* for what? If I let you see my pictures, what do I get from you?"

"A in citizenship."

"Yeah, right. What's the matter, didn't Hoffman's guy remember to put a tape in his camera?"

"Hey, I'd like to help you out," Horowitz said, "but my editor'd have my job. You know how it is. We got our job, you got yours."

A third reporter elbowed his way into the little group. "Ms. Delancey, Kirby O'Leary from the *San Vicente Weekly Press.* Got a few questions for you."

"I'm sure you do, Mr. O'Leary. But, like I was just telling Mr. Palmer and Mr. Horowitz here, I have nothing more to say yet."

I reached down and grabbed the sleeve of Max's frayed 'N Sync T-shirt. "Come on, Max, let's go have some lunch." He closed his book and lurched to his feet.

O'Leary frowned and took half a step forward. "But—"

"Nothing, gentlemen. That's final."

"I still get to drive, right, Mom?"

"Sure, Max." I steeled myself for another adventure, opened the passenger side of the car, climbed in, and rolled down the window. "Listen, guys, if you change your mind, I really would like to see any crowd shots you got last night."

"I'll think about it," Palmer said, sounding like he wouldn't.

Just as I'd figured. None of these reporters was about to buck his editor. Certainly not while I was withholding information they wanted. I couldn't really blame them; if I'd been on the other side, I'd have done the same thing.

Horowitz threw me a crumb. "You might try one of the free-lancers, Ms. Delancey. I saw Suds Androwski here with his Pentax. He'll sell his moth— I mean, he'll sell his photos to any-body's got the fifty bucks."

"Chris Farr was here for a while, too," Palmer offered, proba-bly to counter any advantage I might have given Horowitz in exchange for his tip.

"Thanks, guys, appreciate the help."

Max started the car and shifted it into drive. The Volvo bumped down off the curb. "Where we gonna eat?" he asked, screeching the car into a U-turn.

"Anywhere," I answered, as my stomach leapt into my throat. "Just so it's close by."

Chapter Five

MY administrative assistant, Ricky Lindeman, stood in the open doorway of my office holding a stack of this morning's newspapers in his massive hands. "Morning papers, hot off the presses." His expression shifted into mock pity.

"How bad are they?"

One at a time, Ricky lifted the newspapers on the stack and read the large, bold-faced type: "'Baby Snatcher torch strikes again.' 'Arson czar stymied by murders of moms.' 'Chorus of critics corrals Delancey on crispy critters cases.'"

My jaw dropped. "You're kidding!"

Ricky's handsome, angular face broke into a wide grin. "I made up the last one, but the others are real. And there's more along the same lines."

"Damn." I already had as much as I could handle on my plate. The last thing I needed right now was a lambasting by the news media. As I sat at my desk, poring over a stack of computer printouts, I could feel my eyelids drooping, and it was barely ten

o'clock. I'd gotten up early this morning, and after reassuring myself that Max was okay, I made another quick trip to San Vicente to check on the investigation there before coming into work. Now I was barricaded in my Townsend Street office avoiding phone calls. My current task was to find as many similarities as possible among the four women's deaths, using the data we'd entered into the office computer system. "These cases are becoming a real PR nightmare," I said.

Cocking one blond eyebrow, Ricky shrugged his brawny shoulders. "Comes with the territory." A former firefighter, Richard Lindeman fled the Midwest for San Francisco ten years ago, after his boss and a couple of his coworkers discovered he was gay and proceeded to make his life as miserable as humanly possible. He'd hoped to sign on with the San Francisco Fire Department, but by the time a slot opened up, he was past the maximum age requirement.

Ricky dumped the stack of newspapers on my desk; they landed with a thud, raising a cloud of dust that tickled my nose. The department's meager funding covered janitorial services only once a week.

I groaned.

"But wait," Ricky said with an evil grin, "things can get worse." With a magician's flourish, he whipped several scraps of paper from the pocket of his hand-tailored aqua shirt and fanned them out. "*Voilà!* This morning's phone messages."

"More journalists?" I asked.

"Mainly. The *Courier*, Channel Three, the *San Mateo Herald*, and the *Crime Journal* all want exclusive interviews. Immediately, of course. A producer from 'Inside Scoop' is arriving from New York tonight and wants to talk to you and all four police chiefs first thing tomorrow morning. And a reporter from *Professional Woman* wants to include you in a series she's doing for the magazine—prominent women in law enforcement."

"What did you tell them?"

"That you'd decided on the spur of the moment to leave for a vacation in Maui and wouldn't be available for interviews for another month."

"Ricky—"

"Just kidding. I went with the standard delaying tactics—explained that you're spending twenty-five hours a day solving these crimes, sometimes twenty-six. Then I promised each and every one of them they'd be first on your call-back list. Also that we'd hold a news conference the minute we have anything to announce."

"Good. So that's taken care of."

"Not quite."

"What do you mean?"

With his forefinger and thumb, Ricky pulled a phone memo from the bottom of the pile and dangled it as though fearful it might contaminate him. "Afraid you're going to have to deal with this little headache today."

I grabbed it and quickly read what Ricky had written. "Shoot. Great way to start the week—my own personal audience with Bart Waldron, current holder of the state's Premier Pompous Ass title."

"And defending champion. But maybe he just wants to praise us for working so hard on solving these cases."

"Right. And maybe the Golden Gate Bridge is made of Cheetos."

Governor Marinda Bennett's right-hand man, Bart Waldron was the main architect of her successful battle to be the first woman to win the state's highest office. Since the election, he'd become a real power-monger, taking it upon himself to play bad cop to her good cop whenever he believed a major appointee was screwing up on the job. Apparently I was destined to be his first target of the week.

Putting off the inevitable for a few more minutes, I briefed Ricky on the need for any crowd photos taken in San Vicente on Saturday night. I asked him to start calling back some of the same reporters whose interview requests he'd just turned down and ask them for a favor. He appeared roughly as thrilled about that task as I was about returning Waldron's call, but he gamely headed for his desk and telephone in the outer office, which he shared with Connie Rodriguez, our part-time clerical worker and the department's only other employee.

I called after him, "Try Suds Androwski first if you want, Ricky."

"We got the fifty bucks?"

"Hey, if petty cash is broke, I'll pay Androwski myself... assuming he's got anything we can use."

I closed my office door and picked up the telephone. Bart Waldron, of course, was unavailable, as I'd known he would be. To speak to me at my convenience would have indicated his schedule was less full than mine, a subtle shift of power a man like Waldron would never allow. He returned my call fifteen minutes later.

"The governor's not happy with the publicity on this dead-mothers thing," he announced.

What a shock. And here I'd thought she'd be thrilled to see my name in the papers so often.

"Please assure the governor that we're moving on these cases as fast as we can, Bart," I said in my best bureaucratic manner. "These crimes cover four different jurisdictions and—"

"Our opponents are lapping this one up, Susan, absolutely licking their whiskers. They've already scheduled the caterer for the party they're going to throw when another one of Governor Bennett's pain-in-the-ass feminist appointees bites the dust."

"I have no intention of biting the dust, Bart. Maybe if I could get the funding for an adequate support staff I could—"

"Don't start down that trail. It's a dead end." I could just see Waldron's face reddening as his voice rose in pitch. "You know as well as I that your department wouldn't exist at all if the conservatives weren't so damned afraid to look like they're not fighting crime."

"If anybody in Sacramento really wanted to fight crime, I'd have a budget that—"

"You just don't get it, do you? Listen carefully, Susan, and I'll explain it again. As long as the conservatives control the legislature, anything Governor Bennett proposes is going to be funded toward one end—*abject failure*. That's their plan. Your job, like mine, is to beat the hypocritical bastards at their own game."

Waldron continued his patronizing lecture for another five minutes, using pet phrases like "the demise of affirmative action" and "delivering constituencies for the governor's reelection."

Translated, he meant that Governor Bennett had expected to score points with at least two segments of California society, women and Asians, when she made me her arson czar. Her flack had even made sure to use my middle name, Kim, in the news releases announcing my appointment, just to make sure anyone who missed seeing my picture would know Susan Delancey was Asian. Truth was, my folks had named me after actress Kim Novak, not some Korean ancestor, but Sacramento didn't care about that. They were after image, not truth.

Now, if I screwed up on the job, Waldron was letting me know, the governor would have squandered her resources on a vote-loser, and she would not be happy. In the end, I promised him I'd make a daily progress report to Sacramento.

"Ms. Delancey, Ms. Delancey, wait up a sec!" I heard a high-pitched male voice calling me as I headed out of my office building at lunchtime.

Glancing over my shoulder, I spotted a short, slight, dark-

haired man in an ill-fitting navy suit standing next to the building's business roster. He hurried across the foyer toward me.

"I have nothing to say to the press," I told him.

"I'm not a reporter," he said, catching up to me. The man's pretty-boy face sported a two-day growth of beard, and a tie the color of pea soup hung loosely around his neck. "I'm Steven Snyder. Think you've been looking for me."

That was one I hadn't heard before. "You've got the wrong person," I said, certain he was another pesky journalist, despite his denial. I proceeded through the doorway and down the steps at the front of the building. I'd planned to spend my lunch hour taking another look at the site of the San Francisco fire where Betsy Cavendish had burned to death just over six weeks ago.

"Please. I saw you on TV." When we reached the sidewalk, Snyder impulsively reached for my jacket sleeve. As his fingers brushed against the fabric, I took a quick half step backward, and his hand dropped as though I'd slapped it. "Please, Ms. Delancey," he pleaded. "I'd just rather talk to you than the cops."

"About what?"

"Ginger," he said, "what else?"

Ginger. The man's name was Steve. I finally made the connection. "You're the father of Ginger Smith's child?"

"According to her, anyway," he said. "This morning's paper says the cops think I'm the one that killed her. Already got me tried and convicted for murder, but it wasn't me. I never hurt Ginger, honest. Never laid a finger on her, no matter what she did to me."

At no more than five-feet-five and a hundred thirty pounds, Steven Snyder didn't look much like a batterer. Still, if half of what the dead woman's neighbor had told me was true, he'd hurt Ginger Smith plenty in other ways. And Snyder's small stature hardly ruled out setting fires.

"If you're worried about talking to the police, you're entitled to bring your attorney along with you," I told him.

He made a sour face. "Why should I have to pay some money-grubbing lawyer two hundred bucks an hour to protect me from the cops when I didn't do anything wrong? Damn lawyers are already trying to rob me blind."

"So where were you Saturday?" I asked.

"Had a—a date. She'll prob'ly vouch for me…if she has to… so long's we keep this thing real quiet." He looked around as though worried that we'd be overheard. "Me and her, we went to a club for a couple of hours and then back to her apartment in the Marina. I—I was there all night."

Avoiding eye contact, Snyder was suddenly fascinated with a mound of cigarette butts somebody'd dumped on the curb.

"So, see, I couldn't've hurt Ginger," he added, his gaze traveling upward again. "I wasn't anywhere near San Vicente."

"If you really were with this woman all night on Saturday, Mr. Snyder, why wouldn't she vouch for you?"

"I—it's sort of an awkward situation."

He wasn't smirking now, he was squirming, and I wasn't going to let him off the hook. "Awkward, how?"

He began examining his shoes. They were old-fashioned black dress loafers sporting little fringed ties.

"Could she maybe talk to you confidentially? I mean, and not have to talk to the cops?"

"Mr. Snyder, I'd like to help you, I really would," I said, quickly losing patience, "but I'm mainly a coordinator, an analyst. Usually the police do the interviewing and pass their findings on to me. So you really should talk to Detective Berry." I started walking toward my car.

"It's just that this woman, my date on Saturday, she—she's married and I—I don't want to get her in trouble."

I stopped walking. "You stayed all night with her, at her apartment, on a Saturday?"

"Yeah, well, her husband travels a lot for his job, and…"

"Right." I could see this guy was going to walk if I didn't listen while he was still willing to talk. "Come up to my office, Mr. Snyder," I said, deciding that I could spare a few minutes. "Let's hear what else you have to say."

Snyder sat across the desk from me, occasionally shooting a resentful glance at the tape recorder.

"Told me she was on the pill," he whined. "Not my fault she got pregnant."

Apparently Romeo Snyder had never heard of condoms…in San Francisco, condom capital of the world.

"Seen your daughter lately?" I asked.

"*Ginger's* daughter."

"So you have no idea where the baby is now."

"Told you, I was with Trudy all Saturday night. Ask her if you don't believe me."

"Don't worry, we will."

Snyder claimed he hadn't seen or talked to Ginger Smith in more than two months, and that he'd never seen his baby. He was clearly very angry that Ginger had filed a court action seeking child support against him, and he readily admitted he'd intended to fight the suit in court. Now he probably wouldn't have to.

His self-serving theory was that Ginger had intended to have a baby all along, so she'd tricked him into getting her pregnant. Then, not satisfied with just having his baby, she decided to go after a big chunk of his income as a major-appliance salesman as well. Ginger Smith was a greedy, conniving, little bitch. He stopped just short of saying she'd gotten what was coming to her.

I didn't like Steven Snyder and I was having trouble hiding it.

The man was a weasel, a coward, a two-timing sneak, and a cheapskate to boot. Yet did that make him a serial killer? Clearly, his pattern was to avoid direct confrontation at any cost, and I'd uncovered no link to the other dead women, only to Ginger Smith. Still…

Of course, we would have to check his alibi carefully, not only with Mrs. Trudy Gillman, but with the staff at Club Seven, where he claimed he and his date had spent the early part of Saturday evening. Snyder's whereabouts on the nights of the other fire deaths would have to be verified as well.

In addition to recording our complete conversation, I checked the address Snyder gave me against the one on his driver's license and wrote down the names and addresses of his employer and all the people we would need to interview to check out his alibi.

I shut off the tape recorder. "That should do it for now, Mr. Snyder. I'll call the San Vicente police about you. But I can't guarantee they won't want to talk to you themselves."

"But you'll be the one to see Trudy, won't you?"

"Either that or I'll send one of my staff."

With a feeling of relief, I finally escorted Snyder to the door and shut it firmly behind him.

Ricky remained seated behind his desk, a dark expression on his face. "Pond scum like that shouldn't be allowed to reproduce," he said.

"Can't argue with you there. Steven Snyder's not exactly your basic Father of the Year material."

Shaking his big blond head in disgust, Ricky added, "Hope a good family gets to adopt that poor kid once we find her. No way should she ever end up stuck with Daddy Dearest."

"Somehow I don't think we're going to have to worry about Steven Snyder's fighting for custody."

"Hope to hell not. Dozen guys I know would love to be a dad, give their right arm for a kid of their own, but they can't have one. Then somebody like that— Sometimes I think there's no justice." I knew Ricky, at least in part, was talking about himself and his longtime partner, Zeb Caswell. They'd been trying to adopt for years without success.

I went back to my office and picked up the telephone to call Detective Hank Berry. I had a strong feeling he was not going to be pleased that I'd just interviewed his chief suspect in the murder of Ginger Smith.

Chapter Six

"*YOU* interviewed *my* suspect? Without even reading him his rights?" Over the phone line, Detective Berry's characteristic whine rose until he sounded like he might be on the verge of a stroke.

"I'm not a cop, Detective," I said. I focused my gaze on my closed office door, fighting to keep my own voice as calm as I could manage. "Fact is, I'm free to talk to anybody I want, and what I do doesn't have to cramp your investigation in any way whatsoever." That perhaps wasn't precisely true, but I sure wasn't going to admit it to this patronizing cop.

"Yeah, right. Like this slimy little torch isn't gonna have his guard sky-high by the time I get to interview him. Listen, lady, maybe things are different in San Francisco, but here in San Vicente, we don't much like you state bureaucrats butting into our business. You pull a dumb-ass stunt like this again, I'm filing a formal complaint with the governor's office."

Now I was starting to get angry myself. I could forgive "dumb-ass," but if there's anything that really pisses me off, it's being referred to as a bureaucrat or being called "lady."

"File away, Detective," I told him. "You want to cooperate on what is clearly a serial arson–murder case across four jurisdictions, fine. If not, that's fine, too. We'll simply work around you, and San Vicente's finest will end up looking like the territory-obsessed losers you obviously are. You want to interview Steven Snyder, be my guest, but the only way he killed Ginger Smith is if he's a copycat. I'll stake my reputation on the fact that the same creep killed all four of these young women, including Ginger, and that creep is *not* Steven Snyder, however unappealing a piece of slime he might be."

Our conversation lasted another five minutes in an equally friendly vein, during which I reminded Berry that he, too, had a superior officer, and that complaint filing could go both ways. By the time I got off the phone, I found I'd lost my appetite, so I skipped lunch and settled for another cup of Ricky's coffee. It landed on my already queasy stomach like a cup of fresh battery acid.

As my temper cooled, I began to feel a trickle of self-doubt. What I'd told Berry *was* correct, wasn't it? This really was the work of a serial arsonist–murderer and not four unrelated crimes? Maybe Steven Snyder had read about the first three fires and decided this was a good way to get rid of his Ginger problem, but if so, where was their baby? I knew that not all the details of the first three killings had made the papers. There were things Snyder couldn't have learned by reading about the earlier murders or watching the TV news. I just hoped my memory served and that at least one or two of those things were consistent with Ginger's murder.

I opened my file cabinet and pulled out my folders on all four

cases, spreading them across my desk. During the next couple of hours, I reread each file and used my computer to compile a long list of similarities among the crimes, everything from the age of the victims to their all having died early on a Saturday night. Each one, of course, was the new mom of an infant daughter. Three were unmarried and the fourth, Heidi Weill, not only lived alone, she didn't use her husband's surname. Her husband, U. S. Navy Ensign Stuart Keller, was currently stationed overseas. My hunch was that the killer thought Heidi was an unwed mother, just like his other victims, which would indicate she was a stranger to him.

My notes included the various items found at the crime scenes. Most were probably insignificant—more earring pieces, a couple of charred women's wristwatches, a melted gold bracelet, a blackened metal picture frame, loose brass keys, metal clasps and zippers from three burned handbags. My list grew longer—the remains of various pieces of burned furniture and small appliances, a charred cat's tooth, assorted melted plastic baby rattles and mobiles, blackened and misshapen metal rods, springs, and wheels from baby cribs.

This last caught my attention and I decided to take another look. I checked all four files again to be sure, and reconfirmed that the sifting process at each fire scene had turned up the metal portions of burned baby cribs. In every case, the crib parts had been found in the women's living rooms, in the sifting grid closest to where the fire started.

Was the arsonist making a statement by placing the infants' beds at the fires' points of origin? Or perhaps the young mothers simply had been nervous, wanting to watch over their newborns as they slept. In more than one case, too, there was no extra bedroom available for the new baby. The young women were undoubtedly cash-strapped in this super–high rent part of the

world, making do in one-bedroom homes despite their new off-spring.

Still, it seemed odd that all four cribs had been placed near where the dead mothers' bodies were located. Even stranger was the fact that two of the women, Ginger Smith and Heidi Weill, had second cribs in their babies' bedrooms. Why would a young mother, particularly a single mother like Ginger, invest in a second crib?

Then again, maybe they hadn't. Perhaps they had generous friends and relatives, and had received duplicate baby gifts. I re-called having heard a humorous story on the radio recently about a newlywed couple who'd received seventeen toasters as wedding gifts. So it was certainly possible that a new mother might be given two beds for her baby, wasn't it? Still...

Something else caught my eye. There were loose keys at three of the fire scenes, but all were found some distance from the fires' origins, in kitchens or bedrooms. I keep extra keys in my own condo, for guests to use, or in case Max or I lose one. Yet not one key ring of the type everyone carries was found at any of these fire scenes, and none of the loose keys was anywhere near the burned remains of the dead women's purses.

He's taking their key rings so he can lock up on his way out, I realized. The keys probably also served as souvenirs of his kill-ings. Serial killers almost always keep something to remind them of their crimes, gaining sexual pleasure from such keepsakes.

My files indicated that none of the crime scenes showed any signs of forced entry, and if the killer was taking the keys to lock up after he'd started the fire, my guess was that the victims had willingly let him into their homes. If they had, they obviously must have believed him to be harmless.

I mused a bit about what kind of stranger a new mother would let into her home on a Saturday night without feeling

suspicious. A repairman from the electric or phone company, perhaps? An insurance salesman who'd made an appointment in advance? A pizza deliveryman? The possibilities were many, though certainly fewer than at other times during the week.

As I printed my list off my computer, I felt I was beginning to make a little progress in understanding the dynamics of these murders. Still, I was no closer to answering one of the most important questions of the investigation: *Where were the babies?*

It had been more than a month and a half since the first of the new moms burned to death, and not a word about any of the babies' fates had emerged, despite the media blitz and all the efforts of our investigation.

Not one word.

I left the office early, putting Ricky in charge, and headed for the site of the first fire, hoping I might find some clue we'd overlooked. Betsy Cavendish's small, rented bungalow was in the Sunset District in the foggy western section of San Francisco. It took me forty-five minutes to get there in the sluggish late afternoon traffic.

As I pulled up to Cavendish's address on Lawton Street, I could see immediately that I was too late. The little stucco house had been bulldozed and a new foundation for its replacement was already partially poured. I got out of my car anyway, shivering a bit as the damp gray air enveloped me.

As I walked onto the minuscule front yard with its patch of tire-tracked dead grass, a fat gray cat scampered up to meet me and began rubbing itself against my leg. "Scoot," I told it, concerned it might claw my pantyhose. "Go on now, go home!"

Pets aren't allowed in the condo complex where I've lived since inheriting my unit from my mother, and if even they were, I'd choose to own a dog over a cat any day. I'll definitely never be

a cat lady. I tried gently shoving away the persistent animal with my foot, but it seemed intent on becoming my new best friend.

"He home now," an indignant old man's voice announced.

I jerked around to see a wizened, gray-haired elderly Asian leaning on a black cane and staring at me, unsmiling.

"What do you mean?"

"Buster home here." He gestured toward the new foundation. "Owner die. Buster still search."

I felt a quick pang of remorse for the animal I'd been trying to reject so cavalierly. If this was Betsy Cavendish's cat, the poor creature obviously was lonely and confused. Who was I to value my pantyhose over this small beast's mourning process?

"Buster was Betsy Cavendish's cat?" I asked the old man.

He nodded solemnly. "You friend?"

"I'm afraid I never met her." I thrust out my hand and shook his gnarled, leathery one. "I'm Susan Delancey, Governor's Special Assistant for Arson Investigation."

"Mr. Fong," he told me, as though his first name was Mr. "You catch man set fire?"

I shook my head. "We're still working on it." I asked Mr. Fong about his neighbor and the night of the fire, but he assured me he knew nothing, that in fact he'd spoken to Betsy Cavendish only a few times before her death. "Not friendly," he said of the young mother next door. "Keep to self." Still, somehow he knew the name of Betsy's cat.

"What's to become of Buster?" I asked, looking down at the animal, which was now curled up on top of my left shoe.

"Wife feed," Mr. Fong assured me. "Buster not hungry."

I wondered whether the Fongs also let the cat sleep at their house, if they'd in fact adopted him, or if Buster was now relegated to the ranks of the homeless. Yet if I called an animal control officer to take care of him, Buster would have to live in

a cage and he might eventually be put to death. I resolved to ignore the situation, concluding it really wasn't my problem.

"It's good of you and Mrs. Fong to take Buster in," I said, trolling for a reassuring word about the orphaned cat's current housing situation.

"Buster not hungry," the old man said once more, then turned his back and disappeared inside the bungalow next door.

On the way to the office the next morning, I stopped by the other two older arson sites, in Sausalito, across San Francisco Bay to the north, and in Daly City, just south of San Francisco. But I had no better luck there. Both rental houses were well into the process of being demolished by the landlords' contractors.

Given the long distance I'd driven on my fruitless quest, it was almost eleven before I arrived at work. I noticed Ricky's long face the moment I opened the door.

"What now?" I asked him.

"You're not going to like it."

"What else is new?"

He handed me three of this morning's newspapers, the *San Mateo Herald*, the *Bay Crime Journal*, and the *San Francisco Inquirer*. "Check out the front pages."

With a strong feeling of foreboding, I carried the newspapers into my office, set down my briefcase, and quickly glanced at the front pages. "What the—"

I dropped into my chair. All three newspapers had front-page articles about a letter the arsonist had sent them, each one claiming to have the exclusive story. Apparently this time, instead of sending his tirade to San Vicente's fire chief, the murderer had sent it to the press.

ARSON KILLER TALKS TO CRIME JOURNAL, the first story was titled. A bit of a stretch, I thought. The killer didn't "talk" to the *Crime*

Journal. He sent one of its reporters a letter, just as earlier he'd sent letters to the fire chiefs of San Francisco, Sausalito, and Daly City. None of the three newspapers ran the letter in its entirety. Undoubtedly, if this one was like its three predecessors, it was overly long and its language was too strong for easy consumption over the breakfast table.

All three stories paraphrased most of the letter, quoting specific phrases to illustrate the writer's vitriol toward his victim. Once again, the killer claimed to have "burned a whore mother in the flames of hell," while he "liberated her baby from a perverted life with its immoral parent." I recognized the choice of words from the other letters, and even without reading the entire document, felt convinced the same man had written it. The language, though frequently verging on the fanatic, was grammatical, indicating that the killer was an educated, articulate man.

What was different this time was that he had sent his letter to the press instead of to the fire chief. Or perhaps he'd done both—for all I knew, Chief Hoffman in San Vicente had received a copy, too. There was a new addition in this one, too: "The intellectually challenged fire chiefs, along with Governor Bennett's bogus arson czar, are guilty of conspiring to keep my righteous cause hidden from the public," he'd written. All three stories quoted this portion of the new letter, which concluded, "As a result, I have no choice but to take my message directly to the news media."

The media certainly had obliged the murderer, giving him the publicity he obviously craved. That fact made me profoundly depressed. Until now, we'd managed to keep the existence of the arsonist's letters a secret, at least from the general public. Now every crackpot in town would be sending us—and the media—more letters in the same vein. Probably, too, we could forget

about lifting any fingerprints from this trio. Even if the newspapers agreed to turn them over, which was questionable, by now they'd undoubtedly been handled by everybody from the copy boys to the newspapers' legal staffs.

The only tiny ray of sunshine I could find here was that this letter made me even more certain Ginger Smith's murder was not a copycat killing. Unless Steven Snyder also had killed the first three victims—perhaps as cover for murdering the woman he really intended to target—he was innocent. Of murder, if little else.

I clicked on the intercom. "Any of these scandal sheets bother to call us this morning?" I asked Ricky.

"No way, José. Probably all busy patting themselves on the back, citing freedom of the press or some such nonsense. Meanwhile, more young mothers are in jeopardy."

"Call their reporters, will you? Tell them I'll hold an exclusive press briefing at three this afternoon, here in my office. Nobody there but the reporters who got the letters and me. Tell them I'll issue a statement at that time, and that the price of admission is their copies of the letter. And, hey, be sure to tell them not to handle those letters any more than they already have, okay?"

"You're the boss." Ricky cleared his throat with a rough sound. "One thought, though. You might want to take a look at the *Crime Journal*'s editorial page before I make those calls."

I braced myself for more bad news as I turned to page seven and began to read:

ARSON CZAR SHARES BLAME

In the opinion of the editors of the Bay Crime Journal, Governor Marinda Bennett's Special Assistant for Arson Investigation, San Francisco's own Susan Kim Delancey, cannot escape at least partial blame for

Saturday's arson–murder of San Vicente resident Ginger Smith.

As detailed in our lead story today, the arsonist known locally as the Baby Snatcher Killer wrote letters to fire chiefs, explaining his specific motivations, after each of his killings of Bay Area young mothers. Certainly, in executing her duty to coordinate the efforts of these fire departments, Delancey knew about each and every one of these letters, yet she chose to keep their existence secret from the news media and therefore from the public.

We can't help wondering, if our "arson czar" had gone public with the murderer's written motivations in a timely manner, might young Ginger Smith have been more wary of opening her door to a murderer? Indeed, would Ms. Smith still be alive?

It is in this spirit of full public disclosure that the Crime Journal's editorial board has chosen to run extensive excerpts from the letter we received from the killer in today's lead story. We believe his letter may contain certain clues that could lead to the capture of this brutal killer. At the very least, our report will serve to warn young mothers to be much more careful until this murderous menace is caught and prosecuted.

We hope that our action—one that Susan Kim Delancey could have taken weeks ago—might well save the life of the killer's next intended target.

I swore under my breath. What right did they have to trash me this way? To practically call me an accomplice to murder?

I was tempted to exclude the *Crime Journal* from my little press conference this afternoon, to bar that filthy rag from every

news briefing I did for the rest of my career. But I knew better. I already had one war on my hands. I couldn't afford to fight the local press, too.

I switched on the intercom again. "You can go ahead and make those calls now, Ricky."

"You sure?"

Of course I wasn't sure. I just had to look as though I was. I had a job to do.

"Start dialing," I said with a sigh. Then I pressed my palms against my throbbing temples and tried to figure out what on earth I was going to say at that afternoon briefing.

Chapter Seven

"HERE," Sid Rhodes said, handing me a raspberry smoothie in a tall paper cup, a straw stuck through its plastic cover. "If you're in your usual state of chaos, I know you didn't take time for lunch."

I flashed him a grateful smile as I reached for the slushy mixture of yogurt, sherbet, and fruit. "You're a lifesaver. How do you always manage to know exactly what I crave most?" I asked, thinking that a smoothie was the perfect thing to settle my queasy stomach.

He grinned. "Hey, I'm a shrink, Susan. I'm supposed to able to read minds, right?"

"Last I heard, that particular talent was passed out to psychics, not psychologists." Sid Rhodes was an old colleague from my teaching days. He'd been a frequent guest speaker in my criminal justice classes, invariably mesmerizing my students with his talks about psychological profiling of criminals. Now, in my new job, I often had occasion to ask his advice and counsel.

"So, what's today's crisis, Ms. Arson Czar?" he asked, plopping himself down in a chair on the other side of my desk. He took a second smoothie out of a paper bag, crumpled the bag into a ball, and went into his Michael Jordan routine, tossing the bag across the room, where it landed in a wastebasket. "All right—definitely a three-pointer," he said with a grin.

Sid began to sip his drink. He was a small, light-skinned black man, half a head shorter than I and probably fifteen pounds lighter. He and I had had numerous conversations over the years about being of mixed race. He claimed ancestors from Africa, Scotland, Germany, Italy, and the Sioux Nation. Still, in the United States, anyone with a drop of black blood feels comfortable calling himself black and identifying with the black community. It's always been different for me.

A physical fitness nut, Sid frequently wore sweats around campus. Today was no exception—he was decked out in a navy exercise suit, a Giants baseball cap that concealed his thinning hair, and a pair of grimy white cross-trainers.

My phone call had caught Sid on his way to the gym for his daily workout and he'd obviously recognized the panic in my voice. I hadn't had to beg very hard to get him to come see me before he did his stint on the aerobic exerciser.

"You sounded pretty freaked out on the phone, to use a sophisticated psychological term," Sid told me. "What's up?"

"Don't tell me you didn't see the morning papers," I said, taking a long sip of my smoothie. It felt soothing and cold.

"The *Inquirer* and the *Crime Journal* is all. Did the killer's letter get wider coverage than that?"

"Just in the *San Mateo Herald*. The worst of it was the editorial in the *Crime Journal*, at least from my personal perspective."

"So you're feeling personally attacked."

"Wouldn't you?"

Sid nodded.

"I also just got another call from Bart Waldron."

"Mr. Subtlety."

I rolled my eyes. "Right. Well, according to good old Bart, the governor is not pleased with the morning papers, to say the least. Not only that, Assemblyman Paul Vogel is forming an ad hoc committee to study closing my office and diverting my budget to more traditional law enforcement agencies. Not that there's all that much budget to divert."

"No surprise there. I heard Vogel was planning to run against Governor Bennett next term."

"Bingo. And apparently Vogel believes she's vulnerable on the subject of appointing people like me to public office. I think the term Bart quoted the assemblyman as using was 'wasteful affirmative action appointments,' followed by something about 'squandering precious public resources on ill-conceived, politically correct agendas.'"

"Ouch! You're getting it from all sides."

A look of sympathy flashed across Sid's kind face, making me feel like bursting into tears, something I could ill afford at the moment. "This really isn't about my personal feelings, Sid," I said, swallowing hard and blinking rapidly. "I didn't ask you to come here because I wanted a shoulder to cry on." Even though I certainly could have used one, that bit of self-indulgence would have to wait. "I need you to help me figure out how to corner this bastard, how to bring him in. I need to know what makes him tick."

I told Sid about my scheduled press briefing, now less than two hours away. "How would you handle it?"

Sid took a long sip of his smoothie, then tilted back in his chair. "We've already talked about this guy's likely psychological profile," he said. He set down his drink on my desktop and began to tick off the points we'd discussed on his fingers. "He's a youngish white guy, judging by his choice of victims, and he's

heavy into ritual. Fixated on fire as a child. Almost certainly has an early history of fire-starting. Fire is intricately connected to his sexuality in some vital way, and he's targeting a particular kind of woman. Most likely, his mother was the same general type."

"Single mother, living alone."

"More than that. I'd bet she was never married, probably had a long string of sex partners. If she wasn't promiscuous, there had to be something else the child saw as abusive about her, something that scared him, made him feel small and helpless and powerless. She could have been a drunk, a drug addict, a batterer, maybe all of the above. Notice how the killer's letters always refer to his victims as whores, never anything as benign as single mothers."

"We know he's plenty smart, too," I added. "You can tell that just from the way he uses language in his letters."

"Not to mention the way in which he's kept you folks from catching him. He definitely knows a lot about fire, the way it works, how to set a fire that will reach flashover in a hurry, yet give him enough time to escape without getting trapped. Despite what has to be a split-second timetable, he's not leaving behind any of the clues you need to identify him. As we all know, Susan, we definitely can't rule out a firefighter on this one."

Almost all firefighters share a fascination with fire that begins in their childhoods. Most are genuinely good people who channel that interest, which sometimes borders on obsession, into fighting the thing that most intrigues them. They're genuine heroes who save life after life, often putting their own safety in peril in the process.

Yet every once in a while, a firefighter goes in the other direction and turns into an arsonist. We've even had a number of cases where firefighters have secretly started fires just so they can play the role of hero by later extinguishing them.

I shook my head. "I sure do hope it doesn't turn out to be one of our own this time around."

"Me, too, but it might be. We have to face that possibility." Sid took off his baseball cap, scratched his head, then replaced the cap. "There is something else we need to consider, Susan—the letters this guy writes are clearly meant to taunt you, to let you know how much smarter he is than you are. He's definitely got no shortage of ego.

"Yet those letters, like the fire sites, don't hold much in the way of clues to his identity—other than to his general psyche, anyway. No fingerprints on them, no saliva. He never mails them at a post office, where somebody could ID him or he could be caught on a closed circuit camera. This guy's done his home-work, and he's toying with you in the same way he toyed with his victims."

I shivered. Must be the icy smoothie, I told myself. "What do you mean, *toying with me?*"

Sid reached for his drink again and drained it before replying. "I think this has become a kind of contest for him. If I recall cor-rectly, he referred to you directly in this last letter, right? The one he sent to the newspapers?"

I grabbed one of the papers to make sure I got the phraseolo-gy right. "He talks about 'Governor Bennett's bogus arson czar'," I read. "That would be me, all right."

"So it's obvious he blames you personally for keeping him out of the limelight he feels he deserves. He's reached the point where he needs more than the sexual satisfaction of the murders and the fires. He needs publicity, too, public recognition. He sees you personally, Susan, as the reason he hasn't been getting it."

"So what am I supposed to do about that? I'm sure as hell not going to go running to the news media with every last detail of our investigation just to keep this sleaze's anger from escalating."

"But you've got this press conference scheduled for this afternoon."

"Only so I can get my hands on those letters he sent to the papers. Not that they're likely to tell us much we don't already know." I had higher, although still very low, hopes for a fourth message I'd learned about. Chief Hoffman had received a letter that held only one typed sentence—"Read the morning papers." But at least the San Vicente chief had had the sense to put his letter into an evidence bag as soon as he saw what it was, then messenger it over to the East San Francisco Crime Lab, which is under contract to do all our lab work.

"So make this press conference into your opportunity. Play with this creep's mind. Issue him a challenge and hope he makes a mistake."

The three reporters were right on time, arriving in a tight little group. My guess was that Cheryl Peach, Dusty Horowitz, and Lenny Palmer had met either outside my building or in the hallway outside my office, agreeing to present a united front.

Ricky ushered them into my office, carrying in an extra chair from the waiting room. He balanced it easily on a couple of fingers, as though it were made of balsa wood instead of solid oak.

I exchanged greetings with the reporters and we all sat down.

"Anybody want coffee?" I asked, plastering a warm welcome I didn't feel across my face. "Have to warn you, though, by this time of day it's likely to taste more like paint thinner than Starbucks."

Nobody was willing to take the chance, so we got right down to business.

"Is it true that the fire chiefs have been receiving letters from the killer all along, and that your office has been concealing them from the public?" asked Dusty, looking up from his notebook.

"First things first, folks." I held out my hand and wiggled my fingers. "The letters, please."

The three exchanged a look, but opened their briefcases, removed the three letters, and handed them over. Only Cheryl Peach's remained in its original envelope, and all three obviously had been handled repeatedly. A quick glance showed me that they were identical, undoubtedly composed on a computer, then printed out in bulk on a laser printer. "Thank you." I slid them into an evidence envelope. "I may need you all to be fingerprinted, for comparison purposes," I announced. "That okay with—"

"No way!" It was Cheryl who protested first, a look of horror on her round face. "It's bad enough we had to agree to turn over our letters. No way are you entitled to fingerprint us!"

The other two chimed in their agreement. I'd expected nothing less.

I held up my palms in a peacemaking gesture. "Okay, okay, I won't try to force you."

"Let me ask my question again," Dusty said, his pencil once more poised over his notebook. "Is it true that the fire chiefs—"

"I heard you the first time, Dusty." I looked down at my desktop and steeled myself. "It is indeed true that the fire chiefs have received letters claiming to be from the killer," I admitted. "But we have no way of knowing whether these letters are really being sent by the man who started the fires, killed these young mothers, and stole their babies. They could easily be from some publicity hound who's done nothing more than read the papers and watch the television news reports. In fact, my best guess is, they're *not* from the killer at all. There's not a single thing in any of the letters, including this one you all received copies of yesterday, that proves they're from the arsonist. If you want to know what I think, I believe you've all been duped by a master manipulator and you're going to look pretty darned silly when we catch the real guy."

"You haven't a whit of evidence that we were suckered, do you?" Lenny Palmer demanded, sounding angry.

"No, Lenny, I don't. That's exactly my point—we have no evidence either way. We just don't know. But that didn't stop you from immediately assuming the letter you received was genuine, did it? *Despite having no proof whatsoever.* You not only gave it front-page play, you even ran an editorial trashing me for not telling you about the other bogus letters."

"I don't get this," Cheryl said. "Do you really mean to say we've been used? That the letter was fake? That it wasn't really from the killer at all?" Cheryl never was the brightest bulb on the Christmas tree.

I nodded. "Like I said, there's nothing in it that proves anything to me, one way or the other." I paused and took a deep breath. "Now, you show me a letter that has some actual facts," I challenged, "facts not already revealed in the news media—instead of just some angry ravings about single mothers—and *then* I'll believe you've got something genuine."

"Maybe," Dusty interjected. "But if our letters are frauds, why'd you bother tricking us into coming over here and giving them to you?" He had a self-satisfied smirk on his face, as though he'd just trapped me big time.

"Because I—unlike you three and your editors—am not afraid to admit I could be wrong. We'll run this—" I held up the sealed evidence bag "—through our lab tests, see if we can find any clues to who sent it. In the meantime, you have my statement."

I pushed my chair back and stood up, signaling that the interview was over.

"That's *it*?" Cheryl was indignant. "You got us all the way over here for *this*?"

"Unless you have another alleged letter from the killer to discuss with me, I'm sure you all have deadlines to meet."

The three shared a glance and shook their heads in obvious disgust.

"Oh, one last thing," I told them as they started out the door.

They turned back in unison.

"If you do get another letter, give me a call before you reserve your front pages, huh? Maybe I can stop you from making fools of yourselves."

As they left my office and spilled into the hall, I thought I heard one of them call me a bitch, but I wasn't sure which one. It didn't really matter, anyway. The way things were going, I was pretty sure they all shared the same sentiment.

I hand-carried the evidence bag to the East San Francisco Crime Lab a quarter of a mile from my office, using the task as an excuse to get some fresh air, clear my head, and spend a little time with my old friend Hannah Goldman, who heads the lab's arson division.

"Susan, my dear, you look like hell on wheels," Hannah said as I entered her lab. "Those pesky wolves nipping at your heels again?"

"How can you tell?" I asked, running a hand through my wind-blown hair.

"Something to do with that deepening crease between your eyebrows and that haunted look in your baby browns, I suppose."

I laughed. Hannah always lifts my mood. She is truthful in the extreme, personal feelings be damned, which I find oddly refreshing in today's phony, spin-crazy society. At least with Hannah you always know exactly where you stand. As we chatted in her lab, surrounded by everything from test tubes and computers to spectrometers and a selection of space-age gadgets I couldn't even name, I gave her a condensed version of my day.

"Sounds like you could use a nice cup of tea," she said,

grabbing my arm and yanking me into her private office behind
the lab. When Hannah grabs, you have little choice but to follow
wherever she leads. She's only a couple of inches taller than I
am, but must weigh close to three hundred pounds, a fact that
neither bothers her nor slows her down. "You want herbal mint
or the hard stuff?" she asked.

"Definitely the hard stuff," I told her. To Hannah, "the hard
stuff" means tea with caffeine. Her personal vice has always
been food, not drink.

"So how's your little Max these days?" she asked, pouring
water from her electric pot over a couple of Twinings Earl Grey
tea bags she'd plopped into matching bright blue mugs.

"Not so little anymore, Hannah. I think he's grown another
couple of inches since you last saw him. Maybe more, if you can
judge by my grocery bill."

"And his band?"

"Still trying to find a place to practice where they won't get
somebody's parents evicted or fined by their condo boards.
They're driving Doug crazy, which, of course, is mutual."

"Hah! I can just see it. Stuffy old Doug trying to coexist with a
rock 'n' roll band. Sounds like a plot for a bad sitcom. Sort of
'The Odd Couple' with music, maybe."

My friendship with Hannah goes back to the days of my mar-
riage. She, like Sid Rhodes, used to lecture about her work to my
criminal justice classes each semester, then conduct a tour of her
lab the following class session. In exchange, she recruited me to
work with her in her pet project, teaching an arts-and-crafts
class for homeless children on weekends. I don't have Hannah's
artistic flair, but I've always been pretty good with kids. Sadly,
since I took my job with the governor's office, I simply hadn't
had time for volunteer work, and as a result, I'd seen far less of
Hannah than I liked.

"A sweet boy, your Max," she told me.

"Thanks, Hannah. If only Doug would loosen up a bit and realize what a great kid we've got." I gave her a blow-by-blow description of my attempts to teach Max to drive and she rewarded me with one of her deep, hearty laughs.

"Max should thank his lucky stars it's you driving with him and not Doug. Those two would probably kill each other before they hit the first stop sign."

"With Max driving," I said, "hit might be the operative word." I glanced at the clock and realized it was already getting late. "Much as I'd like to, I'm afraid I didn't come here just to chat, Hannah. Brought you something." I pulled the evidence bag out of my briefcase and told her what it contained.

"Not very likely to yield the fingerprints or DNA you're looking for, I'm afraid, not unless our boy got unusually sloppy, but I'll check. Nothing on the letter or envelope Chief Hoffman brought in this morning, except the chief's own prints. The usual drill."

Even though, realistically, I'd expected nothing more, my disappointment must have shown on my face.

"*But,*" Hannah said, grinning and sounding as though she was about to pull a rabbit out of a hat, "if you hadn't stopped by, I was planning to give you a call. I have something else for you."

"Shoot," I said with a twinge of anticipation.

Hannah opened a desk drawer and pulled out a folder. "The FBI lab finally finished the follow-up tox screen on Betsy Cavendish."

I hoped the new results would tell me whether the first victim had been drugged unconscious before her home was set afire. "And?" I prompted.

"The FBI found just one thing we didn't in Cavendish's bloodstream—ether."

"*Ether.* So she *was* knocked out before the fire was set." I had another thought. "Hannah, can you check the ashes found

around Cavendish's body, see if there's ether there as well?" All the chemical screens for the most common accelerants arsonists use—gasoline, kerosene, charcoal lighter fluid, and the like—had been negative. But labs can't possibly check for all flammable agents—there are thousands of them—so they check only for the most common. Usually, they come up with a match, but in this case they hadn't.

"Way ahead of you, my dear," Hannah said. "I had the same thought and the answer's a definite yes." She handed me a printed report. "Didn't find much, but we did manage to get a positive response for ether."

Ether is used not only for anesthesia, it's also used in manufacturing methamphetamine, so it's readily available, not only from legitimate medical sources, but on the black market. It's also extremely flammable, with a low flash point, and it's frequently responsible for explosions and fires at illegal meth labs. I felt a sudden surge of confidence, certain we now knew a good deal more about how the young mothers were being killed and burned. Somehow their killer was subduing them into unconsciousness with ether. Then the rag or whatever he used to hold the chemical over their noses and mouths was added to the initial fuel load of the fire, helping it reach flashover before anyone could possibly save the victims.

"You're a genius, Hannah. I could kiss you!"

"Not necessary," she said, holding up her hand in protest. "Just see if you can prod the State of California into paying our bill on time, okay?"

I felt a new burst of energy, managing to make it back to my office in record time. I couldn't wait to share the good news with Ricky. We were finally making some real progress toward understanding—and I hoped, catching—this killer.

Chapter Eight

"*IF YOU* want me to, I'll check out the medical sources for ether tomorrow, see if we can scare up any leads," Ricky said, "but I'd bet my last nickel this guy's not buying this stuff legitimately. Gotta have an underground source."

"You're probably right," I argued, "but it's always possible he's a veterinarian or a medical resident or a nurse or that he has access to ether in some other legally sanctioned way. Give Connie half the list of medical suppliers. Shouldn't take the two of you long to finish calling at least the local ones. There's no reason she can't help out after she types those letters I left on her desk." I couldn't avoid noticing the doubtful expression on Ricky's handsome face. "Hey, I'd love to spend our time on something more promising, too, but we can't afford to overlook anything. We can't get sloppy on this one."

He crossed his long legs and leaned back in the chair. "You're the boss."

Right. Clearly, if I wanted to pay my assistant and my secretary to waste their time, that was my decision. I glanced at my watch. It was nearly six o'clock and Max was spending the night at my place tonight. He should be there by now, yet there was one more thing I wanted to talk to Ricky about before closing up the office for the day. "Listen, Ricky," I said. "I don't mean to stick my nose in your personal business or anything, but there's something else I think you might be able to help with."

"Sure, fire away. I don't like the subject, I'm not shy. I'll just tell you to butt out."

"Fine." I shifted in my chair, uncomfortable despite Ricky's habitual openness. "I know you and Zeb have been trying to adopt a child," I began. Zeb, Ricky's partner, worked as a paramedic in Daly City.

"And hitting every brick wall ever built in the process." Ricky grimaced. This had to be a painful subject.

"So I have to assume you've done plenty of research into different kinds of adoption, right?" It felt particularly strange for me, an adoptee myself, to be asking for information on this subject from my gay male assistant. But the truth was, Ricky certainly knew far more about modern adoption practices than I did.

"Public adoption, private adoption, foreign adoption, surrogate mothers, foster parenting, contracting with a lesbian couple to make a baby and raise it together, you name it," he replied. "Zeb and I have looked into everything short of cloning. Fact is, we'd probably try that, too, if we thought it would really work. Unfortunately, so far we've done nothing but bomb out everywhere we turn. And—" he patted his still-flat belly "—neither of us is getting any younger. But what's our wanting a kid of our own got to do with this case? You think the victims' babies are being stolen so they can be adopted?"

"I don't really know, but it's possible that the fires, the letters, they're all just a cover for taking the babies. I just have this—this

feeling that the babies are the key to solving this case. If we can find them, I think we can find the killer."

"I suppose you could be right, but if the infants are being adopted, it definitely has to be a black market deal. No legitimate adoption agency is going to take an infant whose origin is unknown." He rolled a pencil between his fingers while he thought things over. "I suppose our killer could be a private adoption lawyer, somebody like that. Still, I don't see how he could possibly do a normal, legal private adoption all by himself. He'd have to fake the birth certificates, probably find a medical doctor to sign off on them, get some women to play the part of the birth mothers in family court, hope the adoptive parents didn't get too—"

The phone rang, cutting him off in mid-sentence. Ricky reached across my desk, picked up the receiver, and spoke into it. A moment later, he handed it to me. "It's Max for you," he said.

"What is it, Max?" I asked, feeling irritated by the interruption.

"You forget I've got practice, Mom? The band's getting together at Bucky's, and I gotta be there by seven-thirty to set up. You promised to be home early tonight, remember?"

"Are you home now?"

"Yeah, I've been here since four, and I got all my homework done, like we agreed. And I'm starving to death." I couldn't help noticing the whine in his voice. "Want me to go ahead and eat by myself?"

Guilt washed over me. I hadn't seen my son since Sunday. How could any decent mother tell her kid to make himself a sandwich or microwave something for dinner and get himself to band practice when she'd promised she'd be home? Yet I couldn't help wondering, as I so often do, whether I'd feel the same way if I hadn't divorced Max's father and broken up my

son's home. Was my shame over the divorce making me over-react, become too indulgent with my only child?

"Hold on a minute," I told Max. Cradling the receiver against my chest, I turned to Ricky and asked, "How'd you like to come over to my place for a quick dinner? I'd really like to brainstorm this some more, if you're willing to, and Max has to leave for band practice in an hour."

Ricky grinned and nodded. "You're in luck, boss. Zeb's working tonight, so I'm free as a bird. Why don't you head on home and see Max? I'll pick up Chinese for three and meet you there."

"You're an absolute lifesaver," I said, grateful one more time that Ricky Lindeman was working for me and not some fire department. Although I'd never admit it to him, I was secretly glad his dream of becoming a San Francisco firefighter hadn't worked out, that he'd taken this job instead. I pulled out my wallet and handed him a couple of bills. He began to protest, but I shook my head. "Hey, you're doing me a favor. It's my treat or we're not doing it."

"Okay, if you insist," he said finally, accepting the money and stuffing it into the pocket of his slacks. "See you in half an hour." He grabbed his briefcase and made a beeline for the door.

"I'm leaving right now," I told Max. "Ricky's having dinner with us, and he'll pick up the food. You set the table for three. See you in fifteen or twenty minutes."

"You'd think we were, like, playing off-key or blasting our speakers or something, the way Dad acts. Bands gotta practice or how are they ever gonna get good, right?" Throughout dinner, Max whined and complained about his father's lack of either toler-ance for his son's obsession with music or a musical ear of his own. Between gripes, my son stuffed his face with vegetable pot-stickers, crab puffs, mu shu pork, scallops in garlic sauce, cashew

chicken, and Mongolian beef. Gesturing at his plate, he mumbled, his mouth full, "This stuff is so excellent!"

"Wasn't sure what you guys liked, so I just picked up some of my own favorites," Ricky replied. Like my son, he was doing a yeoman's job of wolfing down the takeout. When he'd offered to pick up Chinese food for three, I'd envisioned Ricky arriving with three portions of something. But he'd bought appetizers and a couple of extra entrées as well. And at the rate the two of them were devouring the food, it was a darned good thing he had.

As for me, I was happy with a single crab puff and half an order of mu shu, along with a dollop of rice and some tea to wash it all down.

"So tell me about your music," Ricky said to Max.

"Our band is called Pacific Rim," Max replied. He launched into a comparison of his band's style with that of several current headliners. According to him, Pacific Rim blended one famous band's rhythm with another's vocal styling and a third's melodic risk-taking. I had a feeling most of Max's description of his band's talents veered well into the arena of wishful thinking, although I couldn't swear to it. I'd barely even heard of these other bands, supposedly notable though they were, and I couldn't have named one of their hit recordings if my life depended on it.

Ricky seemed to understand exactly what Max was talking about, however, somehow coming up with precisely the right responses to impress a teenage boy with dreams of rock music stardom.

Too bad Doug couldn't share our son's interest this way, I thought wistfully. Where did Max get his musical genes, anyway? Certainly not from his father's side of the family. I knew most of the Macalesters and not one of them could manage to carry a tune on a piece of sheet music. And while I can manage to sing on key, I've certainly never felt the urge to perform in public. Perhaps one of my birth parents was musically gifted, I thought,

knowing there was no way I'd ever actually find out. Maybe that really didn't matter, though, certainly not as much as whether my birth parents had passed down some fatal hereditary disease to me and Max.

"The big problem," Max said, wiping his mouth with his paper napkin, "is, we don't get to practice anywhere near enough. Everybody's always going, 'Keep it down, guys!' or 'Go somewhere else to practice!' the minute we get going good. I mean, 'N Sync didn't make it by keeping the volume down, right?"

Ricky laughed. "See what you mean, Max. Sounds like you guys need a real studio to practice in."

"Don't I wish." Max looked at his watch. "Hey, I gotta get going." He slid his chair back from the table and headed for the door.

"Clear your dishes, Max," I called after him.

He mumbled under his breath, but returned to the table and carried his dishes to the kitchen sink.

"Be back by ten, hear?"

"Yeah, sure."

"I mean it, Max. No later than ten."

"Okay, I promise. 'Bye, Mom. 'Bye, Ricky, and thanks for the excellent food."

"No problem, man. I didn't even pay for it, your mom did," Ricky said. "Hey, have a good practice."

When Max had left, Ricky and I returned to our brainstorming session about the missing babies.

"Could be they're ending up being used in ritual sacrifices of some kind," Ricky suggested as he helped clear the table. "Still all kinds of cults around these days, New Age stuff, voodoo. California's always been the repository for everybody else's outcasts, right? Shoot, I ought to know all about that—that's how I ended up here. Anyway, who knows what some of these idiots are into nowadays. Could be human sacrifice is part of the killer's

obsession. Either that, or he could be selling the babies to somebody else who's into human sacrifice."

I cringed as the grisly image of an infant being murdered to satisfy some bizarre religious cult's beliefs invaded my mind.

"You got an apron I can borrow?" Ricky asked, casting a worried look downward at his creamy silk shirt. "I'll rinse these dishes for you, load them into the dishwasher."

"Just leave them," I insisted. Truth was, I hadn't owned an apron in years. I simply took my chances when it came to slopping on my own clothes. But then my clothes weren't nearly as nice as Ricky's.

I ushered him into the living room, where he settled on the sofa, spreading his long legs out before him in a V. He smoothed almost invisible wrinkles from soft grayish blue slacks I guessed were made of the finest wool.

"Or, if you don't buy the ritual sacrifice scene, here's another thought—what about medical experimentation?" he added. "Maybe these babies are being used for organ transplants for rich people's kids, or to test new drugs, or—"

"Lord, Ricky, you've got an evil imagination!" I pressed my fingers hard against my temples. "I'm going to have nightmares tonight, I guarantee you that."

"Just trying to help. Look, Susan, you said you wanted to brainstorm. That means coming up with anything and everything that pops into our heads, no matter how weird, right?"

"I know, I know. It's just that— Well, all of a sudden black market adoption is looking like it could be the *best* possibility for these poor baby girls. As a mother, this is driving me crazy. I just keep thinking how awful it would be if something like this ever happened to Max. Whatever this guy's perversion is, we've got to catch him, Ricky. We've got to stop him before he can even *think* about stealing another infant and burning her mother to death."

We discussed the pattern of the killings again. "Why do you

think he steals only baby girls?" I asked, twirling one of my earrings. "Why isn't it ever a boy baby?"

Ricky crossed one of his legs over the other and clasped his hands around his knee. "If the babies are ending up in black market adoptions, girls would be easier to place, and they'd bring a higher price," he told me.

"Why?" As far as I knew, male babies were far more prized throughout the world. Why else were so many female infants drowned in wells and female fetuses aborted so the parents could try for a son instead of a daughter?

"I guess it's all mixed up with the tradition of passing on the family name with the genes, that sort of nonsense," Ricky said. "Lots of couples who've been trying to have a baby without success don't want to give up all hope of someday having their own biological child to carry on their name. If they ever do manage that, they want the biological kid to be a boy, because boys keep the family name all their lives. So, when they adopt, they tend to choose girls." He shrugged his shoulders. "Hey, a daughter's going to get married someday anyway, right? She'll probably take her husband's name, so the idea is that the bloodline just isn't as important with a daughter. From what I've seen, in America, anyway, healthy white females are the hot attraction at all the adoption agencies."

I wondered whether my gender had given me an edge when I was adopted. I didn't meet the racial criteria, of course—or half of me didn't, anyway—but I was certainly the right gender. If I'd been born a boy, would I have lived out my childhood in the squalor of a Korean orphanage? "Makes sense, I guess, in a sexist sort of way," I said.

"Of course, we might be way off base. If the babies are being used in sacrificial rituals, who knows how bizarre the reasoning is. Vestal virgins, whatever."

I closed my eyes and leaned back against my chair. "Know

what, Ricky? Maybe we're going about this the wrong way. I've been concentrating so hard on *why* he's doing this that maybe I've been neglecting *how* he's doing it."

"What do you mean?"

I raised my head and made eye contact. "There's a darned good chance we won't discover this guy's reasoning until we catch him, and maybe not even then. Even if we figure out his motivation, it might not make a whit of sense to us. The guy's probably crazy."

"That's certainly possible."

"So maybe we're better off concentrating on his methods, not his motivation."

"So we're back to locating the source of the ether, right?"

"Sure, but that's just a start. For instance, how does he find a victim who meets his criteria—young, probably single, recently gave birth to a daughter, lives alone, willing to open the door to a stranger, the whole pattern?"

"Maybe he works for a hospital," Ricky suggested. "He sees the women come in to give birth and gets their addresses from the hospital records?"

"That was my first thought, too, but there are four different hospitals involved here. Unless there's some sort of medical personnel company that provides temporary fill-ins for a lot of local hospitals, I don't see how a single killer could get the information that way."

"I'll check tomorrow, see if a temp service like that exists."

"Good, and here's another thought—what about somebody who owns or works for a business that caters to new moms?" I said. "A diaper service, maybe, home nursing, a baby-sitting business, something along those lines."

"Maybe, but don't forget, Susan, the killings all took place on Saturday nights. Do diaper services deliver, or do nurses visit, on Saturday nights?"

"Probably not." It had been at least fourteen years since my own child had worn diapers, and in those days, I laundered them myself, so I didn't really know all that much about diaper services.

"And would a single mom with a brand new infant hire a sitter for more than the hours she might have to go to work during the week?"

"You're right, Ricky." I thought a while longer. "Maybe the killer is somebody who works in the vital statistics department of the county. He could get the information that way."

"Sounds more promising, but remember we're dealing with several different counties here—San Francisco, San Mateo, Marin."

"Still, there's got to be a database for all these records, right? How about somebody hacking into the various county databases? He could search for female births easily enough, then select those where the father's last name is different from the mother's."

Ricky leaned forward, an excited look on his face. "I think you've got something here, Susan. At least your method would give the guy a list of potential victims."

"Once he's got names and addresses, he could check out the houses, pick the ones that are easiest to torch without being seen."

"Still, what's his basic scam?" Ricky asked. "No signs of forced entry at the burn sites, right?" I nodded. "So how does he convince these women to let him into their homes?"

"Maybe he claims to be from the gas company, says he's checking out a leak, something like that. All I know is that, whatever his line, it's good enough to get his victims to open their doors on a Saturday night." I searched my mind, but couldn't come up with anything else that seemed on target, and I was getting tired. "Look, Ricky," I said, "I've got things to do before Max gets home and I'm bushed. You must be, too. Tomorrow, I'll get

Connie started on the search for sources of ether. You see if there are any temp services for hospital personnel. Then try to get into those vital statistics databases and compile a list of new moms. See if you can duplicate whatever our guy might be doing to come up with his choice of victims.

"If nothing else," I added, "we'll be able to compile our own list of women we should warn, and we'll have a much better idea where our killer's likely to strike next."

The morning newspapers were waiting on my desk when I arrived at the office. I glanced at them and was happy to see that all three reporters at yesterday's little "news conference" had written front page stories.

Cheryl Peach's article in the *San Francisco Inquirer* began: "A letter originally believed by the *Inquirer* to be from the Baby Snatcher Killer is fake, state arson czar Susan Kim Delancey claims.

"Delancey held a brief press conference at her San Francisco office yesterday to denounce the letter, which was received by the *Inquirer* and two other area newspapers on Monday. It was the subject of front page stories in all three newspapers...."

I skimmed the rest of Cheryl's story, then read those in the *Crime Journal* and the *San Mateo Herald*. All three were basically the same.

I didn't recall having been quite so dogmatic as I came across in print, but that didn't matter. If these stories provoked the killer into sending more letters, into revealing more details of his crimes in an effort to claim the public notoriety he so obviously craved, my ploy would have succeeded.

Luckily, I saw as I turned the pages, none of today's papers had another editorial attacking me.

"I see you're getting more and more famous all the time," Ricky said, leaning against the doorframe of my office.

"Right, me and Julia Roberts," I said, making a face.

"I'm still waiting for a few people to call me back on that temporary medical employee idea," he reported, "but so far, I'm drawing a blank. At least two of the hospitals where the stolen babies were born say they've never used that kind of service. They just require their regular staff to work extra shifts to cover things when somebody calls in sick or goes on vacation."

"So even if there is a temp service like that, we're not going to find any individual employee who's worked at all four hospitals."

"That's the bottom line."

"So much for that brainstorm."

"Max's practice session turn out okay last night?" Ricky asked me. Today, his coordinating shirt and tie were a shade of steel blue that matched his eyes. He also wore a pair of camel hair slacks with a double-pleated front, and a brown snakeskin belt that matched his shoes. Sometimes I wondered how he could afford his wardrobe on what the state allowed me to pay him.

I shrugged. "The band ran into more of their usual hassles, I'm afraid. Max told me Bucky Chong's folks made them practice without plugging in their amplifiers. Can't say I blame Mr. and Mrs. Chong, not if they don't want their neighbors calling the cops on them, but it makes it hard for the boys."

Ricky raised his chin. "What they really need is a soundproof practice studio."

"No lie. And what I really need is to put away this Baby Snatcher Killer freak, then spend a month in Paris with Todd getting my sanity back."

"Hey, I'm doing all I can about the first part. As for Paris, Todd, the month's vacation, and your sanity, you're on your own. But—" he dropped into the chair across from mine and leaned forward, his elbows on my desk "—I think I might be able to help solve Max's problem." A self-satisfied grin began to spread across his face.

"What do you mean?"

"Remember I told you about that remodeling project Zeb and I've got going at our house?"

I nodded. The two men had purchased and moved into an old house in the Twin Peaks section of the city nearly three years ago, just before San Francisco's real estate prices began to spike. But the place had been used as a rental for years, and it was in such a state of disrepair that they were still spending many of their nights and weekends trying to get it into decent shape. "You mean the charming place you call the money pit, right?"

"Where else? We certainly can't afford two houses like this sucker." He rolled his eyes. "We're making headway on our project, *very* slowly, but what we really need is some reliable help—nothing skilled, just somebody to help us knock down a few walls, shovel out the debris, carry in lumber and Sheetrock when we get a delivery, that sort of thing."

My eyebrows knitted in confusion. "And this has exactly what to do with Max and his band?"

"I had this idea, Susan. See, our place has this old freestanding studio at the back of the lot. It's nothing to write home about, nobody'd want to actually live there, but it does have an intact roof and electricity and even a toilet that still flushes—most of the time, anyway. I talked to Zeb last night and he agreed that Max and his friends might be able to make it into a sound studio where they could practice. In exchange, they could help us with this grunt work we need to get done on the house."

"That's very generous of you, Ricky, and I'm sure the boys would love it, but you've got neighbors, too. Believe me, you don't want that kind of noise making enemies for you."

"Hey, I'm not finished. There's more to my idea," he said. "Before they start practicing there, the boys can soundproof the place. Zeb's got this buddy who sells beds to the major hotels—not flophouses, the three- and four-hundred-bucks-a-

night luxury hotels. Zeb's friend is about to replace all the beds for one of his downtown customers, so he'll have to cart away all the used mattresses and pay a landfill to take them. We figure he can drop off fifteen or twenty or so at our place and the boys can use them to line the walls of the studio, maybe cover them with some cheap tarps so they won't look too bad. Tack up some extra-thick insulation on the ceiling, and they'll have themselves a sound-proof studio."

Conflicting thoughts invaded my mind: That this could solve Max's problem, and by extension, one of my own; that it was a really, really stupid idea to mix my personal and business lives by letting my son and his friends work for or accept favors from my assistant; and that, if I turned down this opportunity, Max would never forgive me.

"It—it sounds promising," I said, hesitating, "and it's awfully nice of you and Zeb to offer, Ricky. But—well, just let me think about it a bit, okay?"

"Sure thing," he said with a casual shrug. "Talk it over with Max, see if he and his buddies are willing to do a little sweat labor to earn themselves a rent-free practice studio. Just let me know as fast as you can, before those old mattresses end up in the landfill, okay?"

"Can't believe you and I actually have a whole evening together. *Alone*," Todd said, grinning lecherously at me as he opened the bottle of chilled Chardonnay I'd bought on my way home from work.

I reached over and placed my index finger gently across his lips. "Don't say that kind of thing out loud," I told him. "You'll tempt fate." I took my finger away, leaned over, and planted a gentle kiss on his tasty mouth.

Todd was looking particularly sexy tonight in a pair of well-worn, form-fitting jeans and a blue plaid sport shirt, his fair hair

already disheveled from the brief make-out session we'd had while I tried to prepare dinner. I hoped I looked equally fetching in my favorite emerald green velour lounging outfit, my long, straight hair tied back at the nape of my neck with an ivory silk ribbon.

"You know I don't believe in that superstition nonsense, Suze." Todd is the only person I've ever allowed to call me "Suze," a name I normally abhor. He pulled the cork out of the wine bottle, twisted it off the corkscrew with an efficient motion, and tossed it in the trash.

Before heading home for my big date, I'd worked in the office all afternoon, going over the detailed rosters Connie and Ricky managed to compile.

There were no suspicious names on the list of people who'd bought ether from legitimate sources, at least nobody who'd ever been arrested for an arson-related crime here in California. And every buyer appeared to have a sanctioned reason for his or her purchase. That search seemed a dead end, at least until we identified a suspect and could look for his name on the list. Ricky'd undoubtedly been right—the killer'd bought his ether on the black market, probably from somebody who also supplied some of the state's hundreds of illegal methamphetamine labs, no questions asked and no records kept.

Our second project turned out to be much more promising. It took Ricky less than an hour to figure out how to use his computer to locate the vital statistics data from all three counties and retrieve their lists of recent birth registrations. We could have called the counties, of course, and simply had them fax over the information. But I wanted to see how easily someone with computer skills could get it without anyone's noticing.

Once Ricky had the names from all three counties, we spent a couple more hours separating out the new mothers whose surnames were different from their babies' fathers', then paring our list down to include only those who'd given birth to daughters.

By the end of the day, our task was completed. And sure enough, among the new mothers on our final list were Betsy Cavendish, Isabel Morrisey, Heidi Weill, and Ginger Smith—all four of our fire victims.

"I think this has got to be how the killer found his targets," I told Ricky, my heart heavy as I read the names of the dead mothers. "Tomorrow, we can call the rest of the new moms on this list, warn them to be extra careful about who they let into their homes."

"Good idea," he agreed, as he packed some papers into his briefcase and prepared to leave the office. "You and I can split up the names. If we can manage to reach the women at home during the daytime, it shouldn't take us more than a couple of hours to warn all of them."

As I was getting into my car to head home, Max called me on my cell phone.

"I really gotta come stay with you tonight, Mom," he complained. "Can I, please? Dad's all over my case again, and all I did was turn on the TV while I was doing my homework. He's really driving me nuts, honest. Geez, you'd think I was building bombs in my room or something!"

I spent a few minutes trying to smooth Max's ruffled feathers, all the while hoping my evening with Todd wasn't about to go down the drain because of my son's latest little spat with his dad. I'm not proud of it, but the truth is that, in the end, I bribed Max by telling him about Ricky's offer of a practice studio in exchange for grunt labor.

"You're kidding! A real studio?" he replied, apparently forgetting his latest gripe about his living situation. "That's way cool!"

"Hey, it's not free, kiddo. You and the guys will have to earn the use of the studio, and the work Ricky has in mind for you won't be easy. It'll be hard, sweaty labor and you'll have to do it without complaining to Ricky and Zeb. So don't say you'll do it

and then not follow through one hundred percent, or you'll be spending the rest of your life living at your dad's. Understand?"

Max agreed to talk to the other band members as soon as he checked out Ricky's place. I gave him my assistant's address and phone number and suggested he call Ricky to see if he could take a look around later tonight. By the time he got back to his dad's, I suggested, Doug would have cooled down.

Then, with a feeling of relief that my son would be staying at his father's tonight after all, I hung up.

Now Todd and I were in the compact dining room of my condo, about to eat the late dinner I'd managed to throw together. I'd picked up two freshly steamed Dungeness crabs and some crusty sourdough bread at Fisherman's Wharf, cooked a package of Trader Joe's wild rice pilaf, and tossed together a green salad. I had a ripe honeydew melon in the refrigerator for our dessert.

Max was occupied either at Ricky's or at his dad's, Todd's kids were with their mother, Todd wasn't on call at the hospital, and the stereo was playing some mellow Neil Diamond. For tonight, at least, life was good.

Todd poured us both some Chardonnay. We clinked our glasses together. "To better days ahead for both of us," I toasted, then took a sip. "Not bad," I said, assessing the wine.

But before I'd finished swallowing my second sip of Chardonnay, the telephone rang.

"Damn." I glanced at my watch. It was already eight-thirty. "Probably just Max with more gripes about his dad's rules and regulations," I said, fearing he might have been unable to reach Ricky. "Or maybe somebody selling something. Whoever it is, I'll get rid of him quick." Might as well think positively.

"Why not let your voice mail pick up?" Todd suggested, cracking a crab leg and spearing a morsel of its meat with his fork.

But letting a telephone ring without answering it is something I'm congenitally unable to do. Visions of every possible

emergency always flash through my mind. I pushed back my chair. "I'll make it fast," I promised, heading for the phone in the kitchen. "Just keep eating. I'll be right back."

I grabbed the receiver and held it to my ear. "Hello." I could hear the irritation in my own voice as I spoke.

"Susan, glad I found you home," a deep male voice said. "This is George Minelli." I recognized the name of one of the San Francisco fire chiefs.

"Hi, Chief. Got something new on Betsy Cavendish?" It must be important, I thought, for him to call me at home this late about the San Francisco murder.

He sighed audibly. "Wish I did, but that's not what I'm calling about."

I stiffened and my heart skipped a beat, fearing what I was about to hear. "What's up?" If I acted and sounded casual, I told myself, surely everything would be okay.

Wouldn't it?

"I'm in the Haight on a three-alarm," the chief told me. "Looks like our boy's struck again. We got another young mother burned to death over here, and so far no sign of her baby." He gave me the address.

My breath caught in my throat and it took me a moment before I was able to speak. "Th—thanks for letting me know," I managed, finally. I glanced through the kitchen doorway at Todd, who was gazing back at me with a half-irritated, half-quizzical look on his face.

"I'll be right there, Chief," I said into the telephone.

Chapter Nine

AS I hurried across town, I pondered why the killer had suddenly deviated from his established pattern. Until now, he'd always struck on Saturday nights. Today was Wednesday. Besides that, it had been a mere four days since his last murder. Clearly, he was escalating, but why?

I couldn't help feeling a little guilty, as though I were responsible in some vital way for this latest murder. Had the challenge I'd issued in this morning's newspapers resulted not in motivating the killer to write additional letters, as I'd hoped, but in pushing him to commit another murder instead?

I also derided myself for not having stayed at the office longer. Obviously, it had been a big mistake for Ricky and me not to call and warn the new mothers as soon as we obtained their names. Instead, anticipating my cozy dinner date with Todd, I'd convinced myself we had until Saturday to make those phone calls.

Now another young mother was dead and I couldn't shake the feeling it was, at least in some part, my fault.

I drove west on Fell Street, then made the left onto Masonic and crossed the strip of grass known as the Panhandle. I caught the pungent scent of wood and chemical smoke in the air as soon as I reached Haight Street, although the space cadets lounging along the sidewalk and in the doorways seemed pretty oblivious to it. In their retro-hippie clothing, tattoos, and body piercings, they looked no more alert to their surroundings than on any other night of the week. Maybe the burning joints so many of them held in their fingers overpowered the odor of the house fire a couple of blocks away. Or maybe they actually could smell the fire, but were so high or so busy making drug deals that they simply didn't care.

Every time I see the kids who hang around the Haight, I feel grateful Max never got into drugs. Next to this sort of thing, playing rock music at an ear-splitting level or turning on the TV while doing homework seems ridiculously innocent. For at least the millionth time, I wondered why stodgy old Doug couldn't see and appreciate that fact. Max was a good kid, period, and both his parents had reason to be proud of him.

The scene near the address Chief Minelli had given me was much like Saturday night's in San Vicente, except that here I could find nowhere to leave my car. Finding a parking space is always a major problem in this part of the city, and now fire engines, police vehicles, the news media, neighborhood residents without off-street parking, and onlookers had further complicated things, causing complete gridlock.

I finally found a spot on a corner more than two blocks distant, next to a sign informing me that a resident's permit was required to park there. I pulled my official state parking pass out of the glove box, slapped it on the dashboard, and climbed out of my car.

I spotted Chief Minelli standing outside the yellow plastic crime scene tape that had been strung across the front yard of

the small house, which was still smoking. The chief was a huge man, half a foot over six feet tall, and a good two hundred sixty pounds. Still in good physical condition—he could probably lift me with just one of his burly arms—he was now somewhere in his late fifties. I knew from past experience that he had a full head of thick, wavy grayish-white hair, but now it was completely hidden by his firefighter's helmet.

Minelli was surrounded by members of the media who'd somehow managed to get here before me. I spotted Channel 3's van parked on a neighbor's small patch of muddy grass. Luckily, I saw, Ben Silverman was reporting for the station tonight, instead of my nemesis, Lauren Meyers. Lenny Palmer and Cheryl Peach also were already on the scene, as were several other reporters I'd seen at previous fires but whose names I didn't recall.

Chief Minelli saw me, split away from the reporters, ducked back under the police tape, and waved me over.

When we were out of the reporters' earshot, the chief told me, "Neighbor on the west says the girl living here is named Maureen Benavente." He consulted a small spiral notebook and spelled the last name for me. "Has a three-week-old daughter, no husband, no other kids. No man living with her, either, according to this neighbor, a Mrs.—" he consulted his notebook again "—Mrs. Jessica A. Parr, that's P-A-double R."

Had the killer managed to find and target poor Maureen and her child since reading the newspaper this morning? Probably not, I decided. More likely, he'd already checked her out and chosen her as his next victim. He'd simply moved up his schedule to prove—what? Probably that we couldn't predict what he would do next. And to demonstrate that he remained many steps ahead of the poor idiots like me, whose job it was to stop him.

"What's the scene inside, Chief?" I asked, plopping my hard hat on top of my hair and tucking my ponytail beneath the collar of my coat.

"Same as the Cavendish girl." Minelli still referred to young mothers as "girls," as though the feminist movement had never happened. "Found her in the middle of the living room. Extremely hot fire, quick flashover condition. The place was fully involved by the time we got here. It'll be a while before we know the cause, officially, but I'll bet tomorrow's lunch it's the same arsonist that torched the Cavendish place."

I had little doubt about that myself.

"I'll go inside, take a look," I said.

"I'll go with you, but we better wear masks and make it quick. Pretty smoky in there yet. Back end of this place is still partially engaged—my guys got water on it."

I nodded and took the mask he handed me. I snapped it over my face, doing my best to fight off the instant panic of claustrophobia that wearing a gas mask always gives me. I can't imagine how soldiers spend hours wearing these things in battle, although I have to admit it has to be better than inhaling smoke or poison gas.

Chief Minelli was right. The scene in the living room, where the fire had obviously started, was eerily similar to the others I'd observed. The victim lay in the center of the room, her charred body on its side, her limbs pulled up into the classic pugilistic position of the burned corpse. I stepped into the space as gingerly as my thick boots and the sodden ashes beneath them would allow, playing my bright flashlight on the fire debris surrounding her. I started several feet away from the body and slowly circled in on it.

It took only a few minutes to spot what I was looking for half-buried in the ashes. Less than three feet away from the corpse were the metal remains of a burned baby's crib—partially melted rods, springs, and wheels, plus a warped and blistered length of plastic I took to be the teething protector commonly attached to the side rail of a baby's bed.

I made a mental note, then stooped down and shined my light on the corpse itself. Maureen Benavente—assuming this was Maureen Benavente—seemed to have been a larger woman than Ginger Smith and the others. Her form was longer, and her body seemed more heavily charred.

"Bigger corpse!" I shouted, attempting to be heard through my mask. I sounded like I was talking under water, if not through thick mud.

"Big girl—better'n two hundred pounds before the baby," the chief shouted back. He added something else I couldn't quite catch, probably that he'd gotten this bit of information from the neighbor, Mrs. Parr.

That Maureen Benavente would be more completely burned made sense. Her extra body fat would have fueled the fire, making her flesh burn that much hotter and faster than the smaller victims.

I signaled the chief that I was ready to leave for now. I'd be back in the morning, when the fire was fully out and the floodlights were in place. But for now, in this smoky darkness, I felt all I'd accomplish would be to damage the evidence.

The moment we stepped back into the soggy little front yard, I ripped the mask off my face and took a deep breath. Even though the air I breathed remained laden with wood and chemical smoke, I felt a strong sense of relief that the mask was off. I did my best not to show how big a wimp I was, forcing a smile of thanks onto my lips as I handed the torture device back to Minelli.

As I turned away, I spotted Ricky standing twenty feet away, taking pictures of the crowd with his digital camera.

"Hey! Ricky!" I called to him over the noise of the crowd and the sound of water rushing through the fire hoses.

He turned and waved, then ducked under the yellow tape. A cop immediately grabbed his arm and challenged him until he showed his credentials.

"What're you doing here?" I asked as he approached me. "I thought you'd be at home. I told Max to call you—"

"Right, he caught me on my cell phone, said he was coming over. No problem, Zeb will show him around the place, spell out the deal. Heard about this on the radio—KBA. They're already calling it another Baby Snatcher Murder. Figured I'd better haul ass over here, make sure we get our crowd photos this time." His face was grim. "Was this victim's name on our list?" he added in a confidential tone.

"Pretty sure."

He sighed. I wondered if he was feeling the same guilt I was, but I didn't mention it. This was my responsibility, not Ricky Lindeman's.

"Nothing we can do about that now but warn the others," I told him, "and make sure we catch this bastard."

Ricky patted me on the back. "I better finish those crowd shots before people start splitting."

"Hey, thanks for coming out."

"Least I could do." He lifted his camera and resumed taking photos of the crowd, proceeding in a semicircle and including no more than four or five faces in each shot.

I turned back to Minelli. "Which one is Mrs. Parr?"

"Once we could assure her that her house wasn't gonna catch fire, she went back inside. Seemed real upset about her friend. Come on, I'll introduce you." His hand on my elbow, he led me around the side of the ruined house. We waved off the crush of reporters shouting questions at us.

"Hey, Delancey, ID the victim yet?" somebody called.

"You guys gonna catch him this time?" another voice shouted.

I ignored them, concentrating on putting one foot in front of the other so I wouldn't slip in the mud or trip over one of the bulging fire hoses. All I needed was for a picture of me falling in the mud to end up on the eleven o'clock news. Maybe I was

paranoid, but I felt certain a couple of these reporters would be tickled pink to be able to show me taking an embarrassing pratfall.

The place next door was a duplex, and Jessica Parr lived in the lower unit. Somehow I'd expected an older woman, but Mrs. Parr was no more than twenty-four, maybe twenty-five, a petite and pretty blonde. After Chief Minelli told her who I was, he left us and went back to supervising his fire crew.

"Come on in," Jessica said, holding her front door open for me. Her cornflower blue eyes were red and puffy. I was pretty sure it wasn't just from smoke irritation.

"Did you know Maureen well?" I asked, as I stepped out of my boots and left them at the door. The hardwood floors were pristine and I didn't want to muddy them.

"She was the only friend I had here in San Francisco."

I took off my coat and hung it on an old-fashioned oak coatrack in the foyer. "How's that?"

"We just moved here from Wisconsin, about six months ago. My husband, Luke, he got this job at a dot-com, couldn't pass up what sounded like a lot of money, at least by Wisconsin standards." She shook her head. "Little did we know it would cost us half of what he makes just for rent. This place is maybe a third as big as what we had back in Madison, and there's not even a backyard for Matthew to play in." She gestured toward the tiny living room. "Come on in, have a seat."

The room was sparsely furnished with a green futon sofa, two blond end tables with matching lamps, a couple of canvas chairs, a collapsible bookcase filled with paperbacks, and a big-screen TV. Classic newlywed decor from Ikea. In the corner was a playpen, empty except for a small pile of toys.

I sat on one of the canvas chairs while Jessica perched on the futon.

"I'm home all day with Matthew—he's two," she explained,

"so I don't get out to meet people all that much. Luke works such long hours at his job that—" She looked down at her lap and rubbed her eyes with her knuckles. "Anyway, Maureen was friendly when we moved in. Brought over a cake she baked and everything—chocolate with fluffy pink frosting. I can still see it. Had all these questions she figured I could answer for her—you know, about childbirth, raising a baby, that sort of thing." She glanced at the playpen, as though she wanted to make sure it, at least, was still there. "So it's like Maureen and I had something in common right off."

"Any idea who might have done this to her?" I asked.

She looked up and I saw her blue eyes begin to fill. "Kill her? No, of course not."

"What about her baby's father? Do you know him?"

Jessica shook her head. "Maureen told me she used a sperm bank to get pregnant, said she wanted a baby but didn't want to wait around until she found somebody to marry. I—I don't know if I really believe that, though. My hunch is, the dad was a one-night stand and she didn't want to admit it—thought I was pretty straitlaced, I guess. Suppose I am, by your standards. Wisconsin's not exactly San Francisco, is it? But, whatever the truth is, I don't think the dad even knew she was pregnant."

"What about her work? Did Maureen have a job?"

"She worked at home, had her own business doing legal research on her computer for a bunch of law firms. She pretty much could set her own hours, so we used to go for walks together in the afternoon, put Matthew in his stroller and walk down to the park."

"So she made a pretty good living, I take it?"

Jessica made a dismissive sound. "Enough to scrape by is about all, I think. It costs a fortune to live around here. I gave her some of Matthew's old baby clothes so she wouldn't have to buy new ones. You know, if she lived anywhere else in the

country, she'd have been doing real well. But I guess if she lived anywhere else in the country, she wouldn't be making as much money, would she?"

I pushed an errant lock of hair out of my eyes. "Seems to work out that way, doesn't it?"

"Maureen—she—" Jessica's chin began to quiver and she pulled a tissue from the pocket of her jeans.

"It's okay. Take your time," I told her gently as her shoulders began to shake.

"It's just that—just that she was so happy this morning when she heard she won that baby contest and now—now—" Her voice broke and she wept into her tissue.

As I waited for Jessica Parr's tears to stop, I began to feel a tingle of excitement. A baby contest—could delivering the prizes be the arsonist's excuse for entering his victims' homes?

When Jessica got herself back under control, I asked, "You mentioned a baby contest Maureen won, Jessica. What do you know about it?"

"It was amazing luck, really. Maureen said she didn't even have to enter to win. Some newspaper runs it, I guess, in its lifestyle section or something like that, automatically enrolls all the new babies when they're born. Anyway, she was thrilled she was going to get all that stuff she really needed for Brittany—that's what she named her baby."

I had a hunch Maureen Benavente'd had amazing luck, all right. All of it bad.

"Did her winnings by chance include a new crib?" I asked, almost holding my breath as I waited for the answer.

"Right, plus all the bedding for it, a diaper service, stuff like that. It was really going to help her out a lot."

"But didn't she already have a crib for Bethany?"

"Brittany."

"Sorry, Brittany."

"No, all she had was this old wicker bassinet I loaned her. It was my sister's baby's first, then it was Matthew's when he was born." She looked around as though seeing ghosts. "I guess the bassinet's gone now, too, huh?"

"I'm afraid so."

"I wouldn't really want it back, anyway, not after something like this. If Luke and I can ever afford to have another baby, we'll just have to get all new stuff."

"I'm interested in this contest, Jessica. Do you know how Maureen was notified that she'd won?"

Jessica thought for a moment. "Somebody from the paper called and told her this morning and then she called me. Funny, it was just a few hours ago, but it seems so long after all—all this."

"And someone was going to deliver Maureen's prizes to her home?" I began to feel more and more certain I'd finally discovered the killer's scam.

"Right, I guess so. I mean, Maureen didn't even own a car, and she didn't ask to use ours or have Luke or me drive her. Sure can't haul a crib home on the bus, can you?"

I shook my head. "This could be really important, Jessica. I want you to think real hard. Did Maureen tell you which newspaper called her about the contest?"

She chewed her lower lip. "The *Inquirer*, I think, or maybe it was the *Courier*. Seems like it was one of the local ones, but I'm afraid I'm not sure. Why? Do you think the contest had something to do with the fire, with Maureen—Maureen's death?"

"I don't really know." Not for certain, anyway, and I definitely wasn't about to discuss my suspicions with a young woman who might be inclined to talk to the media. "I just want to check it out, see if the prizes were delivered yet. You never know—whoever delivered Maureen's winnings to her house might have noticed something, might have seen someone lurking around."

"Sure, that makes sense."

I left Jessica to mourn alone and went back to the arson site. I gave the media a few more non-answers to their questions. By now they seemed to know and generally accept the drill—that I wasn't going to risk jeopardizing our case by giving them any vital information prematurely—and they spent less time pressing me for something they knew they weren't going to get.

The television vans departed in plenty of time to prepare their stories for the late evening newscasts, and the print and radio reporters headed back to their cars. I looked around and noticed that Ricky had already left the scene. I hoped the photos he'd taken would help, that we'd recognize somebody suspicious.

The fire appeared to be completely extinguished now and the crowd of neighborhood gawkers had dissipated. The odor of smoke still hung in the air, but that would linger nearby for days.

I saw that Chief Minelli's crew was reeling in most of the fire hoses in preparation for its return to the station house now. A couple of firefighters would stay at the site overnight, in case of another flare-up, but most of them would head out, having finished their work. If this section of San Francisco had no more fires break out tonight, they might even get some sleep.

The chief remained guarding the scene with the cops, as they waited for the medical examiner and the police brass to arrive. I told Minelli I'd be in touch with whichever homicide detective was assigned to the case tomorrow, and began to hike back to my car.

I climbed into the Volvo and shut the door, relieved to have a quiet moment to myself. I knew Todd would have gone home by now, so there was no need to rush back to my condo. Instead, I sat in the dark and used my cell phone to call the detectives in charge of the other murders. I was anxious to have them deter-

mine whether the other dead mothers had also "won" contests shortly before their deaths, and if so, who had supposedly sponsored these giveaways.

Two of the cops were grateful for the lead, thanking me profusely and promising to let me know immediately if they learned anything. I couldn't reach the third, so I left a message on his voice mail. Predictably, the only resistance I got was from prickly Detective Berry in San Vicente.

"I got my own investigation going along just fine here," he snapped. "I need you to tell me how to do it, I'll let you know." I'd called his home number, and I wondered whether I'd interrupted his favorite TV show or if he'd been asleep.

"I appreciate that, Detective," I told him, "but I really need to know whether Ginger Smith won any kind of baby contest, like this latest victim did. I figure you and your men are interviewing her family and friends already, so it'll be easiest if you simply ask them one more question. I think this could lead to a major break in these cases."

Berry mumbled something. I didn't quite catch it, but it definitely sounded less than cooperative.

"Tell you what," I suggested, starting to lose my cool. "Guess I've got this backward. I had this silly idea you and I were on the same side of this thing, but apparently I was wrong. So I'll just take this up with your lieutenant first thing tomorrow. Probably save us both a lot of time in the end."

Apparently I'd finally hit the right chord with this yahoo. "Hey, lady," Berry replied hastily, "never said I wouldn't do it, did I?"

"Let me know what you find out tomorrow, Detective," I said, and pushed the button to disconnect the call.

"Asshole," I complained as I shoved the cell phone back into my purse.

✿ ✿ ✿

My home phone was ringing as I came through the doorway of the condo. I dumped my purse on a chair and grabbed the receiver, wondering if one of the detectives had actually learned something useful so quickly.

"Mom, *finally!*" Max sounded completely exasperated in that irritating way only a teenager can. "I been calling you for the last hour! I left at least four messages."

I briefly explained where I'd been and why.

He cooled off. "Oh, sorry. Didn't know."

"So what's so urgent?" I sank onto the sofa. The adrenaline surge I got whenever I was called to a fire had ebbed as I drove home, and I was suddenly exhausted. I glanced over at the dining table Todd had cleared so neatly and remembered I hadn't even eaten dinner yet. No wonder I felt so bushed.

"Me and Brian went—"

"Brian and I went," I corrected him.

"Hey, *I* was with Brian tonight, Mom, and no way were *you* there."

"Very funny, kiddo, but I'm not in the mood right now."

"Okay. *Brian and I* went over to Ricky's place and checked out the guest house. It's gonna be totally cool when we get it done!" He described in loving detail what honestly sounded to me like a decrepit old shack, but he could see only the place's potential. It took every ounce of mother love I could summon to ignore my exhaustion and hunger and murmur appropriately encouraging words as my son gushed on about this hovel with promise. I began to wonder if Max might have a future career in the real estate business.

"This project is going to be a lot of work, though, don't forget that," I warned.

"No prob. Bri and I were gonna get going on it tonight, start hauling out some of the old junk that's stored in there, but Zeb said we had to wait until tomorrow after school. Said he was

baby-sitting a friend's new baby up at the main house and he didn't want us making a lot of noise, maybe waking her up. She's real little, only a couple weeks old, and Zeb said he finally got her to sleep just before we got there. The baby's dads were s'posed to pick her up by midnight or so, but we didn't think we should stick around that late."

"I should think not! Not on a school night." I thought for a moment. "The baby's dads?" I asked.

"Yeah, she's got two dads instead of a mom and a dad."

It never ceased to amaze me how my son took things like this in stride, that a child could somehow have two fathers and no mother. He'd grown up a true product of modern San Francisco culture, all right. "Sounds like it must have been some sort of emergency, using a sitter for such a young baby," I suggested. I couldn't imagine my having left Max with a sitter at two weeks old, but maybe women just feel differently about these things.

"Maybe. Zeb said they were having trouble with their Sears gate or something like that, and he was helping them out."

"Their Sears gate? What on earth is that?" I couldn't imagine the two fathers had actually gone shopping to buy a new gate, leaving their brand new daughter behind. Then it hit me. "Could Zeb have been talking about a surrogate instead of a Sears gate?"

"Maybe, sounds about right. Didn't really listen, I guess."

Now Max's tale began to make a bit more sense. Obviously, this baby was the product of a surrogate mother the two dads had hired. If the surrogate was now giving them trouble, perhaps threatening not to sign over full custody, it made sense not to bring the baby along when they met with her. Why risk further inflaming any maternal instincts she might have?

"Anyway, we told Zeb we'd come back tomorrow afternoon," Max said, getting back to what really interested him. "That's okay with you, right, Mom? Tomorrow's Thursday."

Max habitually spent Thursdays at the condo. "As long as you get your homework done first," I told him.

"Ah, come on Mom, be cool. We gotta work on the studio when it's still light out, don't we? I'll do my homework right after dinner—promise."

I was too tired to argue. "All right," I agreed reluctantly. "We'll try it just this once. But if I find out you didn't finish your schoolwork, this'll be the last time."

"All right! I'll call the guys right away, set things up for tomorrow. See you at dinner." He paused. "And Mom?"

"What?"

"This is totally excellent!"

I smiled and started to tell Max I loved him, too, but he'd already hung up.

As I rummaged in the refrigerator for the remains of the chilled crab, salad, and melon that Todd had packaged up and stored there for me, it occurred to me that there must be a whole new baby boom in progress.

Every time I turned around lately, somebody seemed to have still another newborn baby.

Chapter Ten

"*NO* newspaper's running any contest like what you described," Connie Rodriguez told me as I came into the office a little over an hour late the next morning. "Nothing to do with babies at all." I'd phoned my part-time secretary first thing that morning and assigned her the task of calling all the newspapers in the Bay Area. I had a couple of stops to make on my way in, but I wanted to make sure somebody was following up on the contest angle right away.

I spent an hour or so at the new arson site, just to make sure the crime investigation was progressing according to protocol, then drove across town to see Trudy Gillman, Steven Snyder's alibi for the night Ginger Smith was burned to death. At this point, my interview with Mrs. Gillman would be little more than a formality—the San Vicente cops had already verified that the adulterous couple had been at Club Seven during the time Ginger's house burned. Still, I felt I should follow up with her as I'd promised.

I quickly realized I didn't like Trudy Gillman much more than I liked her boyfriend. A mousy little woman with a cigarette dangling from the corner of her heavily lipsticked mouth, she readily backed up Snyder's story, but refused to let me tape her statement.

"Have to take my word for it," she said in a defiant tone, "and get the hell off poor Steve's back. Ain't testifying at no trial, either."

"Why not?" I asked her. "Surely you must care about Steve."

She put a fresh cigarette in her mouth, lit it off the stub, and inhaled deeply. "Dead women don't testify," she informed me, stone-faced. If her husband ever found out about her affair, Trudy insisted, he would kill her. It was that simple.

As far as I could tell from the fifteen or twenty minutes I spent with her, this woman had been exhibiting incredibly poor taste in men and unbelievably bad judgment in general for some time now. Here she was, sleeping with a loser who'd refused to support his baby by another woman, plus she was doing it behind the back of a husband with homicidal tendencies. In my assessment, she had to be either suicidal or really, really stupid.

Or maybe both, I thought as I left the Gillman apartment, my hair and clothes reeking of smoke from both the burn site and Trudy's Marlboros. But at least now I could honestly tell Sacramento I'd followed up on every possible lead. I could already hear a new barrage of criticism and second-guessing heading my way after last night's fire.

I strode into my office and set my briefcase on my desk, Connie following in my wake. "You're sure you called every one of the papers?" I asked her.

"*Of course I did*, even called the advertising throwaways. Called all the radio and TV stations, too, just in case that neighbor misunderstood." Connie's exasperated expression asked why on earth I would ever question her competence with such a

simple task. She undoubtedly was right. Almost old enough to be my mother, Connie Rodriguez was gray-haired and plump, and she'd been working in various city and state government offices for more than three decades. She knew where all the bodies were buried, which was sometimes an invaluable asset, and she had a healthy, if not inflated, sense of her own worth.

"Good work, Connie," I said, feeling like I was eating crow. "There's one more thing. I've got a progress memo to write. If you can get it typed up in time, we can fax it to Sacramento before lunch."

"Just so long as you get it to me by eleven," she said, checking her watch. Sometimes I had to wonder just which one of us was the boss here and which one was the employee. "Like I told you Monday, I can't stay late this week—Juan and Hector are on half days at school."

Connie had been caring for her two young grandsons ever since their mother, her daughter Socorro, died of hepatitis three years earlier. That new responsibility prompted her to give up her full-time job as executive secretary to one of the San Francisco county supervisors and take the part-time position with my office when it opened up. She'd taken early retirement from the city. With her city pension, plus the salary the state paid her to work for me, her little family seemed to get by reasonably well.

There was no denying that my staff had gained an experienced employee in Connie Rodriguez, but there was a definite downside—competent though she was, Connie obviously felt she was doing Ricky and me a big favor by working in our low-budget operation. Maybe I was overly sensitive, but it seemed she never missed an opportunity to let me know how she felt.

"I'll do my best," I promised, watching as Connie turned without a word and went back to her desk in the reception area.

I spent most of the next hour crafting my memo to Bart Waldron, figuring I'd better head him off at the pass before he

called me demanding to know what progress we'd made. So I brought the governor's right-hand man completely up to date on the investigation, including my theory about the role of the bogus baby contest.

We'd actually accomplished quite a lot for such a small operation, I reassured myself as I read the memo for the final time. Maybe if I'd had a bigger staff and an adequate budget, we could have solved these crimes faster, but that clearly wasn't an option. I had to keep reminding myself of that fact.

Still, when I handed the memo over to Connie for typing and faxing, I couldn't help feeling another kind of unspoken criticism emanating from her as she reviewed the pages and kept glancing at her watch. My own secretary had a real talent for making me feel like a schoolgirl turning in a late paper to a particularly stern teacher.

"Hey, Susan, ever seen this guy before?" Ricky asked me as I headed back to my office, feeling a bit deflated. He gestured for me to come and take a look at his computer screen.

It displayed a digital photo of a man standing in a crowd. He was in his late twenties or early thirties, dark-haired, muscular, and a bit more than average height, with a bulbous nose and a Z-shaped scar piercing his right eyebrow. He was wearing a Giants baseball cap and a navy bomber jacket.

"Doesn't look familiar," I said as I studied the man's face.

"Sure he's not one of the reporters covering the fires?"

"Couldn't swear to it, but I don't remember this guy ever asking me any questions." I felt a tingling sensation move down my spine. "Why?"

Ricky smirked as though he was about to pull a rabbit out of a hat. Instead, he took three photos out of a manila folder and laid them out on his desk. "Notice anything?"

"Same man, different clothes?"

"Sure looks that way to me." He pointed to his computer screen. "Took that one last night. This one—" he held up one of the other photos "—is a print made from the video taken at the Sausalito fire." It definitely looked like the same man, but now he was wearing a gray sweatshirt and his crew-cut hair wasn't hidden by a cap. "These other two were taken at the first fire, here in San Francisco, and at the one in Daly City. Couldn't find this guy in what we had from the San Vicente crowd, but what we had was basically crap, because the photographer showed up so late."

"This is fantastic, Ricky," I said, getting a feeling that the case finally might be starting to break our way. "Can you fax that image to the police and fire departments, see if anybody recognizes this guy?"

"I'll edit my digital image, get rid of some of the distracting background stuff, and e-mail it to all of them right away."

After Connie went to pick up her grandsons and we'd wolfed down a take-out lunch from a deli a few blocks away, Ricky and I spent most of the rest of the day on the phone. I wasn't about to make the same mistake twice—I vowed we would contact all the new mothers whose names Ricky had pulled off the vital statistics records before another night passed, or die trying.

While we worked, we let the office voice mail pick up the incoming calls. All of them turned out to be from reporters wanting a comment on last night's fire. No real surprise there.

Luckily, we managed to reach all but three or four of the new mothers to warn them they could be on the killer's target list. We advised them not to open their doors to strangers, particularly in response to any call claiming they'd won a baby contest. And if they did get such a call, we asked them to write down as much information about it as they could and contact us immediately.

Needless to say, we alarmed quite a few young women who

were already going through a particularly stressful time in their lives. Whether what we were doing really would manage to thwart the killer, I had no way of knowing, of course, but at least we were doing what we could to prevent more loss of life. No way did I want to wonder whether I might have prevented still another young woman's death just by making a few phone calls.

Ricky'd left and I was almost ready to close up the office for the day when the phone rang once more. I reached for it, hoping it wasn't one of the reporters whose calls I hadn't returned. I had nothing more to say to the news media, not yet anyway.

"Arson Investigation," I answered. "Delancey."

It was Chief Bill Hoffman, the helpful fireman who'd been a positive counterpart to surly Detective Berry at the San Vicente fire. "Investigator Delancey," he boomed in my ear. "Glad I caught you. Got that e-mail from your office, photo of that guy in the crowd?"

"You know him?" I asked, feeling a quick spurt of hope.

"Could be…think so, anyhow. Looks something like a guy applied for a job here in San Vicente three or four months back. Didn't have any spots open, though, so I couldn't hire him."

"He wanted to sign on as a firefighter?"

"Real eager about it. Muscular young fellow, looked like he worked out a lot. Remember he showed some promise. Think he said he had experience as a volunteer someplace out of state, mainly brush fires. But like I told you, I didn't have a job for him."

My knuckles whitened on the telephone receiver. "His name, Chief, do you remember his name?"

The confidence fled from his big voice. "I'm afraid that's the thing, Investigator. Can't for the life of me come up with it."

I sighed. We'd come so close. "What about anybody else on your staff? Might they remember his name?"

"Tried that. Showed this fellow's photo around the station

house, but generally I do the interviews myself. We don't have anything open, it doesn't go any farther." My spirits sagged. "We keep the applications, though," he added, "for at least a year."

"Could you go through them, see if anything rings a bell?"

"Doing that now, but it's gonna take me a while—my file drawer's got close to five hundred applications in it. Just wanted to let you know before you left for the day. I find the right paperwork, I'll give you and my counterparts from the other fire departments a heads-up. Maybe one of the other chiefs will know more about him."

"Thanks, Chief," I said, grateful he was so dedicated to his job. "Let's hope this is our big break."

"I'll be in touch."

When I got home, the place was deserted and blissfully quiet, but there was a message on my voice mail. Hoping it was Todd, I played it, but immediately recognized Max's voice. "Sorry, Mom, gonna be a little late. Some dude delivered a whole stack of mattresses over here and we gotta get them inside the studio before the fog gets them totally soaked. Go ahead and eat if you want. Just save some dinner for me. See ya."

I smiled, picturing Max and his fellow not-terribly-athletic band members hauling around the stack of mattresses they needed for soundproofing Ricky's backyard shack. I'd bet tonight's dinner that every one of them would have sore muscles in the morning.

I switched on the TV news—ever a glutton for punishment— as I prepared quartered chicken and potatoes to bake for dinner. Congress was still fighting over tax cuts, the stock market was down again, a hurricane was approaching Baja California, and a car bomb had exploded outside a movie theater in Israel. The news anchors switched to local stories, reporting a gang shooting in Oakland and a runaway car that had crashed into the front of a

deli in San Francisco's Cow Hollow district, seriously injuring three people.

It was the next item, datelined Sacramento, that made me drop the potato I'd been scrubbing in the sink and take notice. "Modesto Assemblyman Paul Vogel, expected to be the leading Republican candidate for governor in the next election, held a news conference on the steps of the Capitol today to criticize Governor Bennett's policies," the reporter said. "One of his main targets was a notorious arson–murder investigation centered in the Bay Area."

The report cut to a tape of the self-righteous Vogel, dressed in his trademark Central Valley cowboy hat, boots, and string tie, and surrounded by a sea of microphones. I'd always figured the assemblyman wore the hat to make himself look taller on camera, and I wondered whether he'd ever actually spent any time on a ranch or was simply play-acting at being a cowboy to garner votes from his farmland constituency. Judging by the streaming sunlight on the Capitol steps, the tape had been shot much earlier in the day.

"As of last night, five young mothers have been burned to death, murdered in their own homes around San Francisco Bay, and their babies have been stolen," Vogel said. "And what effort has the governor made to stop this obscene crime wave? *Affirmative action*, that's what! The one and only attempt Governor Bennett has made to apprehend brutal killers like this one is to appoint Susan Kim Delancey as her so-called 'arson czar.'" The diminutive assemblyman punched the air and spit out the last two words as though they'd put a sour taste in his mouth.

"I've been looking into these tragic deaths personally, and one of the police detectives working on it told me they might have caught the killer long ago if Arson Czar Delancey and her crew of incompetents hadn't been allowed to meddle in what should rightly be police business. The last two women, at the

very least, might still be alive if the governor had simply let the police do the job they've been trained to do.

"But no! Marinda Bennett has different priorities. She wants to make sure she employs enough minorities and women—regardless of their lack of qualifications for the job—to satisfy her special interests. Those same special interests that support her with large campaign contributions."

Vogel pointed a stubby finger at the camera like he was auditioning to pose for one of those old "Uncle Sam Wants You" posters. "And she's been using *your* tax dollars to do it," he concluded.

The camera switched back to the reporter standing on the now-deserted and dusky Capitol steps. "The governor was out of town today," he said, "and unavailable for comment. Now back to you in the studio." The shot switched back to the anchors, who segued into a summary of international news.

Trembling with rage, I switched off the set. I knew exactly which cop had given Vogel fuel for his latest sexist, racist diatribe. Hank Berry had wanted me off this case from day one, and it was obvious to me that he was becoming more hostile than ever.

After the display I'd just seen, I was sure I'd hear from Bart Waldron tomorrow. I picked up a potato and stabbed it with my paring knife half a dozen times, using it as a safe substitute for both Berry and Vogel, that pair of slimy, sexist, self-serving worms.

It wasn't enough that I had to catch a serial arson killer responsible for the deaths of five innocent women. I had to fight political and turf wars at the same time. And I had to do it with an office staff of exactly one and a half.

I slept fitfully that night. As I lay in the dark, I ricocheted between wondering if I'd still have a job by the time I got back to

the office and feeling guilty for worrying about something as meaningless as my own employment while five young mothers were dead.

I felt and looked haggard as I opened the office door the next morning and spotted the dark look on Ricky's face.

"Now what?" I asked, feeling a strong sense of dread. Was Governor Bennett folding under pressure and shutting down our office?

"Our firebug's been writing to the press again," Ricky said, handing me a copy of this morning's *Bay Crime Journal*. "Except this time his letter went to Lenny Palmer personally. None of the other papers seems to have it. Plus, as we might have predicted, Lenny's milking his personal communication from the killer for all it's worth."

I groaned as I scanned the front page story. Ricky was right. The letter contained more of the same sort of tirade against the victims as its predecessors had, along with the addition of a couple of lines praising the *Crime Journal*. In the killer's opinion, it was the only publication that understood his message and chose to give it proper public exposure.

Right. Undoubtedly the *Crime Journal's* earlier editorial attacking me had been a real feast for the murderer's warped ego. No surprise there.

Lenny Palmer began his bylined story with a few self-serving paragraphs claiming that his newspaper was meeting its responsibility to inform the public by providing the killer with a forum. Then he ran the letter in its entirety.

"Get Palmer on the phone," I said as I stomped into my office.

By the time I'd hung up my coat, Ricky's voice came through the intercom. "Lenny Palmer on line one."

I picked up the receiver. "So you'd rather have your shoddy fifteen minutes of fame than catch this vicious killer," I said

angrily. "Look, Lenny, I thought we agreed you wouldn't touch any more of the killer's messages without at least giving us a chance to fingerprint them first."

"I never agreed to anything even remotely like that," Lenny said. "Ever hear of the First Amendment? My responsibility is to my readers, not to the government. Besides, this guy is smart enough not to leave fingerprints on his letters. But you already know that."

"Everybody slips up sometime."

"You're just angry because you can't control the press," Lenny countered. "Hey, welcome to the good old U.S. of A."

I bristled, wondering if Palmer's last remark was intended to remind me I was foreign-born. Then I took a deep breath and told myself that taking this too personally, making it into a contest of personalities, wasn't going to help catch the killer.

"Look, Lenny," I said, forcing a conciliatory tone into my voice, "I understand about your responsibility as a journalist, really I do. But don't you have a little responsibility as a citizen, too? I'm not asking you not to print whatever you and your editors think is newsworthy. I'm simply asking you to help us catch this guy before more women die. That's not too much to expect, is it?"

"Tell you what, I'll think about it, okay? But it'll have to be later. Right now, I'm on deadline." He hung up the phone.

I sat at my desk and pressed my fingertips hard against my temples, trying to quiet the throbbing there. I could feel this thing quickly spinning out of control—not that I'd ever really had much control, of course. I knew I had to do something and I had to do it fast if I were ever to solve this series of crimes.

And I had to do it before anyone else died.

I reread the killer's letter to the *Crime Journal* for clues, but it seemed to hold nothing new, not a single word that would cause me to alter the psychological profile Sid Rhodes and I had

compiled. Yet an unwelcome thought kept invading my mind. This guy definitely knew a helluva lot about fire—the ways in which it started and how fast it would spread; how quickly flames and smoke could kill people and then destroy most or all of the evidence of a crime; the various ways in which arson would be investigated.

A firefighter, I thought once more. A firefighter would know all of this, plus he'd be physically strong enough to overpower those young women. Or maybe an aspiring firefighter, like the guy whose face Ricky had spotted in the crowd photos at the fire scenes. As much as I didn't want to believe a firefighter could be responsible for these horrible deaths, I knew we couldn't afford not to consider that possibility.

I quickly drafted a letter, marked it confidential, and asked Ricky to fax it to all the fire department brass in the Bay Area, along with a copy of our psychological profile of the killer. "Do you know anyone who fits this description?" I asked each of them, adding an impassioned plea that they take a particularly hard look at the firefighters now or previously working under their command.

As I heard the hum of the fax machine in the next office a few minutes later, I thought about the fact that my request was undoubtedly the last thing any of the fire commanders and chiefs would want to consider.

My already questionable popularity among the professionals of the local fire and police departments was about to take another major hit.

Chapter Eleven

"*GOING* to head back out to the Benavente fire scene," I told Ricky as I crossed the outer office wearing my coat. I wasn't really sure what I hoped to find there, but at least by going to the scene I'd be doing something. Plus, I wouldn't be in the office to take today's inevitable irate phone call from Bart Waldron.

"Might want to read this first," Ricky said, holding up a fax. "Just came in. Looks like this could be the break we've been waiting for."

I snatched away the two sheets of paper. The cover sheet bore the name and address of the Marin County police detective who was handling the investigation into the murder of Heidi Weill, the Sausalito military wife who'd been the second of the arsonist's victims.

It read, "I just received the following from Navy Ensign Stuart Keller, husband of Heidi Weill, in response to my question about whether his late wife had won any baby contests. Because Ensign Keller is currently stationed in the Persian Gulf,

all communication with him must take place by fax and/or e-mail."

I wondered how much time off the Navy had allowed poor Ensign Keller when he'd learned his wife had been murdered and his baby stolen. Whatever his bereavement leave had been, it obviously was over now.

I skimmed the ensign's letter quickly and breathed a sigh of relief at what I read. "All right!" In her last e-mail to him, Heidi Weill had indeed told her husband that she'd won a variety of things for their new baby and was expecting them to be delivered soon. My hunch finally had been confirmed by at least one of the other victims—both Maureen Benavente and Heidi Weill thought they'd won a legitimate baby contest.

"Figured that might make your day," Ricky said with a wry smile.

I had another thought. "Call the detectives and see if they can have somebody canvass their local furniture stores, find out if anyone's been buying baby cribs in quantity, will you?"

"Sure thing. I'll check out the Net, too, see if there's a source on-line our guy might be using."

"Good idea. When you're finished with that, see what sources are available locally for buying polyurethane foam, too." I reached for the doorknob. "And Ricky."

He glanced up from his Rolodex. "Yeah?"

"When Waldron calls, tell him we got a confirmation on the baby contest scam. With luck, that will pacify him for another day or two."

"Just in time," Chief Minelli told me as I walked past the sifting operation set up outside the house where Maureen Benavente lived and died, and entered its burned shell. "Come take a look at this." He was standing near the spot where the body had been found, a pencil and notebook in his hand.

I stepped gingerly around the numbered investigation grids, doing my best not to disturb any evidence that had not yet been examined and catalogued or moved outside for sifting. The acrid odor of burned wood and chemicals filled my nostrils and I tried to breathe through my mouth.

"See this?" The big man pointed at some ashes lying a foot or so from the spot where the dead woman had lain Wednesday night. Her body had been removed to the morgue for examination more than a day earlier, but I couldn't help still seeing her charred corpse in my mind's eye.

I squatted down, making sure the hem of my coat didn't come in contact with the fire debris. Intrigued, I examined the trail of ash the chief was indicating. "Cigarette," I observed.

"My conclusion, too," he replied.

"You thinking it was used to start the fire?"

"I checked with the neighbor, Mrs. Parr. She says the victim didn't smoke, and that Miss Benavente was adamant about not letting anyone else smoke in her house. Because of her baby and all."

I nodded. "Figured our guy had to be using something simple like this."

Many arsonists use cigarettes in various ways to start their fires. One device commonly used is made by simply wedging a lighted cigarette into a paper matchbook and placing the combination on top of something highly flammable, perhaps a pile of oily rags or some dry grass or even an ether-soaked rag atop a polyurethane sofa cushion. When the lighted portion of the cigarette burns down far enough to reach the matches in the matchbook, there's a burst of flame that ignites the flammable material, and the fire quickly accelerates.

"Truly excellent work, Chief," I told him, and was instantly rewarded with a broad smile. From the arson investigator's point of view, the major problem with this primitive sort of incendiary

device is identifying it conclusively. Typically, the telltale trail of cigarette ash ends up mingled with the rest of the soggy debris at the crime scene and we can never be certain exactly what started the fire. It takes a particularly meticulous examination of an arson crime scene, plus a good dose of luck, to discover this kind of clue. Chief Minelli and his crew had done a superbly professional job here.

"I also instructed my men to take a few samples from each grid in this part of the burn scene and put them aside for you," Minelli told me. "Otherwise, it'll be another day or two before we finish here, and our lab tests for accelerants could take a week or better."

"I'll take whatever you've got for me now, see if I can lean on my lab, at least get them to determine whether we've got ether present as fast as possible." I looked around at the small crew that continued to inspect the crime scene carefully and professionally, then turned back to the chief. "Turn up anything else you think might be significant?" I asked him.

He shook his head. "Not really, I'm afraid. This one burned hot, though, I can tell you that much. Look at that hunk of metal over there. Looks like steel to me, just eyeballing it. You can see the one end is partially melted. You need some pretty darned intense heat to do that."

I glanced at the misshapen form. "Looks like part of that crib Ms. Benavente supposedly won," I said. I told the chief what I'd learned about the phony baby contests, adding, "I'm pretty sure that's how the murderer's gaining access to these houses. His victims are expecting delivery of their prizes, so they're primed to let him in when he shows up at their doors."

He rubbed his chin. "Makes sense, but there's one thing that doesn't fit. Why bother to haul a crib into the house? A crib's gonna be big and bulky, and it certainly can't be cheap. Hell, these girls would probably let the guy in if all he showed up

carrying was a couple of packages of disposable diapers. They'd think the crib and the rest of their prizes were in his van or truck or whatever he drives up in. I mean, hell, all he needs is for the girl to open her door so he can come in and do his thing with the ether, right?"

"Right, Chief. So there has to be another reason for the cribs. Maybe he's simply making sure the women let him in willingly, sort of covering his bets. But I suspect there's more to it than that. Could be that cribs somehow work into his psychological compulsion, his sexually driven urge to kill young mothers by burning them to death. But I'm wondering if the cribs don't serve another purpose as well—if they don't also provide the initial fuel load that makes his fires burn so hot."

"You mean the wood they're made of?" His brow furrowed. "It wouldn't catch all that easy."

"No, I'm thinking the mattresses."

The chief looked even more doubtful. "Don't know about that. Crib mattresses are required to have fire-resistant covers nowadays, just like kids' pajamas."

I nodded. "But what if he's not using typical manufactured mattresses?" I suggested. I had a half-formed theory of my own, that the arsonist was making these mattresses himself, from some sort of highly flammable material, probably polyurethane foam. That was why I'd asked Ricky to check out retail sources for that product.

Polyurethane, in combination with ether and a cigarette-based incendiary device, could result in an extremely hot fire within just a few minutes after the killer grabbed his victim's baby and fled from her house. Long before she could possibly wake up from her drugged state and escape, the young mother would be engulfed in flames. And within a matter of minutes, the fire would reach flashover, destroying virtually any evidence the murderer had left behind, including the fact that the charred

crib in the living room had come with a bogus mattress designed to make the fire spread more quickly.

I spent another half hour at the fire scene watching the sifting process. Then I took the sample bags Chief Minelli had set aside for me and headed across town to Hannah Goldman's lab.

"There are definite signs of ether in the ashes collected from where your corpse was found," Hannah reported, after she'd done her tests and we'd downed our habitual cup of tea. She'd also pressed me to try one of the double fudge brownies she'd brought from home that morning. I rationalized that a brownie could easily substitute for the lunch I hadn't eaten, and wolfed down the whole thing. I wonder if it's true that chocolate lifts your mood. Or maybe it was just being with a trusted old friend, but I began to feel a bit more hopeful about the case as I hung around Hannah's lab while she tested my samples.

"My money says this is the same guy who murdered the other women," she announced, perching precariously on a flimsy-looking stool I'd have guessed would never support her weight. She stared at her computer screen as we talked, obviously unconcerned that her stool might collapse and throw her to the floor. "Same exact MO."

I peered over Hannah's shoulder at the screen. "Considering the metals we found at the crime scenes and the melt patterns," I asked, "what can you tell me about the maximum temperatures these fires reached?"

"Tell me again. What have you got?" The tent dress Hannah was wearing today was brilliant orange—she'd always made big statements with her choice of wardrobe.

"Crib supports that were partially melted, probably made of some kind of steel," I told her. "We found those at all of the fires. Then there was a copper alloy hair ornament, twisted and partially melted, from the Ginger Smith fire. We found a surgical

steel earring hook at that one, too, but that was just blackened, not melted." I added several more examples as I recalled them.

Hannah pressed a few keys on her keyboard and a list of common metals and their corresponding melting temperatures popped up on the screen. "Pure copper melts at just under two thousand degrees," she said, "steel at a few degrees over twenty-six hundred." She turned and looked at me. "You've got yourself an extremely hot fire in all of these cases, but maybe not for all that long a period of time."

I bit my lower lip. "Go on."

"You know as well as I do, Susan, that some of the metal items you're describing would have ended up as molten blobs if the fire had gone on for, say, an hour or more at those temperatures, and I don't think the fuel load was adequate for that. Besides, your autopsy reports indicate only partial incineration of the bodies, right?"

"Right," I said. "Refresh my memory. What's it take to cremate a body? You know, an average-size adult."

This time she didn't need to check her computer. "Funeral homes figure sixteen to eighteen hundred degrees for an hour to an hour and a half. And you still end up with two or three pounds of ash and bone fragments we can easily ID as human remains. You have at least that kind of temperature here, based on the damage to your metals, but obviously not for long enough periods to completely cremate your victims. Remember, too, your metals show different kinds of damage depending on where in the houses they were located."

"The closer to the body, the more damage," I said.

"Generally speaking, yes. Except for that earring hook. Did you say it was found on the victim?"

I searched my memory. "I think it was found underneath the corpse—the ears were consumed in the fire, of course. I'll check, but I don't think we found a second earring."

"Could be that the victim was wearing only one. Or, more likely, if she was lying on her side, her body protected the one you found while its mate melted and got mixed into the discarded ash."

I'd already figured out much of this myself, but it didn't hurt to hear someone I respect validating my conclusions. As Hannah talked, my mind started down another path, one I probably should have considered well before now but hadn't really wanted to think about. "What's your best guess about how long these fires burned?" I asked Hannah, as I did a few mental calculations of my own.

"Probably not more than half an hour, forty minutes, at top temperatures. Maybe not that long, depending on your fuel load."

"Thanks. You're a gem for handling this so fast, Hannah, and your brownies were great, too." She beamed at me. Hannah Goldman is almost as proud of her cooking skills as she is of her precise lab work. "Gotta get back to the office," I told her, "find something in my files."

"We aim to please," Hannah said. "Whatever I can do to help you get this bastard off the street, just ask." She climbed off her stool and accompanied me to the door. "Hey, Susan," she said as she ushered me out, "keep your chin up, okay? We'll manage to get this murderer long before the good assemblyman from Modesto can cost you your job."

"From your lips to God's ears," I replied, borrowing one of Hannah's favorite phrases. I sure hoped she was right.

I saw the Channel 3 news van parked outside my office as I pulled up. *Damn!* Was there no getting away from these reporters? I considered not going inside until after the news crew had left, but decided it wouldn't be fair to Ricky to make him deal with them alone. Besides, I wasn't about to lose any more valuable working time simply because of the news media.

Lauren Meyers and her crew were crowded around Ricky's

desk as I entered the office. "Ms. Delancey, thank goodness. You got back just in time," she said. The tall brunette glanced at her Rolex disapprovingly, then looked up with her heavily made-up eyes and flashed me her trademark plastic smile. The odor of perfume was so cloying in the air of the tiny cubicle that I almost gagged. "We're doing a piece on the Baby Snatcher Murders for tonight's broadcast," she said, "and I felt obligated to give you a chance to take part."

Sure, like she was doing me a real big favor by showing up here with her crew without an appointment. "Sorry, Lauren," I told her, waving my hand in front of my face as I tried to fan away the stench. "I really haven't got the time to give you an interview right now."

"But I'm sure you want to respond to—"

"I'll let you know when I hold my next briefing for *all* of the media, Lauren. You know I never play favorites." I pushed my way though the crowded area and went into my private office, closing the door behind me. The odor of the reporter's perfume had permeated the air even in here.

As I turned the knob, I clearly heard Lauren Meyers say, "What a bitch! She's going to be sorry she did that."

If not dancing to Lauren Meyers's tune made me a bitch, I figured, so be it. I opened the window a crack for some fresh air and spent the next hour going over my lists of items catalogued from the debris at all five fire scenes. I found what I was looking for deep in the file on Betsy Cavendish's murder.

I picked up the phone and dialed Dr. Helen Chafos, the woman who'd been Cavendish's obstetrician. The doctor actually took my call. I wish my own OB-GYN would respond that quickly when I call her. Now, however, I was calling as a representative of the governor, not as a patient. I guess that carries a whole lot more clout in today's medical world.

I had just one question for Dr. Chafos. She promised to check

her records and call me back as soon as she could. Things were continuing to fall together, but before I could know for certain, I'd need to hear back from Dr. Chafos. I'd also need to retrieve another piece of evidence and have Hannah run an entirely new battery of tests.

I opened my office door, relieved to see no one left in the outer office except Ricky.

"That Meyers woman claims you're going to be real sorry you dissed her," he told me, looking up from his paperwork.

"I heard her. But what can she do besides make me look bad on TV, and she's already managed that more than once. I don't think I need to help her trash my reputation."

"You don't think you ought to use whatever forum you can get to counteract Paul Vogel's venom? That was a pretty nasty swipe he took at you yesterday, boss. Plus, Bart Waldron is definitely in a pretty snit about it."

"Waldron's always in a snit about something."

"Still," Ricky said, arching one eyebrow, "this job is definitely a large part politics, whether we like it or not."

I sighed. If even Ricky thought I was playing the media wrong, I probably was. "Tell you what," I said, "we'll hold a press conference on Monday, invite the whole bunch. With luck, we might even have something concrete to announce by then. And, even if we don't, I'll give a rousing stump speech, or as close to one as I can manage."

"Seems to be a necessity if we don't want our jobs to be the next thing to go up in flames around here."

"Ricky, please," I said, thinking of the five charred corpses. "That's pretty sick."

"Just a little fireman humor." He gathered up his papers and slid them into his desk drawer. "Afraid I've gotta leave on time today," he told me. "Zeb and I promised to baby-sit for some friends and we have to be there by seven."

I thought about asking him whether they'd be caring for the same baby Max had mentioned, then thought better of it. Ricky's personal life and my own were already becoming a bit too intertwined for comfort, what with Max and his band making the guest house into their studio.

"Have a good weekend," I told him. "I'll be out of here myself in fifteen minutes." Suddenly I was exhausted. It was Friday night, but I knew I'd be working most of the weekend.

"Better get home in time to check out that Channel Three newscast," Ricky reminded me as he headed out the door. "See what kinda fires we're gonna have to put out around here on Monday."

I made a face at him.

He held up his hands in mock self-protection. "Hey, chill. Just some more lame fireman humor, Susan."

When I got back to the condo, I found a note from Max on the kitchen table, propped against the salt and pepper shakers. He and his cronies had gone back to Ricky's house, this time to soundproof the studio by nailing the old mattresses against its walls. He promised to be home for dinner no later than seven.

He had the whole weekend to do his homework, I reassured myself. I'd be hard-pressed to toss together a decent dinner by seven o'clock anyway.

I opened the refrigerator and peered inside. The only thing that looked the least bit interesting to me right now was an open bottle of Chardonnay. I took it out, poured myself a glass, then checked the freezer.

I was in luck. There was a frozen cheese pizza. Baked with enough sliced mushrooms and artichoke hearts on top, and accompanied by a fruit salad, it might actually pass for a balanced meal.

At six o'clock, I took my glass of wine, and with a strong feel-

ing of trepidation, plopped myself down in front of the TV and turned on Channel 3.

The carnage to my department's reputation turned out to be worse than I'd feared. Lauren Meyers's report on the so-called Baby Snatcher Murders was the lead local story. She'd interviewed Lenny Palmer, who seemed inordinately proud of his status as the sole reporter with whom the supposed murderer was now communicating. Palmer's already broad chest seemed even more puffed out than usual. Or maybe it was just that he was wearing a bulky tweed sport coat over the turtleneck shirt and jeans that seemed to serve as his uniform. He'd apparently made some effort, however minor, to dress up for his TV appearance.

"What about the authorities' criticism that your printing his letters gives this vicious murderer a platform for his warped religious and sexual views?" Meyers asked. "That you're helping him torment all the other single mothers in the Bay Area who are completely terrified of becoming his next victim?" Leave it to her to heighten the fear factor with her tabloid style of questioning.

"The *Crime Journal* strongly believes in the public's right to know," Palmer replied self-righteously. "We're simply upholding the United States Constitution and the Bill of Rights, those most cherished of American ideals."

Right, by printing the latest anonymous letter verbatim on the front page. How did Lenny Palmer even know whether that letter was from the real killer or just some copycat nut job trying to cash in on the case's notoriety? To hear him tell it, though, he was single-handedly upholding every citizen's civil rights. In fact, he quickly added, "I'd be willing to go to jail for contempt of court before I'd give up my right to publish whatever news the *Crime Journal* thinks the public needs to know."

Oh, please. I sighed loudly. At no point had anybody ever

suggested Lenny Palmer be jailed for printing that letter. Talk about self-aggrandizement. Now he was trying to paint himself as some sort of journalistic martyr.

After she'd finished burnishing Lenny Palmer's reputation, Lauren Meyers used an interview clip of Assemblyman Vogel, speaking from his Sacramento office. I had to give Lauren credit. As obnoxious as I found her to be, she clearly was a hard worker—she'd managed to get her butt and her crew all the way to the state capital and back again since last night's broadcast. No wonder it had been so near the end of the day before she and her men invaded my office.

Vogel sat behind his massive desk, looking smaller than he had yesterday, when he'd stood in his cowboy boots on the Capitol steps. He couldn't wear his ten-gallon hat indoors, either, which detracted further from the he-man image he'd so carefully tried to project at his earlier press conference. His choice of words, however, was equally stilettolike.

"This kind of clear misjudgment by Marinda Bennett—" I noticed Vogel wasn't even giving my boss the courtesy of referring to her as *Governor* Bennett "—is precisely why she will be defeated in the next election. Californians won't stand for their tax dollars being spent to employ thousands of inept minority workers while violent crime is allowed to escalate all around them. And there's no better example of Marinda's misdirection than her unforgivable mishandling of this Baby Snatcher Murder rampage in the Bay Area...."

I was starting to get a tension headache when the report cut to a second Sacramento interview. I straightened up in my seat and stared intently as Bart Waldron's face came on the screen.

"Paul Vogel is simply trying to run for governor," Waldron said in response to a question from Meyers. He was sitting in his own mahogany-lined office, a rather more opulent one than Vogel's. "The assemblyman is pandering to the lowest instincts

of his right wing—blatant racism and sexism—and he's using the deaths of these unfortunate young women to do it."

"But what about Assemblyman Vogel's charge that, if it weren't for Arson Czar Susan Kim Delancey and her staff, this murderer would have been behind bars long ago, that two of these women might well still be alive?"

The camera shifted from a two-shot including Meyers to a close-up of Waldron's face. "That's sheer nonsense, nothing but grandstanding," he said. "Vogel doesn't have a clue about the tremendous progress Arson Czar Delancey and her staff have made toward solving this case. Fact is, he doesn't care. He simply wants a convenient scapegoat to use to discredit the governor. And he's chosen Ms. Delancey and her staff to play that unenviable role."

"Way to go, Bart!" I said out loud, lifting my glass in a toast to the TV screen. But the smile on my face quickly died.

"You may well say that," Lauren taunted him, "but we now have five dead women and five stolen babies. This week, as you know, the pattern escalated further, with still another young mother dying on Wednesday night. All the other women were killed on Saturday nights. Yet I don't hear you giving us even one concrete example of this so-called progress Delancey's department has made toward arresting the man who did it."

Bart Waldron leaned forward in his chair and pointed his finger at the reporter. "All the governor's appointees are hard workers, the best," he said, now sounding both angry and defensive. "Susan Kim Delancey is making very serious strides toward getting this guy off the streets."

"Exactly what kind of strides?"

My grip on my wineglass tightened and I held my breath as Waldron glowered into the camera. "All right, I'll give you one good example. Arson Czar Delancey has discovered that the murderer's been using a bogus baby contest scheme. He

convinces his victims that they've won a lot of prizes. That way, they willingly let him into their houses when he shows up there, posing as a deliveryman," he said.

"Damn!"

In the next twenty seconds, Bart Waldron managed to inform Channel 3's television audience—and I had to assume the killer as well—all about my theory.

I knew in my gut that the next time the murderer tried to set up a victim, he'd no longer use that baby contest scheme. He was far too smart for that. No, he'd devise a completely new way to lure and trap some unsuspecting young mother.

All my efforts to prevent another tragedy from happening had just been catapulted back to square one.

Chapter Twelve

FURIOUS, I reached for the phone and quickly punched in Bart Waldron's number in Sacramento. How could he have been so incredibly stupid?

The phone rang four times before Waldron's voice mail answered. I looked at my watch. It was well after six. Of course—by now he'd have gone home for the weekend, and I didn't know his home number. I didn't bother leaving a message.

Feeling devastated and betrayed, I slumped into a chair, leaned forward, my elbows on my knees, and held my throbbing head in my hands.

That didn't help all that much. I had a strong need to vent, to talk to somebody who'd take my side, somebody who'd tell me that, despite what seemed to be increasing evidence to the contrary, I really was doing a good job. It was just that I was up against nearly insurmountable odds, being sabotaged at every turn. I picked up the phone again and dialed Todd's number. If I got lucky, he might be home from the hospital by now. If

I got really, really lucky, he might actually be free for the evening and we could do something more than just talk on the telephone.

"Hello."

I was caught completely off guard when a woman answered. Had I dialed the wrong number? "Uh—may I speak to Todd, please?"

"Who's calling?"

What business was it of hers, I thought, quickly directing the hostility I was feeling in a new direction. Still, I answered, "Susan Delancey."

"Oh." Long pause. "Well, Todd's showering right now, Ms. Delancey, so he can't come to the phone. I'll sure tell him you called, though." Maybe I was wrong, but I thought this woman, whoever she was, sounded extremely smug.

I was in no mood for smug. "Don't bother," I snapped at her. "I'll call him some other time." I hung up.

Was there nobody I could count on anymore? I wasn't stupid. I knew Todd wouldn't be taking a shower if the woman who'd just answered his phone was simply his cleaning help or a neighbor. The fact that he wasn't taking his shower *with her* didn't really console me. Obviously, I could see, he'd gone out and found someone to replace me.

I dragged myself into the kitchen and refilled my glass of wine, then began to slice mushrooms to put on top of the frozen pizza, chopping through each of the small brown fungi a bit harder than necessary. The sharp *bang-bang-bang* as the knife blade struck the chopping board matched my mood.

Todd's finding another woman was probably my fault, I'd decided by the time I accumulated a mound of mushroom slices. I grabbed the can opener, opened a can of artichoke hearts, and began to chop them. I had to admit, Todd and I hardly ever saw each other lately, not since I'd taken this job as so-called arson

czar. He had to be lonely, just as I was. Could I really blame him for meeting somebody else, some woman whose work schedule conformed better to his, assuming she even had a work schedule? A pretty nurse from his hospital, maybe. She was probably a lot younger, too.

Still, I couldn't help being hurt and angry. If Todd were going to dump me, at least he should have had the class to tell me to my face. Why did I have to find out this way?

That was probably my fault, too, I decided in the end. Maybe I was too intimidating. (I'm pretty darned good at self-flagellating, in fact I've elevated it nearly to an art form.) Obviously, I'd put my trust in the wrong person one more time. If only I'd been attracted to some nice, steady Asian man instead of all these Northern European types with fatal personality flaws, I told myself, I wouldn't keep getting hurt this way.

I was alone again, and I was absolutely convinced it was my own damned fault.

I kept myself busy over the weekend. In part, that was an effort to avoid thinking about Todd's betrayal, but I'd like to think my more important motivation was to make sure I hadn't overlooked a single thing that might help catch the killer...despite Bart Waldron's loose lips.

I tried to put myself in the arsonist's place, to think the way he did. If my main method of snaring my prey had just been taken away, how would I fulfill my growing needs? What new scheme would I invent to lure my victims? I came up dry.

I touched base once more with the police and fire officials assigned to each of the five murders. I revisited the burn sites where Ginger Smith and Maureen Benavente had died. I went into the office and read through all my files one more time. And I located a piece of evidence from one of the sifting operations that I thought might be of some importance. So I called Hannah

Goldman at home and harangued her until she agreed to come into the lab and examine it.

I hardly slept at all Saturday night, waiting for the phone on my bedside table to ring. I was hoping for a call from Todd, of course, to hear him tell me I'd somehow misinterpreted the fact that another woman was now answering his phone, or else that he'd made a terrible mistake with her and he was madly in love with me after all. At the same time, I was terrified of getting a call from one of the local fire or police departments, telling me that yet another young mother had been burned to death.

But my phone remained silent.

Max spent most of the weekend with his band members, hauling mattresses and furniture, getting their sound studio in shape. So at least I didn't have to worry about neglecting my son. He wasn't home to be neglected.

We'd just sat down to dinner on Sunday night when the phone finally rang.

"Got it," Max said, pushing back his chair and bolting toward the kitchen. Where he got all that energy after spending the last few days doing little but physical labor was beyond me. Most of what I'd done all weekend was mental work, and I was so tired it was all I could do to lift a forkful of steamed salmon to my lips.

Max came back from the kitchen, the portable phone in his hand and a disappointed look on his young face. "It's for you, Mom, some dude named Hoffman."

Chief Hoffman of the San Vicente Fire Department. My heart sank as I reached for the phone. Please don't let it be another dead mother, I prayed.

I quickly choked down the mouthful of salmon I'd been eating. "Chief Hoffman, hello."

We exchanged brief pleasantries, during which I lied and reassured the chief that he hadn't interrupted my dinner.

"Called to follow up about that Ellison fella," he told me.

"Ellison? Who's that?"

"Berry didn't tell you about him?"

I stiffened. "Berry didn't tell me about anything," I said, feeling my energy returning in the form of irritation. What was this about?

"Afraid of that. Had a hunch I should call you myself, but Berry insisted he'd take care of it, and my wife had her heart set on driving up to Bodega Bay this afternoon, doing some antique shop—"

"Maybe you'd better start at the beginning, Chief."

"Sure, sure. Probably turn out to be nothing, but I finally remembered that fella's name, that fella in the photo you sent me."

"The man who was at the fires? The one you interviewed for a job?"

"Right. Popped into my head in the middle of the night, a few hours after you and I talked yesterday. Went down to the station this morning and picked his file out of the bunch. Guy's name is Louis Ellison, lives in San Jose. I told Berry about it first thing, and he promised to call you, let you know. Should've called you myself, I guess, but my wife—"

"It's okay, Chief, really," I said, fighting to keep the anger I was feeling out of my voice. "You've let me know now."

"Anyhow, when I heard Berry was bringing him in for questioning and you weren't involved, I figured maybe something funny was going on."

"Berry brought this Louis Ellison in for questioning?"

"Yeah, he's got him at the station now. I'm on my way over there to make the ID, confirm it's the same guy I interviewed."

"Now."

"Right. Soon as I make the ID, they'll start questioning him."

I took a deep breath and glanced at the dinner growing cold on my plate. "Do me a favor, Chief?"

"What's that?"

"Stall a while, give me time to get down to San Vicente before that interrogation gets underway. The governor definitely will not be happy if I'm not there."

"Sure. Give you half an hour. That enough?"

"I'm leaving right now."

"Just one thing."

"What's that?" I asked.

"This stays our secret—the fact I told you, and my taking my time getting over there. After this is over, I still gotta work with Detective Berry."

As I sped south toward San Vicente on Highway 101, I switched on the car radio and tuned it to the local all-news station. The first item after the traffic report definitely did not improve my mood.

"This just in—an important break in the Baby Snatcher Murders appears imminent," the anchor said. "At this hour, police in San Vicente are questioning a San Jose man who reportedly was seen hanging around all five arson–murder scenes. Sources say the man is the leading suspect in the deaths of five young Bay Area mothers and the kidnapping of their babies over the past several weeks. The detainee, whose name has not yet been released, is expected to be under arrest within the hour. He is reported to be an aspiring firefighter who applied for work with several of the municipalities where the murders took place, but was never hired. Police say revenge is a possible motive. We're dispatching a reporter to San Vicente and we'll keep our listeners posted as details of this breaking news story unfold."

Swell. So the news media knew about Louis Ellison almost as quickly as I did. I gripped the steering wheel until my knuckles turned white, wishing it were Detective Hank Berry's double-crossing neck.

I pulled into the lot behind the San Vicente PD and parked. I spotted at least three news vans at the red curb near the back

door, plus a crowd of reporters milling about, apparently waiting for confirmation that the Baby Snatcher Murderer finally had been apprehended.

I braced myself and headed for the door.

One of the TV reporters blocked my path and shoved a microphone into my face. "Ms. Delancey, is it true the murderer's finally been arrested?"

"Too early to know that," I said, elbowing my way past him.

"Too early to know if an arrest's been made, or too early to know if this is the real murderer?" another voice asked. I turned and recognized Cheryl Peach, her reporter's notebook and pencil in hand.

"Both, Cheryl," I said and kept walking.

"Is the name of the man who's been arrested Louis Ellison?" This time the question was Lenny Palmer's.

How did these jackals find out these things so quickly? "I can't comment on that."

"Is it true Louis Ellison was seen at all five fires?" asked Lauren Meyers, who sounded slightly out of breath. She'd just leapt out of Channel 3's van and sprinted into the crowd. She was perfectly put together for the camera, even though she didn't normally work weekend shifts. Either she wore her TV makeup all the time, I figured, or she'd applied it as fast as I'd managed to do no more than comb my hair.

"Look," I said, turning to the group as I grabbed the door handle and pulled the door open, "this man hasn't even been questioned yet. There might be a perfectly reasonable explanation for his being where he was, something completely unconnected to the murders. You'll just have to wait until we know a whole lot more than we do right now. When we do, we'll tell you."

I escaped into the interior of the police station and yanked the door shut behind me. The last thing I wanted this to turn into was a Richard Jewell–type media lynching of an innocent man.

✿ ✿ ✿

"Look, I've always wanted to be a firefighter, ever since I was a kid. Is that some kind of crime?" Louis Ellison sat in the interrogation room, across the table from Hank Berry, as I observed them through the two-way mirror.

Ellison was a large man. I recognized his prominent nose and the Z-shaped scar that bisected his right eyebrow from the crowd photos Ricky had shown me. Ellison's hair was a bit longer now, but this was obviously the same man. Tonight he wore jeans, a Giants sweatshirt, and a pair of dirty white athletic shoes. He sat leaning back in his chair, his burly arms folded across his chest in a posture that seemed both self-protective and defiant.

"You can help yourself here, Louis," Berry told him in what he probably thought was a friendly, confidential voice. It sounded oily to me, however, like the classic used car salesman's pitch. "Nobody's gonna believe you just happened by all those fires. You 'fess up, son, tell us what you did with those women's babies, I'll do what I can to help you cut a deal, save your life. Otherwise—" Berry shook his head in feigned pity. "Otherwise, California's a death penalty state, and you and I both know this one's gonna be prosecuted to the fullest."

"Like I told you before, Officer—"

"Detective." Berry bristled visibly.

If this weren't such a deadly serious matter, I might have smiled at the put-down.

"Like I told you before," Ellison said, "the reason I went to those fires was to watch the fire crews work, see what I could learn by observing them. Figured the more I know about fighting fires, the better my chances of getting hired on with one of the departments."

"And you actually expect us to believe that the fires you chose to watch just happened to be the ones where these five

young mothers died, the ones where their newborn babies were stolen?" Berry's voice and demeanor dripped with sarcasm.

Ellison closed his eyes briefly, sighing in obvious frustration. "Look, it was not just those fires. I go to *all* the fires, or at least as many as I can. Hell, last night I went to that high-rise fire over in Oakland, the one near Jack London Square."

Berry scratched his head. Perhaps he was considering whether he might be able to charge Ellison with more than just five homicides and five kidnappings. Maybe he could get him for the high-rise fire, too.

I, on the other hand, found what Ellison was saying to ring pretty true. Like many young men who end up working as firefighters, he obviously was fascinated by fire, probably had been since boyhood. The question was whether he'd crossed the line and become an arsonist, or was simply a decent guy who wanted a career helping people and property escape the element that so captivated his attention.

"Tell me again how you knew about these fires almost before the fire departments did," Berry demanded of the younger man.

"I have a police scanner. I listen to it all the time. For God's sake, you can buy one yourself at Radio Shack."

"About this contest thing, how did you work that?" Berry asked, as though Ellison's last answer hadn't been logical.

Ellison uncrossed his arms and leaned forward, palms flat on the table and shoulders hunched. "I think I've answered enough of your stupid questions. I want a lawyer."

"Sure, if you want. That's your right, but it's really not going to help you," Berry told him, switching back to his paternal demeanor. "Once lawyers get involved, son, it's gonna be a whole lot harder to cut yourself a deal on this thing."

"I want a lawyer *now*. I've answered every one of your damn questions and you don't listen to anything I say. Either let me go home or I want a lawyer."

Berry stole a glance at the two-way mirror with what looked a lot like regret. I couldn't help wondering what he might have done if he hadn't known witnesses were standing there, watching his interrogation.

The detective pushed back his chair and rose to his feet. He sneered at Ellison and asked, "You got your own lawyer or are we gonna have to find you a public defender?"

I had to drag myself to the breakfast table the next morning. After working all weekend, plus the Sunday night session at the San Vicente Police Department, I felt like I hadn't slept in a week.

To my surprise, Max was already up. Usually, like most teenage boys, he practically had to be dragged out of bed, particularly on school days. His backpack was already standing ready by the front door, as was his electronic keyboard. I found him in the kitchen, scarfing down a serving-bowl-size portion of granola.

"How come you're up so early?" I asked.

He wiped a dribble of milk off his chin and grinned. "Gotta drop my stuff off at Dad's before school. We guys need to get over to Ricky and Zeb's soon as school's out, put in some rehearsal time before our big audition tonight."

"Audition? What audition?" Clearly I'd missed something.

"The coolest thing, Mom. This dude called last night, he's a talent agent. One of Zeb's buds. Said he heard about Pacific Rim and he wants to hear us play. If he likes the band, he's gonna book us into some paying gigs—wedding receptions, graduation parties, stuff like that. Get us a real start in the business." Max shoveled two more spoonfuls of cereal into his mouth before pausing to chew. "Maybe he can get us a recording deal," he mumbled, his mouth full.

"Has Zeb ever even heard you play?" I asked, feeling like the proverbial wet blanket. Suddenly chilled, I pulled my bathrobe tighter around my body.

"On tape," Max said through his breakfast. "Played a couple of our tunes for him and Ricky the other day. Guess he must've liked our sound."

"Apparently so, if he recommended you guys to his friend." I felt suddenly overwhelmed by very intense, very mixed feelings. I was happy to see my son happy, of course. Playing with his band was clearly what Max wanted to do, and that certainly meant progressing to performing before an audience...eventually. Yet what had, until now, seemed merely a distant dream, a harmless hobby, suddenly threatened to overwhelm his young life. If Pacific Rim really began to get bookings, when would Max study? Would his schoolwork start slipping? Would he forgo college for what might well be momentary success in a terrifically cutthroat business? I definitely didn't want my only son growing up too fast, making a mistake that could affect the rest of his life.

Fighting a growing feeling of panic, I reached for the coffeepot and forced myself to calm down. It was far too early to jump to any conclusions. I couldn't be thinking clearly—I hadn't even had my morning jolt of caffeine yet. Chances were, this talent agent was simply doing Zeb a favor by agreeing to listen to the boys play, right? He probably had no real intention of ever booking them for any gigs. After all, the last time I'd heard Pacific Rim play, the band definitely didn't sound ready for prime time. On the other hand, what parents ever understand their kids' taste in music? Maybe the band really was good and my taste in music was simply uncool by today's standards.

Max pushed his cereal bowl aside and reached for his glass of orange juice. "You don't look very happy for us, Mom," he said, staring at me.

I sometimes think kids are born with built-in radar that allows them to read their parents' moods in an instant. Or maybe it's just my kid. "It's not that I'm not happy for you, Max," I protested. "I'm worried about your keeping this band thing in

perspective, not letting it affect your studies. I just don't want it taking over your whole life." A lock of thick, straight brown hair fell over his left eye. I suppressed a strong urge to push it back into place, the way I'd done a million times when he was little.

"Hey, I'm cool with that." He didn't look cool. He looked like someone who thought he'd just won the lottery and was about to go on a spending spree with his sole charge card.

"Have you told your dad you're doing this audition tonight?" I asked. "This is Monday, remember." Max's school-year schedule required that he move back to his father's house after school today.

He drained his orange juice before answering. "I kinda thought you could do that, you know, explain how much this means to me and the band and all." He avoided eye contact.

"You thought what?" I reached for a cup and saucer.

"Ah, Mom, you know how Dad gets, all judgmental and stuffy-like. He's probably not even gonna like it that we got our own studio now."

I stopped pouring my coffee and turned to look at him. "You haven't told your dad about the studio?"

Max looked down. "Hey, we've only been working on it a few days. I figured.... I—I mean, let's face it, it's not like Dad's ever gonna understand me like you do, Mom."

I knew blatant flattery when I heard it. "Nice try, Max, but this is your problem. You work it out with your dad. I know he can be a bit stern sometimes, but he's not unreasonable. Don't forget, he was young once, too."

Max mumbled something under his breath. I think it was, "No way."

"Tell you what. You talk to your father about the studio and the audition. If he gives you any flak about it, call me and I'll try to talk to him. But I'm not going to be first to tell him about this. That's your job."

"Okay, whatever." Max carried his dishes to the sink.

"You boys did finish soundproofing the studio, didn't you?"

"Almost."

"*Almost?* Well, you'd better finish before you start practicing. You don't want Ricky and Zeb angry with you."

"They won't be. They're not home tonight, anyway. Got some kinda AIDS project or something."

"Even if they're not home, Max, they've got neighbors. You know that."

He made a beeline for the front door. "Sure, Mom, whatever. We'll take care of it." He slid his arms into his backpack straps and picked up the keyboard case. "Gotta split if I'm gonna make the early bus."

I leaned over to give him a hug and he actually hugged me back with his free arm, very briefly and teenage-boylike.

"Good luck, sweetie," I said, as Max bolted out the door.

Four reporters were camped outside the door when I arrived at the office a few minutes before Ricky and Connie got to work.

"Is it true that an arrest warrant has been issued for Louis Ellison?" Bruce Link asked me, holding up his tape recorder.

"Not as far as I know," I told the radio reporter, truthfully.

Ellison's public defender had managed to secure his release last night. The last I'd heard, the only evidence against the man was the fact he'd been present at the fire scenes—we had photos showing him at four out of the five. But then, I'd been there, too. That didn't mean I'd murdered anybody, and it certainly wasn't proof Ellison had either, at least not proof that would hold up in a court of law. We would need much, much more to make a case that would stick. As of last night, the cops hadn't had anywhere near enough to hold the aspiring firefighter. Yet I knew they would dissect every part of the young man's life just as fast as they could, searching for anything, however minor, that could tie

him to these killings. Had they already managed to find something I didn't yet know about?

"The police are investigating a number of leads," I said. "We'll put out a news release, let you all know, as soon as we arrest anybody, whether it's Louis Ellison or anybody else."

"I talked with the governor's office a few minutes ago," the reporter from the *Courier* said. "Bart Waldron tells me an arrest in the Baby Snatcher Murders case is imminent. He strongly hinted that a warrant's about to be issued for Ellison's arrest. He's not forcing you out of the loop on this one, is he?"

I bristled. "If you're getting your information direct from the governor's office, you certainly don't need me," I told him. I quickly unlocked the office door, stepped inside, and pushed the door shut again. I set my purse and briefcase down on Ricky's desk and leaned my back against the door, fuming. If he didn't watch his words, Bart Waldron was going to dismantle everything I'd spent the past several weeks building. Both he and Detective Berry were undermining me, if for apparently different reasons. As a result, the press was beginning to believe I wasn't in charge of my own department, my own investigation.

Most of the rest of the day went the same way, as I fielded at least fifteen phone calls from news media around the area. From my discussions with reporters and local radio reports, I quickly learned that a pack of journalists from as far away as Los Angeles was now camped outside Louis Ellison's house, taunting him to come out and make a statement. But the blinds on the small San Jose bungalow he shared with his elderly mother remained drawn and the doors locked.

If the guy really wasn't guilty, I thought, this was a fine thank you for his many attempts to get a job with a fire department, a job that would require him to risk his life to save other people on a daily basis. On the other hand, if he were guilty, the reporters might be doing new Bay Area mothers a big favor by keeping

Ellison pinned inside his house. If he couldn't even leave home to buy a bottle of milk without half a dozen reporters on his tail, he certainly wasn't going to be able to kill any more young women.

Assuming, of course, that Ellison was actually inside the little house that had become the subject of such media scrutiny. For all I knew, he'd fled the area as soon as his attorney escorted him out of the San Vicente Police Station. Or maybe he was hiding from the media at a friend's house or in some local motel.

By four-thirty, Connie had gone home to care for her grandchildren, and as I refilled my teacup in the outer office, I could see that Ricky was winding up some research on the computer.

"Did Dr. Chafos call yet?" I asked him. I'd been stuck at my desk on the phone nonstop for the past two hours, and was hoping I'd simply missed the call that would give me the information I needed from Betsy Cavendish's medical file.

"'Fraid not. Lauren Meyers called again, though, and some reporter named Leeson, from the El Cajon *Gazette*."

"Give me a break. *El Cajon?* That's at least five hundred miles away. Why can't they just get this story off the wire service?"

The phone rang again. Ricky moved his hand off his computer mouse and swiveled around in his chair to answer it.

"Don't bother," I told him. "I'll get it. It's going to be another reporter for me, anyway. Probably from Anchorage this time, or maybe Miami Beach."

But the reporter calling wasn't from Alaska or Florida. It was only Lenny Palmer, sounding a little weirder than usual. "I need to see you right away," he told me, a bit breathless.

"What about, Lenny?" I asked, suspecting he was trying to pull a fast one and somehow scoop his competition.

"Got another letter today," he told me. "Some really interesting stuff in it."

I plopped down in my desk chair and stared out the window at the traffic on Townsend Street. Palmer's deadly serious tone

told me I didn't need to ask who had written this letter. If it really was from the killer, however, it went against his pattern of writing after each murder. Why send another letter now? Because we'd exposed his bogus baby contest? Or because Louis Ellison had been taken in for questioning?

"Have you touched the letter?" I asked, afraid I already knew the answer.

"Same as the others. I opened it, read what it said." He sounded a little defensive, almost defiant. "This time I decided to do you a favor, let you see it *before* we run it in the *Crime Journal.*"

"I appreciate that, Lenny. How about bringing it over here so I can take a look? And try not to put any more fingerprints on it, will you?"

"Don't think that would be a very good idea," Palmer said.

My impatience was growing. Did Lenny expect me to drive over to the *Crime Journal* offices to see the letter? I glanced at my watch, trying to figure how long it would take me to get all the way over there at the beginning of a San Francisco rush hour.

But before I could protest, the reporter added, "I'm just a few blocks away from your place. How about you meet me at Java Jamboree in ten minutes?"

"Why? If you're that close, Lenny, just bring the letter up here to my office. You want a cup of coffee, I'll give you one here, no charge."

"Coffee's not the reason I want to meet you there. You'll just have to trust me. I think you're going to want to read this thing before it hits print tomorrow morning. Java Jamboree, ten minutes. And don't say anything to your staff about the letter, okay?"

"Why not?"

"Like I said, there's a good reason. See you in ten minutes."

"But—" I quickly realized I was talking to the dial tone and hung up the phone.

✿ ✿ ✿

Lenny was already sitting at a table in the back of Java Jamboree when I arrived. His coat was flung across an extra chair and he was drinking some frothy concoction from a tall paper cup. I wondered if he'd been here all along and had called me on his cell phone.

I didn't bother ordering anything at the coffee bar, just headed straight for Lenny's table.

"Let's see what you've got for me," I said.

Lenny took an envelope out of his briefcase and slid it across the table. It looked precisely the same as the others—a common white envelope addressed by a laser printer, no return address.

"May I take this with me?" I had no authority to confiscate U.S. mail addressed to Leonard Palmer, not without a court order, and I didn't have one. So I would have to rely on charming the reporter. "It's really good of you to let me know so quickly, Lenny," I told him with what I hoped looked like a sincere smile.

"No way."

So much for charm.

"This might be evidence in an arson–murder investigation," I said, wondering if intimidation might work better.

"Just read the damn thing and then we'll talk."

I decided to follow orders and then figure out a game plan. Maybe there was nothing here that would help my investigation. I took my eyebrow tweezers out of my purse and used them to extract the letter from the envelope, then spread it on the table without adding my own fingerprints to the ones Lenny undoubtedly had already left behind.

This letter was longer than the others, I quickly saw. It began with the same sort of diatribe against whores. I read through that part quickly. But then the tone shifted. I held my breath, hoping the killer finally had dropped a few clues to his identity.

One paragraph in particular caught my attention. "You people

are nothing but a bunch of bigots," he wrote, "and I'm going to keep on making you pay for that. I tried to be on your side. I was a good fireman, the best, but that wasn't ever good enough for any of you, was it? Instead of appreciating the sacrifices I made for you, instead of giving me the promotion I earned, you shunned me like some kind of leper. Then you drummed me out of the department, for no reason except your stinking prejudice."

"This doesn't sound like something Louis Ellison would write," I said, staring at the letter and not even realizing I'd spoken aloud. "He never even got hired onto the job."

"Wasn't Ellison I was thinking of when I read this thing," Lenny said.

I looked at him, sincerely baffled. "Who, then?"

"Isn't it obvious?"

It wasn't to me, but maybe I was just in what psychologists like to call denial. My mind wouldn't even go there.

"Your assistant, Richard Lindeman," Lenny said, his face grim.

"Ricky? That's ridiculous. Ricky wouldn't hurt a fly."

"How can you be certain?" Lenny leaned forward and lowered his voice as a young couple took the table next to ours. "I heard Ted Bundy's friends and coworkers all thought he was a great guy, too. You certainly can't deny that Richard Lindeman could have written this letter. Everything fits him perfectly— he's an ex-firefighter, he was pushed out of his department because he's gay, he couldn't get hired on with the San Francisco Fire Department. Besides, lots of gay guys don't like women. That's a known fact."

"But…" I just couldn't believe that Ricky, my big, funny, kind assistant could murder anybody, let alone a series of young mothers he didn't even know. Why, he'd even let Max's band use his guest house. He was a good man. "Who says gay guys don't

like women?" As my mind churned through possibilities I didn't want to consider, that was all I could think of to say. "I mean, as friends and coworkers, not sexually. Fact is, I know a couple of women whose closest friends are gay men."

"Maybe so, but some gay guys have pretty warped ideas about the opposite sex. Maybe Lindeman's mother was abusive and that's why he turned out to be gay. How do you know?"

"People are *born* gay," I countered, feeling trapped. "They don't turn gay because they've got rotten mothers. The blame-the-mother theory is dead and buried, Lenny." I felt a strong need to defend not only Ricky, but his mother, too. Perhaps all mothers...myself included.

"Not the point." Lenny Palmer wasn't about to give an inch. "Fact is, your assistant is homosexual, which is precisely why the fire department 'drummed him out,' to use the term in the letter. And he knows your every move, so who could avoid detection better? The least you should be doing is investigating him along with whoever else you've got targeted."

I sighed, feeling the weight of the world on my shoulders. Could Palmer possibly be right about this? I began to doubt Ricky, to see all the ways in which he might fit the psychological profile of the killer that Sid Rhodes had helped me piece together. Ricky was a white male, perhaps not quite as young as we'd figured, but certainly far from old. Like all firefighters, he had a certain obsession with fire, probably from boyhood. As a former firefighter, he certainly knew how to set a hot fire and make it spread quickly, and he knew what fire would do to the human body. I didn't know much about Ricky's mother, but I thought he'd once told me his father had left them early on, that his mom had raised him alone. Had he blamed her for his father's desertion?

Then there was the fact that Ricky and Zeb had been trying to adopt a child for ages, that they had gay friends in the same

position. Was it possible he was giving the dead women's babies to gay couples who then claimed they'd adopted them?

The thing that struck me most, however, was Sid's comment that the killer's letters were meant to taunt me, to demonstrate that he was smarter than I was. Was it possible that Ricky believed he deserved my job, that he resented having to work as merely the assistant to the arson czar when he deserved to *be* the arson czar? If so, the fact I was a single mother, albeit a divorced one, might be stuck in his craw as well.

In any case, I had no intention of discussing my thoughts or plans with a reporter from the *Crime Journal*. "Look, Lenny, how about I make you a copy of this letter and I'll keep the original?" I suggested.

He leaned back in his chair and ran a finger underneath his shirt's turtleneck collar, as though it were choking him. "Guess I can live with that," he said after a moment's consideration, "but only if I come along while you make the copy."

I decided to push my luck. "And it would be very helpful to the investigation if you could hold off on publishing this a while, maybe just two or three days, give me some time to look into this new information."

"No way!" Lenny sprang forward in his chair. "This letter's going to run in tomorrow's *Crime Journal*—front page, my byline."

"But can't you see that—"

"Look, it's your job to catch this bozo, not mine. Besides, if I don't run his letter, he'll just write to some other reporter who will print what he has to say and I'll lose my edge. I tell you, this case is going to make my career, and there's no way I'm letting you ruin my chances." He puffed out his chest, obviously impressed with himself. "I've got a job interview with the *Inquirer* tomorrow, might be assistant city editor."

"Looks like you're on your way up, Lenny. Congratulations," I said, glaring at him with thinly disguised contempt. Women were

dead, and all this guy could think about was his smarmy little career. I wanted to throw up. I pushed back my chair and stood. "Come on, walk back to my office with me and I'll make that copy."

He picked up his briefcase and followed me out the door of the coffeeshop.

As we walked, I tried to think of a logical explanation I could give Ricky for bringing Lenny Palmer into the office and for making the copy myself instead of asking him to do it. I didn't want to explain what this was about, just in case....

But I needn't have worried. The door was locked when Palmer and I got to the office. I used my key to let us in. Ricky's desktop was as neat and clear as he always left it at the end of the day, except for a note propped against his pen holder. "Susan: Sorry, had to leave at five. Have to work at the AIDS center tonight." He added, "A crime report came from Hannah Goldman. It's on your desk. And Dr. Helen Chafos called. She'll be in her office tomorrow morning. You can call her then."

I breathed a sigh of relief at having avoided what might have become an uncomfortable confrontation.

"The copy machine's just over there in the storage room," I told Lenny, holding out my hand for the envelope. He dug into his briefcase and handed it to me. "I'll be right back," I promised him.

It took me a few minutes to use my tweezers to remove the letter from the envelope again and spread it face down on the glass top of the copy machine. As soon as the machine whirred into action and spit out the copy, I grabbed it and took it back to Lenny, who was lounging in Connie's desk chair, his legs stretched out in front of him.

"Here's your copy," I said, handing it over.

When Lenny had left, his copy of the letter stuffed in his briefcase, I retrieved the original and placed it in an evidence

bag. I would have Hannah check it for fingerprints in the morning, but I didn't hold out much hope of finding anything new. The letter's prose probably would provide our best clue.

I went into my office and stared into space for ten minutes or so, considering what to do next. Sid, I thought finally, I could tell Sid Rhodes about the letter, share my thoughts with him, see whether he thought Ricky actually might be capable of this kind of atrocity. I reached for the phone.

When Sid answered, I blurted out everything I'd been thinking and fearing.

"You don't want to believe Ricky Lindeman could do something like this," my favorite psychologist told me when I'd finished.

"Of course I don't. He's my employee, and even more than that, he's my friend." I chewed on my thumbnail.

"So, if you gave Ricky your trust, and he turns out to be the killer," Sid said, "what does that say about your ability to judge human nature, right? Is that what you're really afraid of, Susan?"

"Oh, for God's sake, Sid, quit parroting my own worst thoughts back at me. Just tell me whether what Palmer says makes any psychological sense, will you? Could Ricky Lindeman be responsible for these crimes or not?"

There was a long silence, and I could picture Sid sitting in his big leather desk chair, drawing his habitual doodles on his ever-handy pad of paper as he considered my question. "You know him better than I do, Susan," he answered at length, "and obviously you haven't seen him do anything that makes you feel suspicious. Still, I have to remind you that, under the right circumstances, anybody can become a killer.

"Is it possible that Ricky shows one side of his personality at the office and another side outside of the office? Sure, happens with people all the time.

"Could his being rejected because of his sexual preference—

first booted out of his job, and later being turned down for adoptive fatherhood—have eaten at him, made him boiling mad? Could he have taken out his frustrations on women who might have reminded him of his abusive mother? Or perhaps on women whose crime was nothing more than what he thought were rather casual reproductive habits? Sure, it's possible.

"But it's also possible that it will snow in downtown San Francisco tomorrow."

I kicked at my desk in frustration, bruising my toe. "Gee, thanks, Sid. I can always count on you for a definitive answer."

"Psychology is not an exact science, Susan, you know that."

"No lie."

"I do think this theory is worth investigating, however. Maybe you can start by finding out whether Ricky's been keeping souvenirs of these crimes. These guys virtually always do, you know."

"Okay, sure, sounds like a plan." I forced myself to cool off. "Hey, thanks, Sid, really. I'm just frustrated, that's all. But I really do appreciate your being my sounding board, as always."

"No problem. Wish you luck."

"This stays our secret, right?"

"My lips are sealed."

"Just make sure your files are, too. If this turns out to be a hundred percent off target, and I sure hope it does, I don't want Ricky ever to find out I doubted him."

Souvenirs. I knew serial killers kept things to remind themselves of their murders, objects that would help them experience the sexual thrill they got from killing, over and over again. A souvenir of a murder might be a lock of the victim's hair, a pair of her panties, a photograph, even a frozen or mummified portion of her body. I'd read about especially grisly cases in which the killers cut off their victims' fingers or ears or even their heads and kept them as mementos.

If Ricky really was the "Baby Snatcher Killer," how would I even begin to look for such souvenirs? I certainly wasn't about to call the police about my suspicions, ask them to get a warrant to search my own assistant's home. There wasn't enough evidence against Ricky to convince a judge to issue a search warrant anyway, was there?

I wandered into the outer office and stared at Ricky's desk. Other than the telephone and his fancy pen and holder with its green marble base, a birthday gift he'd received from Zeb, the desktop was clear of clutter. Although I knew full well I was alone in the office, I looked around before opening the top drawer. I felt guilty, like a sneak thief or voyeur.

The drawer's contents were neatly sectioned off, with a place for everything—notepads, pencils, Post-its, paperclips, a stapler, a roll of tape, an unframed photo of Zeb and Ricky together at the beach. Both men looked trim and handsome in their swimsuits. Recalling the clutter in my own desk's top drawer, I couldn't help feeling like a slob. Ricky obviously kept his desk as neatly organized as he kept his stylish and expensive wardrobe. I had no doubt his closet at home was carefully arranged, too, with colors grouped together, long-sleeved shirts separated from short-sleeved shirts, formal garb segregated from casual wear, everything freshly cleaned and pressed and ready to wear.

Richard Lindeman was a certifiable neat freak, no two ways about that. His highly developed organizational skills and obsession to detail were among the major reasons he was such a good assistant.

I opened another drawer and found his Rolodex, a petty cash ledger, more office supplies. No souvenirs of serial killings.

On the desk's bottom right was a letter-size file drawer. Inside it, each manila folder bore a color-coded, typed label, and everything was arranged precisely in alphabetical order. I read the labels, quickly recognizing the cases they represented.

I closed the file drawer and opened the drawer on the bottom left side. In the front section was a short stack of recent financial records. I leafed through them quickly, finding bills for the office rent and utilities, copies of Ricky's and my recent expense accounts, and the like.

I could see a pile of papers behind this one, so I pulled the drawer open a bit farther and reached toward the back. My hand froze as I spotted what lay on top of the stack of papers—a Xerox copy of a photograph, or perhaps it was a printout of a digital photo. It showed a mother and baby, standing in front of a crib that was festooned with a large, festive bow.

I picked it up and stared, my heart in my throat. I recognized this woman. I'd seen a photo of her in several local newspapers, alongside the stories about her murder. This was Ginger Smith, the young mother who'd died in San Vicente.

Beneath it was a second photo, this one of Maureen Benavente, the latest arson victim, holding her baby daughter. The smiling young mother was standing in front of a crib that was identical to the one in the picture of Ginger Smith.

What did this mean? Initially, my mind refused to process what I was seeing. I grasped mentally for a way, any way, to explain these pictures. Could these photos be part of Ricky's research into the victims of the crimes we were investigating?

If they'd been photos of the victims and their infants in any other setting, perhaps. But not when they were standing in front of the very cribs the young mothers believed they'd won, the cribs delivered to them by their killer, the cribs whose charred parts we'd found in the debris of each of the fires. These specific shots had to have been taken mere moments before these women were burned to death.

Only the killer could have taken them. There was no logical way I could avoid that basic fact.

I dropped the papers back into the drawer as though they'd

suddenly burst into flame and were burning my fingers. I slammed the drawer shut with my foot, feeling my heart race and my head spin.

This didn't mean Ricky was guilty, I tried to tell myself. Perhaps these papers had arrived in today's mail and he'd intended to tell me about them, only I'd returned to the office too late.

Or maybe Ricky was doing some sort of investigation on his own and had managed to recover these pictures from the killer. He could have made photocopies of them before turning over the actual evidence to the police, couldn't he?

But neither explanation made any real sense to me. The Ricky I knew would not fail to tell me about something this crucial to our investigation, no matter how late I'd returned to the office. Nor would the Ricky I knew go off on his own, like some sort of Lone Ranger, trying to solve these crimes behind my back.

Yet I couldn't accept that there wasn't *some* reasonable explanation for what I'd just found. Emotionally, I had to cling to that possibility, however remote it was beginning to seem. I'd trusted this man completely. Still, there was no way I could simply ignore these photos and wait to ask Ricky about them in the morning.

Assuming he showed up for work in the morning.

Had he really gone to the AIDS center? Or was he out setting up another woman as his next victim? If he'd gone home...

Max! I thought. *Max had to be warned.*

If Ricky was the killer, he'd written those letters, perhaps even on the very computer he used every day right here in the office. And if he'd written those letters, I had to consider Sid's theory that a major reason for the letters was the killer's attempt to demonstrate that he was smarter than I was. All I could think of at that moment was that my son was being used as a pawn to get at me. If Ricky was the killer, Max could be in terrible danger.

Even if my new suspicions about Ricky were completely

wrong, even if there was an innocent explanation for what I'd found in his desk, I didn't want Max at Ricky's guest house. Not tonight. Not until all of this could be sorted out and explained.

I grabbed the phone and dialed Max's father's house, hoping my son would answer. Doug's voice mail picked up. Damn! Max wasn't there.

I tried my own home phone on the off chance my son and his dad had had another argument, that Max had retreated to my place. Again I got voice mail.

I rushed into my office and grabbed my electronic address book. I looked up Bucky Chong's phone number and dialed it.

Finally, I was in luck. Bucky answered.

"Bucky, it's Susan Delancey."

"Huh?"

"Max's mom."

"Oh, Mrs. Macalester."

As usual, I ignored Bucky's nasty habit of refusing to recognize that I didn't share Max's and my ex-husband's surname. "Is Max there with you?"

"Nah, ain't seen him since school." Loud rock music was blaring in the background.

"Do you know where he is?" I nearly shouted to make sure Bucky could hear me over the deafening electric guitar riff emanating from his CD player.

"Nope. Maybe he went to the studio? The band was s'posed to go over there today to audition, but that agent dude called and cancelled out. Then my mom made me stay home and do homework." Bucky sounded put upon.

The audition. I'd completely forgotten about it. "The band's audition was cancelled?" I repeated. I felt like a parrot, my mind numb with worry.

"Well, just postponed really, till Wednesday."

"But maybe Max didn't get word?"

"Maybe. Gotta go, Mrs. M. I hear from Max, I'll tell him you're looking for him."

I tried the other band members. Brian and Jason told the same tale as Bucky. Neither knew where Max was. Both had heard about the audition postponement as soon as they'd arrived home after school.

I had to assume Max had gone ahead to the guest house, perhaps without stopping at his dad's first. That would be like him, I realized, to just leave a message for Doug. That way, his father wouldn't be able to forbid him to audition with his band.

It was now almost six o'clock. If what he'd told me was true, Ricky should be at the AIDS center. I looked up the number in his Rolodex and dialed it.

"May I speak with Ricky Lindeman, please?" I asked the woman who answered the phone. She had a husky smoker's voice.

"Hold on a minute. I think I saw him and Zeb around here someplace. I'll see if I can find him."

Three or four tense minutes later, Ricky's deep voice finally came on the line. I hung up without speaking.

Thank goodness, I thought. At least Ricky was accounted for. If he was at the AIDS center, obviously he couldn't be at the guest house harming Max.

I would go over there myself, I decided. If Max was there, I'd send him home immediately. Then maybe I could sneak into Ricky and Zeb's main house, look around for more evidence. If Ricky'd brought copies of those photos to work, I figured, he might be keeping the originals at home.

If I found anything, I decided, I wouldn't touch it. I'd call the police and urge them to get a search warrant, find the evidence legally. And if I came up empty, in the morning I'd simply have to confront Ricky about what I'd found in his desk, however difficult that might be.

✡ ✡ ✡

As I wound my way slowly though sticky rush-hour traffic on my way across town to Ricky's house, I switched on KBA radio. My mind wandered as the anchor droned through the traffic and weather reports and the financial markets update, but I snapped to attention as soon as I heard the first local news item.

"At this hour, accused Baby Snatcher Murderer Louis Ellison is back in custody in San Vicente," he said. "Our reporter Bruce Link is on the scene and has the story. Bruce?"

"Thanks, Henry. Here in San Vicente, police are reporting that, with the assistance of San Jose authorities, they have arrested Baby Snatcher Murders suspect Louis Ellison and booked him into the San Vicente jail. Ellison is being charged with multiple counts of murder and kidnapping. The twenty-six-year-old San Jose resident was questioned briefly here last night about the murders of five Bay Area women and the disappearances of their infant daughters. However, he was released after—"

My cell phone rang, its blare drowning out the next portion of Link's report. As I fished in my purse for the ringing nuisance, my other hand clenched on the steering wheel, I wondered briefly if I should turn around and head for San Vicente. What new evidence had Detective Berry turned up that had prompted him to arrest Louis Ellison so quickly? Was it something that could clear Ricky of suspicion? Something that would explain away those pictures I'd found in my assistant's desk drawer?

"Hello," I said, as soon as I'd managed to retrieve my phone, turn it on, and switch off the car radio.

"Susan." As I recognized Ricky's somber voice, I felt a strong surge of dread. "Glad I caught you," he said.

"Ricky, what's up?" I tried my best to sound casual, as though I wasn't at that very moment on my way over to his house, planning to break in and search it without his knowledge. Probably, I figured, he'd heard the same radio report I'd been listening to.

But I was wrong.

"I'm here at the AIDS center," he told me. "Just got a call from an old man who lives down the street from our place. He says a boy's been in some sort of accident in our guest house. Don't panic—he says the kid's okay, that it's nothing to call nine-one-one about—but apparently it's Max, and the neighbor says I should get over there as quick as I can."

"Max! What happened to him?" My foot jerked on the gas pedal and I nearly rear-ended the taxi in front of me.

"Wasn't all that clear," Ricky said, "but sounds like maybe he had a fall, could have broken a bone or sprained something, I guess. Anyway, I'm leaving for home right now. I'll drive Max over to the emergency room if it looks like he needs to go there, but I wanted to let you know right away."

"I'm on my way," I said, my panic rising to a new, higher level as I swerved around the taxi and into the bus lane. To hell with San Vicente and Detective Berry. My Max was in trouble. "I can be at your place in less than ten minutes."

It wasn't until I was almost up to Ricky's front door that it occurred to me to wonder how his elderly neighbor had known Ricky would be at the AIDS center tonight. Or how he'd found out there'd been an accident in the guest house. Or even how he'd known who my son was.

But by then it was too late.

Chapter Thirteen

I SCREECHED the Volvo to a stop at the curb as close as I could get to Ricky's Victorian fixer-upper and parked it. As I threw open the door and climbed out of the driver's seat, I could see no sign of Ricky's car on the street. Maybe I'd made better time in traffic than he had, I thought. Or perhaps his house had a garage in back, off the alley.

The old building's once-colorful paint was badly chipped and peeling, but scaffolding had been erected all along its front side, apparently in preparation for a major refurbishing job. I was grateful not to find Max lying in a heap, having tumbled off that scaffolding.

There were no lights on inside the old house, but I couldn't really tell whether anybody was home. I didn't care, not when my boy was in trouble out back. I didn't bother knocking on the front door. Instead, I scurried around the side of the house toward the guest house.

Luckily, the gate that closed off the small backyard was

unlocked. I pushed it open and sprinted across the patch of weedy grass toward what was little more than an old shack.

"Max!" I yelled as I ran. "Max, it's Mom!"

It was eerily quiet back here. A icy feeling coursed down my spine.

"Max!"

I pushed open the unlocked door of the guest house. It was nearly dark inside, with the windows covered against the early evening dusk. The sole source of illumination came from the doorway where I was standing. My fingers groped along the wall beside the door for a light switch and quickly located one. I flipped it on, but the guest house remained dusky. Either the electricity was off or the bulb in the ceiling fixture had burned out.

"Max, are you in here?" I called as I stood in the doorway, my eyes gradually adjusting to the murky light. Slowly, I was able to take in the scene in front of me. Mattresses were neatly nailed up against two of the four walls, covering the windows I'd spotted on the outside of the small building. But the middle of the room was in chaos—a teetering combination of extra mattresses, odd bits of two-by-fours, and plywood scraps was stacked in the center of the floor. Discards from Ricky and Zeb's remodeling project, I guessed.

"Max?"

As I stood there, wondering where Max was, my gaze fell on something sticking out of the bottom of the pile and I froze in place. A white sneaker with a bright purple stripe across it protruded from underneath the debris.

It was Max's shoe.

His foot was still in it.

"Max!"

As I took a step into the room toward my nearly buried son, I felt strong fingers grab my left shoulder from behind and caught

a whiff of ether's pungent odor. Another hand, gripping a wet rag, circled my neck and thrust toward my face.

In a flash, I realized what was happening and my survival instinct kicked in. I held my breath and turned my head to avoid breathing the ether fumes as I lifted my right foot and kicked backward as hard as I could. The heel of my shoe connected with something solid, twisting my ankle painfully. But with any luck, I'd cracked my attacker's kneecap.

"Argh!" an oddly muffled masculine voice protested in surprise. The fingers on my shoulder loosened. Was it Ricky who'd grabbed me? Had he called to lure me here so he could murder me along with my son?

My assailant dropped his rag to the floor and reached for my other shoulder as I spun around, prepared to jab his eyes out with my fingers. If you're a woman in a physical fight with a man, I figure, you've got no choice but to fight dirty.

But I quickly found I couldn't jab this guy's eyes. His entire face was protected by a gas mask.

Instead of blinding him, I managed only to grab a fistful of his thin knit shirt. I yanked at it with all my strength, trying my best to throw him off balance. I became a lioness whose cub was threatened, infused with a physical power I didn't know I had. With all my might, I thrust my knee upward into my assailant's crotch and felt a strong, primitive surge of satisfaction as it connected hard. The jolt of pain that radiated from my knee up to my hip almost felt good, as I heard my attacker groan once more and saw him double over.

His high-necked shirt ripped down the middle as I yanked it again. Yet, despite his apparent physical anguish, the man managed to straighten up part-way and begin flailing at me with closed fists. I caught a hard blow to my jaw and was momentarily stunned. My vision blurred as my head snapped around, and my mouth quickly filled with the salty, metallic taste of blood.

I stepped backward instinctively, stumbling as I rammed up against the piled mattresses. I fell, sitting down hard. Fighting panic, I quickly rolled over and somehow managed to get myself back on my feet before my assailant could reach me.

As my eyesight focused, I saw my opponent coming toward me, his half-bared chest thick with ancient burn scars. I gasped in surprise. I'd seen scars like these dozens of times. There's no mistaking the distinctive mark that fire leaves on its victims.

The man trying to kill me was not Ricky Lindeman, I realized. Ricky had no such scars—I'd just seen that photo of him in swim trunks. This man was far shorter, too, only a couple of inches taller than I was.

He couldn't possibly be Louis Ellison, either. Louis Ellison was locked up in the San Vicente jail.

As my masked attacker staggered toward me, I reached into the debris lying on top of Max and my fingers closed around one of the discarded lengths of two-by-four. I gripped it with both hands and swung it in a circle as hard as I could. With a thud, the makeshift club landed on the side of the man's head, just above the strap of his gas mask. His scalp spurted blood and he stumbled backward.

I dared not allow him time to regain his strong physical advantage over me. As he staggered, momentarily disoriented, I dropped my weapon, grabbed the front of his gas mask, and yanked it down far enough to expose his eyes. I thrust rigid fingers hard into his eye sockets and was rewarded by his muted shriek of agony.

The man spun around blindly, his fists flailing at the air. I ducked beneath his reach and he barely missed landing a second blow to my head. In the brief time when he couldn't see what I was doing, I dropped to my knees and began to pull Max's exposed foot. Blood dripped off my chin onto his sneaker.

"Max," I gasped, my jaw aching and my mouth refilling with blood, "Max, wake up."

My son's body shifted a foot or so from underneath the mattresses as I pulled, but he was dead weight, making no move on his own. He had to be unconscious from the ether, I told myself. My stunned mind wouldn't even consider that he might be dead. It was up to me to rescue my child, to get him out of here, to protect him from this raging madman.

I pulled harder on Max's leg, using all my strength, but his limp body moved no more than another few inches toward the doorway and escape. My teenage son weighed more than I did. Would I ever be able to get him out of here to safety?

I saw that I'd have to move the mattresses off him before I'd have any realistic hope of pulling him any distance. But as I shoved the first one out of the way, I smelled smoke.

My head swiveled around and I stared. The attacker, the gas mask still hanging around his neck and obscuring the lower part of his face, was holding a cigarette lighter to the ether-soaked rag. The cloth quickly burst into flame as he tossed it at me.

The mattress I was lifting caught fire. I dropped it, but not before my jacket, too, had ignited. I felt the shock of searing heat against my skin as I stripped off the burning garment and threw it at my assailant. He dodged the flaming jacket and lunged toward me, his scarred but muscular arms bulging. He grabbed my biceps and began to shove me toward the burning mattress.

I bent my aching head and bit down as hard as I could on his bare forearm. As soon as I felt my attacker's grip loosen in response, I stopped biting and pulled back just enough to knee him in the crotch a second time. He moaned, releasing his hold on me and stumbling backward, both hands now clasped protectively over his genitals.

I grabbed another two-by-four and went after him. Again, I managed a clean, hard strike to his head. This time the strap of

the gas mask split and the mask fell off as the man spun around and fell face down on the floor. Finally, he lay still.

I turned back to Max and was terrified to see that the fire was rapidly spreading to the mattress that still lay over his unconscious body. I dropped the two-by-four and fell to my knees. I tipped the smoldering mattress off my son, grabbed both of his ankles, and crawled backward, dragging him a few inches at a time along the floor toward the safety of the open door.

As I made frustratingly slow progress, flames licked upward from the burning pyre in the middle of the room and I began to choke on the rising smoke as the fire spread. My stinging eyes were running and I had trouble getting enough air, even here along the floorboards, where the freshest air can be found in any fire.

Was this how my life—and my son's—would end? In flames? Would we burn to death the way my father had?

No matter what happened, I refused to abandon Max to save myself. My son was all I had left, my only family. If Max died here, I would die here, too.

"Susan!"

I'd dragged Max another two feet along the bare floor, perhaps three, when I heard the sound of a miracle. Was I hallucinating?

"Susan!" I heard again. That sound couldn't be my mind playing tricks on me. The voice was too familiar.

"Ricky!" I croaked out in response.

I felt Richard Lindeman's strong hands boost me to my knees.

"Keep your head down, breathe the cleaner air," he told me, "and get out of here."

"Max," I choked out. "He's unconscious. He—he can't—I have to—"

"Go on, get going. I've got Max."

My foggy mind could no longer process everything that was happening. I froze in place, crouched on hands and knees, as the flames moved closer and closer. My stinging eyes watched as Ricky bent down, picked up my unconscious son as easily as a sack of flour, and lifted him over his shoulder in the familiar fireman's carry. After filling his lungs, Ricky rose to his feet again and saw that I was still stooped on the floor, choking on the smoke.

"Susan, go, for God's sake! Move! I've got him." Ricky's free hand nudged me hard in the back until we managed to stagger out the door together and escape into the blessed fresh air.

Ricky carried Max across the yard into the shadow of the main house, then gently laid him down on the grass. He placed two fingers on the side of my son's neck, felt for a pulse, and as soon as he'd found a strong one, leapt back to his feet. With indescribable relief, I saw that Max's breathing was regular and he hadn't suffered any serious burns, although he was still unconscious.

"Your boy's going to be fine," Ricky reassured me. "Stay here with him. I'm going back in for the other guy."

"No, Ricky, don't!" I coughed. "That—that man was trying to kill us. He's the one—the one who murdered all those young mothers."

Ricky shook his big blond head stubbornly. "Guy's going to die if I don't get him out of there fast."

I grabbed his strong hand and clung to it, trying my best to keep him here, to keep him alive and safe. "Don't, Ricky, please!" I pleaded. "It's too dangerous. You don't even have fire gear. You'll get yourself killed." I didn't want to lose him, not after he'd saved our lives, and certainly not in this way—in what undoubtedly would be a futile attempt to rescue a serial killer.

But he wasn't listening. I understood Ricky's motivation, even though I didn't like it. He was a firefighter, and this was what firefighters did—they risked their own lives to save other people, never stopping to ask who those other people might be or whether their lives were worth saving.

Ricky shook off my grasp and headed back toward the guest house. I raced after him across the parched backyard, filled with dread that he would perish in this fire. As we approached the old building, I saw flames begin to break through its roof, followed by a rising plume of black smoke.

"Don't, Ricky!" I cried again, terrified that the shaky building would collapse on him as soon as he reentered it, that he would be incinerated like my father, that my lifelong nightmare would soon include another haunting chapter.

But Ricky ignored my plea once more and we approached the burning shack together. As he prepared to make his way into the inferno a second time, I peered through the open doorway, and in the brilliant orange firelight illuminating the smoky haze, saw my attacker stagger to his feet. The man turned and stumbled toward us, seemingly attempting his escape. The gas mask he'd worn now lay on the floor.

"Good God!" With a shock I'll never forget, my mind made the series of connections it should have made hours earlier, and I recognized the man advancing toward us.

It was Lenny Palmer.

But as Ricky barged through the doorway to assist him, Palmer halted in his tracks and stared at us for a split second. Then he swooped down and picked up a glass bottle that lay on the floor in front of him, pivoted, and took a quick step back toward the flaming mattresses.

In a flash, the intense heat reached the bottle of ether in Palmer's hand and the glass exploded, sending shards and flaming liquid flying in all directions.

His clothing now ablaze, Lenny Palmer straightened up for an instant, then plunged face down on what he'd turned into his own funeral pyre.

As the fire in the room approached flashover, the intense heat drove Ricky back outside and he managed to escape to safety.

Chapter Fourteen

I WAS back in the office by ten the next morning, the relatively superficial burns on my arm bandaged, my bruised jaw aching, and my breathing still a little ragged from the smoke I'd inhaled. The paramedics had taken Max, Ricky, and me to the emergency room while the fire department put out the guest house fire. Luckily, none of our injuries required us to stay in the hospital overnight. By the time we'd all given our statements to the police, it was after midnight.

Actually, Max was in better shape than I was this morning—protected by the pile of mattresses, he'd suffered no significant burns and at sixteen, his lungs were both more pristine and stronger than mine. He'd recovered within hours from any after-effects of his unexpected anesthesia and was almost as good as new.

Like me, Ricky had a few superficial burns to deal with, and his breathing remained a bit labored as well, but the doctors assured us he would recover fully.

Max was at his dad's this morning, having successfully par-
layed his near-death experience and unusually late night into a
day off from school. Doug, obviously spurred by raw fear into
acting more like a normal father than he generally could man-
age, had even promised to replace Max's keyboard, which had
burned in the guest house fire.

Where Pacific Rim would practice once the band had reas-
sembled was another issue, but resolving it was at the bottom of
my list of priorities right now. After all, it wasn't as if Pacific Rim
had a real audition pending in the near future. Lenny Palmer
had called the boys and tricked them into believing he was a mu-
sic agent merely as a scam to lure my son and me to our deaths.
The man had been incredibly tenacious, I had to give him that
much. He'd used his reporter's skills to find out about me and
my family, and he'd obviously tailed Max for days as well, spying
on him and his friends, discovering the guest house. I wondered
how long Palmer had plotted to kill us before he'd come up with
his plan to accomplish that goal.

I was exhausted as I thanked Connie for her motherly con-
cern and headed toward my cluttered desk to get back to work
on this frustrating case. We'd been met by a cadre of reporters as
we left the police station last night, so I'd held a brief, impromp-
tu news conference. I revealed the murderer's identity and the
fact that he was dead, but cautioned that there were still many
questions left to be answered.

"What happened to the babies?" Lauren Meyers shouted
above the crowd.

"That's one of the questions we're still working on," I told her,
feeling weak and shaky from my ordeal. Before she could follow
up, Ricky placed a firm hand on my elbow and whisked me to-
ward Zeb's waiting car. Doug had already collected Max and tak-
en him home to his place, and I was grateful our son hadn't had
to face the cameras.

"We'll give you the whole story tomorrow, folks," Ricky promised as we climbed into the car.

I slept fitfully during the night, so I had plenty of time to think about everything that had happened, not the least of which was how close to dying we'd all come. The grisly sight of Lenny Palmer, his clothes ablaze as he breathed his last, was stuck in my mind. Why had he murdered all those young women? And what had he done with their infant daughters? I needed to know before I'd ever be able to rest peacefully again. Far more than my usual pride in my work spurred me to find out. The creep had attacked *my child*. He'd attacked *me*. I had to know why.

I now had strong suspicions about what Palmer had done with the babies, and those ideas were strengthened as I read the papers waiting on my desk, the ones I'd ignored yesterday in my dash to Ricky's house.

On top was Hannah Goldman's lab report on that last small piece of evidence I'd delivered to her. Her scientific conclusion was succinct, a mere sentence long: "The specimen is confirmed to be of human origin."

Sighing, I reached for the phone and returned Dr. Helen Chafos's call.

Again, she came on the line quickly. "I checked my records," she told me, "and you were exactly right about Ms. Cavendish's infant."

"Thanks for checking, Doctor," I said. "I appreciate it." I sat and stared into space for a few minutes after hanging up the phone. Then I grabbed a file folder from the pile on my desktop and reviewed my notes about the objects found in the fire debris at the sites where Palmer's victims had been murdered, and the condition of those objects following the fires.

I should have seen it in the beginning, I realized now. Perhaps I'd been blinded by hope, even spurred on by the fact I was a mother myself. And of course, there were the misleading words

in the killer's letters to the authorities and the press to throw me off the track.

The truth was that these babies had not been "liberated" from their mothers at all, certainly not by any rational definition of the word.

I now had to acknowledge that the cat's tooth found in the ruins of Betsy Cavendish's house, the one I'd retrieved from the evidence room and delivered to Hannah for testing, wasn't a cat's tooth at all. As Dr. Chafos had just informed me, Betsy's baby was born with a rare tooth already in place.

Her baby had died along with her, probably lying at her side in the center of the fire.

Judging by the metal items we'd found, particularly Ginger Smith's copper barrette and her surgical steel earring hanger, as well as the many steel parts of the burned cribs, these fires all had reached temperatures of more than two thousand degrees. They hadn't burned that hot long enough to completely consume the mothers' bodies, but their babies' were another story. Fires this hot could easily destroy all traces of a small animal.

Or a newborn child.

All except for one tiny human tooth.

I assigned Ricky the unenviable task of alerting the fire and police authorities about my conclusion that all the babies were dead while I headed across town to the small, run-down Spanish-style house where Lenny Palmer had lived.

The detectives were already there, waiting for me, when I arrived. All of them expressed genuine concern about the ordeal I'd been through and offered their congratulations on my identifying the killer as well.

Even my nemesis, Hank Berry, had the grace to look embarrassed. "Released Louis Ellison this morning," he mumbled to me, out of earshot of the other cops.

"Mind telling me what evidence you were holding him on?" I asked, not yet ready to sign a peace treaty with this jerk.

He stared at his shoes, which, as usual, were scuffed and dull. "Guy had a restraining order out against him, when he lived back in Michigan," he said. "Used his girlfriend as a punching bag once too often, I guess, so we figured—"

"When was this?"

"Six, seven years back."

Louis Ellison would have been little more than a kid at the time, only nineteen or twenty. With luck, he'd grown up by now, learned to control his temper. "I see," I said. What I really saw, however, was a cop who'd done whatever he could to make the flimsy evidence available fit his preconceived notions.

"I'm glad, at least, that Ellison didn't spend long in jail," I said, turning away and heading inside the cluttered building.

The evidence we sought was in the back bedroom, its windows blacked out with reflective silver insulation. The room looked as if it had served as Palmer's home darkroom at one time, before he'd started using a digital camera. The sharp odor of photo-developing chemicals still permeated the air.

"Well, here they are, guys," I said, feeling sad as I looked around the room, "Palmer's collection of souvenirs."

It didn't take long to find the originals of the photos Palmer had put in Ricky's desk yesterday while I, completely gullible, was in the other room, copying the letter he'd written and mailed to himself at the newspaper. *How could I have been so stupid?* There were photos of the other victims here, too, posed in the very same way, holding their babies and smiling in front of their brand new cribs.

We found a box with five sets of keys in it, too. I was sure these keys had been taken from the victims, that the killer had used them to lock up their houses after he'd started the fires.

Palmer had even had each mother, with the exception of

Betsy Cavendish, his first victim, sign a form he'd printed up on his computer, acknowledging that she was accepting delivery of the merchandise won in his bogus contest. What a macabre joke.

At what point did they realize they'd been conned, I wondered. When did they know they were about to die? Perhaps never, I hoped. Or maybe just for a split second, as the ether-soaked rags were clamped over their faces. It wouldn't have taken long before they slumped to the floor, unconscious. Even Max had little recollection of being overpowered and anesthetized by Palmer, it had happened so quickly. And, of course, he was larger than any of these victims, except perhaps Maureen Benavente.

We found that Palmer's computer held the names and addresses of many other new single mothers in the area, along with his notes about which ones lived alone and which with roommates, which women lived in apartment buildings versus houses, which had given birth to boys and which had newborn daughters. Clearly, he'd done the same computer search Ricky had, then checked out his potential victims. I recognized the names of several women Ricky and I had alerted about the phony contest.

In the single garage tucked under the house, we found two more new cribs, still in their cartons, along with a supply of thick polyurethane foam and the bolt of highly flammable bright blue fabric Palmer used to cover his homemade mattresses. He'd figured on burning at least two more victims and their babies, I realized with a chill. Maybe I hadn't been as quick to solve this crime as I might have been, but at least two women and two baby girls he'd intended to target were still alive. I knew I would have to keep reminding myself of that to make it through the long nights ahead.

There was plenty of evidence at Palmer's house to reassure everybody, including the governor, that he was our serial killer.

We found no sign he'd had an accomplice, or even that he had any friends. No personal address book, no social correspondence, no calendar with dinner dates marked on it. The guy was a complete loner. With Leonard Palmer now dead, these cases could be closed.

But what we did not find in that house was anything that could explain the one question that still haunted me—*why?*

It wasn't until Harriet Walsky told me her story that I began to understand what had led Palmer toward his murderous spree.

I was almost ready to leave the killer's house for the day and head back to the office when Ricky reached me on my cell phone.

"Woman named Harriet Walsky phoned here," he said. "Wants to talk to you."

"Another reporter? I'm just too tired, Ricky."

"No, she's a retired social worker. Says she saw the story on TV this morning and thinks she might have some useful background information. Insists on talking to you personally."

"What about?"

"Remembers Lenny Palmer from when he was a kid, says she's the case worker who placed him in a series of foster homes."

I felt a quick surge of adrenaline. "How can I contact this Ms. Walsky?"

Forty-five minutes later, I was in Harriet Walsky's studio apartment at the Welcoming Arms Assisted Living Center in Daly City, looking on as the old woman prepared coffee for us in her closet of a kitchen.

"Used to be called Leonard Palmento when he was a boy, but I thought I recognized him when I saw that photo on TV," she told me, her shaky hand spilling a dusting of coffee grounds on

the beige tile countertop as she measured the scoops from the can. "Same basic features," she said, ignoring the mess, "grown to manhood. Must have simplified his name, too. Soon as I heard about all those burns he had on his body, though, I was certain he was the same one."

A short, bent-over woman with long gray hair worn in a braid that hung down her back, Harriet—she insisted I call her by her first name—used an aluminum walker to get around her compact home. I guessed she had to be close to eighty, but her mind remained sharp and she radiated a strong sense of compassion that warmed me.

"I tell you, dear, I never forgot poor little Lenny," she told me. She switched on the coffeemaker and we waited while the beverage brewed. "Even if I'd tried, he just kept popping up in the system, over and over again."

A few minutes later, we were sitting at the small table in the living area as Harriet Walsky told me the kind of story I'd heard about dozens of budding arsonists, that of a male child shuffled from foster home to foster home. But this one had a twist that made it far more horrendous than most. When he came to Harriet's attention, Leonard Palmento was the six-year-old son of Sophie Palmento, a hooker who habitually serviced her tricks at her apartment in San Francisco's Tenderloin District while she kept her small son locked in an adjacent room. Sophie later had a newborn daughter, Joanne, of whom little Leonard was inordinately jealous. What scant attention Sophie had for her children she gave to Baby Joanne, to her son's great detriment.

Little Lenny began acting out, as abused children so often do. He hit one neighbor's cat with a hammer; he stole another's Social Security check from the mailbox in the apartment lobby; he began to play with fire.

The tragedy occurred on the day that Lenny took a box of matches from the kitchen and stood, staring through the slats of

his baby sister's crib. With his mother out of the room, he lit a match and dropped it onto the blanket covering the infant as she slept.

I gasped as Harriet gave me this piece of information. "Did the baby die?" I asked her, horrified that Palmer might have killed his first infant, his own sister, at age six.

Harriet set down her coffee cup with a trembling hand, spilling a bit of the dark liquid into her saucer. "Oh, no, my dear, nothing like that," she reassured me, leaning over and patting my arm. "Sophie smelled the smoke and put out the fire before the baby got hurt. It was her method of punishing her son, her misguided attempt to teach him a lesson, that did the damage in the end."

"What was that?"

Sophie dumped two spoonfuls of sugar into her coffee and stirred it. "Dragged him into the kitchen, turned on the gas stove, and held his little hands over the open flame."

I cringed as I pictured the brutal scene.

"Poor child's shirt caught fire. Don't suppose she meant that to happen, but Sophie was a drinker and a heroin user. Clear thinking was never her strongest suit."

"So that's how Lenny got those burns?"

Harriet nodded. "He was wearing one of those polyester shirts the kids wore back then. Thing burst into flame. Pieces of fabric melted right into his skin. Poor tyke spent six months in the burn ward before he was well enough that we could release him to a foster home."

"What happened to Sophie?" I asked, thinking she ought to have been sentenced to prison for a good long stretch.

"Sophie. Well, she didn't make it."

"Didn't make it? What do you mean?"

"When the woman saw what was happening, she tried to beat out the flames. She was wearing one of those filmy nightgown

things, a negligee, something like that, and it caught fire, too. Ended up burned worse than little Leonard—third degree burns over sixty or seventy percent of her body, as I recall."

Sophie Palmento survived just long enough to tell about what had happened on that fateful day. "The woman paid the price for her sins in the end, but it was like she thought the actions of an angry six-year-old justified what she'd done to him," Harriet added, shaking her head, "like she wanted us social workers to tell her she'd been a good mother after all. Fat chance."

Lenny spent the rest of his youth in a succession of foster homes. "He got the worst of the worst, in the beginning," Harriet said. "The boy was in pain in the early years, both physical and mental. But no matter where he was, he kept acting out—beating up on other kids, defying his foster parents, more fire-setting. Nobody wanted him around for long—he was too much trouble. Still, until now I thought Father O'Malley's place straightened him out."

"What's Father O'Malley's place?"

"Used to be a home for delinquent boys, dear, over in Half Moon Bay. We sent Leonard there when he was sixteen, out of sheer desperation. Father O'Malley's passed on now, but he and his staff performed miracles on some of our worst cases, no doubt about that. Don't know if it was the praying that did it, or the strict system of reward and discipline. But last I heard of Leonard Palmento, he was headed for college instead of the penitentiary. Thought we had a real turnaround on our hands."

Maybe they had, for a while, I thought. Certainly Lenny had learned some marketable skills; he'd become something of a success in his chosen profession. Why had he thrown all that away to become a serial killer? What had triggered this fiery rampage?

I refused a second cup of coffee. I was already jittery enough and I didn't want the old woman pushing her walker to the

kitchen a second time on my behalf. "What about the little girl, Lenny's sister?" I asked Harriet. "What happened to her?"

A broad smile lit up her kindly, lined face. "Oh, that part, at least, worked out real well. Soon as the mother died and we saw there was no father named on the birth certificate, we were able to find her an adoptive family."

"That's good," I told her. "I hope she got a good one. I'm adopted myself and I don't know—" I stopped myself. No point in telling this retired social worker how often I'd wondered what might have become of me if the Delanceys hadn't rescued me from that Korean orphanage.

"Thought you might be," Harriet said, her blue eyes examining my face. "Korean orphan, right? Birth father a GI?"

I nodded. For once, I didn't bristle and get defensive when questioned about my racial background.

"Used to be my favorite part of the job," Harriet told me, "being able to refer a child over to the county adoption agency— what the young people nowadays call a win-win situation. So much of being a social worker was wrenching for me, seeing all those poor, abused children and not being able to…" She shook her head as if to excise difficult images from her mind. "I don't know any of the details, of course, that sort of information is sealed, but I'm sure little Joanne did just fine," she said. "If she didn't, she'd have ended up back in my part of the system." One freckled hand began to toy with her long, thick braid. "It's always easy enough to place the babies in a good home, you know, the little ones, as long as they're white and healthy, and Joanne Palmento was, despite everything. It's the older kids, the emotionally troubled ones, the minorities and the handicapped, children like Leonard, that nobody seems to want."

And children like I was? But I'd been extraordinarily lucky. My own adoptive mother and father had been generous enough to overlook my mixed racial heritage—a heritage that would

have condemned me to life as an outcast in my native country—
and raise me as their own child despite my background. Or per-
haps even because of it. My mother once told me she and my
dad figured I'd needed them, and the good home they thought
they could offer a child, more than an American youngster
would have. Most times, I think she was right. Until I hear about
a child like Leonard Palmento, that is. Certainly he'd needed
good, decent, loving parents every bit as much as I had.

Yet it seemed that nobody had ever wanted Lenny as long as
he lived, I thought sadly. Perhaps, if somebody'd ever actually
cared about him, loved him… But that was pointless speculation
now. The fact was, he'd grown up to be a murderer, and if it
hadn't been for Ricky, he'd have added Max and me to his list of
victims while framing Ricky for his murders.

He might have stopped momentarily, but I had no doubt that
eventually Lenny Palmer would have resumed his killing spree.

Chapter Fifteen

WHEN I got back to the office, I couldn't help but notice the massive bouquet of flowers sitting on top of the file cabinet in the outer office.

My eyes widened. "Where did that come from?" I asked Ricky.

He rolled his eyes. "Bart Waldron, would you believe it."

"You've got to be kidding."

Ricky held up two fingers. "Scout's honor. I think the poor guy might actually feel a touch guilty about the way he's been treating both of us, seeing that we almost got ourselves killed and all."

"You trying to tell me career politicians are capable of feeling *guilt*? I don't believe it."

"I've heard a rumor to that effect. Never actually saw any evidence myself, of course. Before today, anyway."

I walked over to the file cabinet and plucked a perfect yellow rose out of the vase, held it up to my nose, and inhaled its fragrant odor.

Ricky held up a small card and read it. "Sensitive old Bart expresses his gratitude for a job well done and wishes us a speedy recovery. Says so right here."

"These must have cost a small fortune," I said. "Bart must want something. Or else he simply charged these flowers to the governor's campaign chest."

"You're definitely right on the first count. Probably right on the second, too, but you couldn't prove that by me."

I knew there had to be a catch. "Break it to me gently," I told Ricky. "I'm much too tired for a major shock."

"Bart's on his way here from Sacramento in the governor's limo. He's got a major press conference scheduled for four o'clock, in plenty of time to make the six o'clock newscast. We've both been put on notice to be there, ready to answer any and all questions the media might throw at us."

"Let me guess. Waldron plans to grab credit for breaking this case."

"Probably not directly. He'll simply praise the governor's vision in appointing the sorry likes of us," Ricky said with a grin.

"Guess I'd better go fix my makeup if I'm going to be on TV," I said, checking my watch. It was already almost three. "Then I'll brief you on what I learned from Harriet Walsky."

"I put your messages on your desk, Susan. It's none of my business, and I'm not asking, but a guy named Todd Hampshire called three times, said it was personal. Seems pretty worked up. Isn't he that doctor you've been dating?"

"I thought you weren't asking any questions," I said, torn between regret and revenge. Todd had left a message on my voice mail last night, too, but I hadn't called him back. It would do him good to be "worked up" about me for a change, I thought. Maybe he'd even rethink the cavalier way he'd dumped me.

Not that I'd ever take him back, of course.

 ❖ ❖ ❖

The press conference actually went quite well and Bart wasn't nearly as big a horse's ass as I'd expected. After making a rather windy opening statement about how the governor had never for a moment lost confidence in the ability of Arson Czar Susan Kim Delancey and her highly competent staff to solve this notorious series of homicides—an appointment that spoke well of the governor's unshakable commitment to her program of full inclusion—he turned over the floor to me.

For the second time, I gave Ricky full credit for saving my life and my son's, fervently praising his bravery. He said nothing, but I could tell he was filled with pride. He'd certainly earned the right to feel that way.

Then I spent the better part of the next hour before the cameras and microphones, telling everything I'd learned about Lenny Palmer, his origins, and his grisly crimes, including the sad fate of the five baby girls.

It was nearly six o'clock by the time I stopped in the lobby of my condo building to pick up my mail, wanting nothing more than to get upstairs for a glass of good wine and an early bedtime. My tense muscles ached for a warm, relaxing bath, but the doctors had forbidden me to get my burns wet for another day or two.

"Suze! Susan!" As I approached the elevator, I heard Todd's voice and spun around. I was stunned to see him standing there, a worried look on his face.

"I heard what happened," he said, "and I've been trying to reach you everywhere. I—I've been worried sick about you."

"Todd. I didn't think you—" I stopped myself in midsentence when I noticed the doorman staring in our direction. No sense in becoming a bigger topic of building gossip than I already was, I figured.

I stood riveted to the floor while Todd approached me and

threw his arms around me in a bear hug. But I remained stiff and rigid, refusing to hug him back.

"What's going on, Suze?" he asked. "Why didn't you return my calls?"

I kept my voice low, trying my best to avoid being overheard. "Why did you dump me, you jerk?" I whispered, pushing him away. "Least you could've done is tell me to my face."

"What the hell are you talking about?" Todd looked genuinely puzzled, I had to give him that much.

I didn't like having this discussion in the lobby, but neither did I want to invite my former lover up to my condo if I could avoid it. I was having enough trouble keeping it together as it was. "Friday night, Todd?" I said, feeling close to tears. "For God's sake, you had your new girlfriend answering your home phone while you were in the shower. What was that about—you had to hose yourself off after a round of sweaty sex? Or were you trying to smell all nice and sweet in preparation for one?"

Todd's face was completely blank for a moment. Then he slapped his forehead as recognition broke through. "Louise. That bitch! Early Friday night, right? Probably thought she was a real laugh riot."

"Louise? Your ex?"

"One and the same. Now I can see what's been going on, Suze. I had my kids Friday afternoon. Took them to the park, and they were filthy by the time we got back. I was bathing them when Louise showed up to take them back to the house. I had to get to the hospital for night rounds. The damn woman never even told me the phone rang, never mind that she answered it."

I'd never met Louise Hampshire, but Todd had told me how vindictive his ex-wife was about their divorce, that she'd been doing whatever she could to sabotage his relationship with his two young children, as well as any other part of his new life she could touch. At least Doug had never forced me to deal with that

brand of hostility. Truth was, I don't think my own ex ever cared enough to get that angry.

My weary mind struggled to find a hole in Todd's explanation, but I couldn't. Maybe I'd been too ready to believe the worst, I told myself, to think that this relationship, like all my past ones, was doomed to fail. Might as well end it earlier rather than later, right? Make it easier to avoid all those messy entanglements.

"Hey, Suze," Todd said, gently putting his arms around me again and cradling me against his chest. "This was all just a silly misunderstanding, okay? Only thing that's important now is that you're safe, and Max is safe. When I found out how close I'd come to losing you, I—"

It was when he choked up and I saw the tears forming in his blue eyes that I completely lost it. "Want to—to come up—upstairs with me?" I blubbered, burying my face in Todd's jacket.

In fact, he did.

The final piece of the Leonard Palmento-Palmer puzzle fell into place the following morning.

When I got to the office, a short, middle-aged, balding man in a rumpled gray suit and red tie was waiting to see me. "Ms. Delancey? Hi, I'm Robert Blaine, ABD Investigations," he said, thrusting out his hand. "The B in ABD."

I shook his hand, annoyed that a private investigator would be taking up my time when I had so much work waiting to be done. I figured he'd been hired by some insurance company to investigate a fire claim it was trying to avoid paying by citing arson as the cause.

But I figured wrong.

"Like to talk to you," Blaine said. "Got a piece of information I think you're gonna want to hear. Got a minute?"

Leery, I glanced at Ricky, then at my watch, our silent if not too subtle signal that he should interrupt me, remind me that I

had an urgent meeting, if this threatened to take up too much time. "What's this about?" I asked.

"Ms. Elizabeth Cavendish, born Joanne Palmento."

"What?" My heart thumped and my knees quickly went weak. "Betsy Cavendish and Joanne Palmento are—they were the same person?"

Blaine nodded grimly and pulled a manila folder from his scuffed brown leather briefcase. "Can we go into your office a minute, talk this over?"

"Where did you get this information?" I asked him as soon as we were seated in my office. I wasn't really sure whether I should believe him, or if this was some sort of scam.

"A few months ago, Elizabeth Cavendish hired me to do some research for her." He opened his folder and spread it out across his fleshy knees.

"What sort of research?" I asked.

He fidgeted a bit, looking nervous. "Generally this sort of thing is kept completely confidential, as I'm sure you know. But Ms. Cavendish is dead and now her brother's dead, too, so I figured opening my file might be helpful to your investigation, that I'd make an exception just this once. Felt something of an obligation, Ms. Delancey, you want to know the truth."

Blaine had my full attention. "I can appreciate that. Okay, Mr. Blaine, I'm listening. Tell me all about it."

"Ms. Cavendish was about to have her first child at the time. Both of her parents were dead, killed in a car accident the year before. Her adoptive parents, that is; she was adopted as a baby. So she didn't really have any family. Hired me to find her birth parents, see what I could learn about them. We see this sort of thing happen fairly often with adoptees, particularly when their first child is on the way."

I could confirm that from personal experience. When I was pregnant with Max, I'd worried about what sort of hereditary

diseases I might unknowingly be passing on to my baby. I still do. I'd have given my eyeteeth to find out who my real parents were, but in my case, there was no way I could ever find out. The records simply didn't exist.

"Obviously, you were able to find out that Betsy Cavendish had been born Joanne Palmento," I said. "You were able to break the adoption seal."

"Took me a couple of weeks to get that far. We have our confidential sources. Unfortunately, there was no father listed on the original birth certificate and the mother, one Sophie Palmento, was long since dead. Only other blood relation I was ever able to identify was an older brother, named Leonard Palmento." He took some papers out of the file folder and handed them to me. "I made copies, so you can keep these," he said.

I looked over the documents. On top were copies of two California birth certificates, one for Joanne Palmento and one for Elizabeth Cavendish. Both bore exactly the same time and date of birth as well as the name of the same hospital. All the other information—the newborn's race, length, and weight—was identical as well, except that the second document listed the Cavendishes as the child's parents, while the first listed Sophie Palmento as the mother and "unknown" as the father. The third document was a copy of a public adoption record and the fourth was Leonard Palmento's birth certificate, dated six years earlier than Joanne's. My pulse quickened as I read. "I take it you were able to locate Leonard Palmento?" I asked.

"Sure was. I was darned proud of it at the time, too—took a bit longer than usual, because of his name change. Now it doesn't look like I did Ms. Cavendish any favors, way things turned out."

"Do you know for certain that Betsy Cavendish contacted her older brother, Mr. Blaine?" I asked.

Blaine shook his head. "All I can swear to is that I gave her

the guy's name and current address. But his killing her sure can't be sheer coincidence, can it?"

Certainly Robert Blaine was right about that.

Sid Rhodes helped confirm my conviction that Lenny Palmer's being contacted by his long-lost sister was what had sent him over the edge. It was the psychological trigger I'd been lookng for.

"My guess," Sid said, as he spread out our lunches—starting with two more smoothies, blueberry this time—on my desktop, "is, the sister's showing up out of the blue brought back that murderous rage Lenny'd felt at age six. I mean, look at how things turned out, Susan. Lenny ends up half burned to death, then shuffled from foster home to foster home. The hated baby sister, on the other hand, gets a good adoptive home, real parents who love her.

"Now she shows up again, from his point of view to rub his nose in it. Not only that, but she's either expecting a baby or just gave birth. And like their mother, she's not married."

"It's the same pattern Lenny experienced as a child," I said.

"Right. In his mind, the sister becomes the whore mother who shunned, then burned, and finally deserted him by dying. All over again, he's consumed by a desire to kill the baby he thinks ruined his life."

I watched as Sid downed his smoothie, then unwrapped a massive veggie-and-cheese sandwich and took a huge bite of it. How he managed to stay in such good physical shape yet eat so much was beyond me. "I get most of this, Sid," I told him, "why Lenny would want to kill his sister and her baby, why he chose fire as his murder weapon. But the rest of his MO—why did he keep repeating the same kind of arson–murder, over and over again?"

"Remember the way the killer stated it in his letters? How he

claimed he was killing the whores?" Sid asked, wiping a drip of mayonnaise off his chin.

"Sure."

"Remember, Susan, this was one screwed-up guy—pardon the vernacular—both socially and sexually. Didn't even have any friends, right?"

"Not that we could find any evidence of."

"So chances are, with the scars he was carrying around on both his mind and his body, he never experienced a normal sex life, either."

"So his sex drive became twisted and—"

"Exactly. I guarantee you Lenny Palmer got a major sexual thrill from that first fire, from getting rid of sister Joanne and her baby once and for all."

"Except he didn't really get rid of them, did he?"

"Physically he did, but not mentally. He wanted—needed—to keep repeating the violent event, to re-experience the sexual charge he got from it."

"So he started researching women like his sister—single, young, with newborn daughters—and then targeting them for murder."

"He came up with the contest scam—"

"—and now ten innocent people are dead."

"It was almost twelve, Susan, you can't forget that."

"As if I ever could."

Within a week or two, life was almost back to normal, whatever that might prove to be.

Ricky announced that he and Zeb had been approved as foster parents for a four-year-old boy born with HIV. They were thrilled, although I was privately terrified for them. They had so much love to give a child. What would happen if they poured their hearts into this needy little boy and then lost him?

Max and his dad seemed to have signed a truce of sorts. Maybe it wouldn't last, of course, but at least there was new hope.

In a weak moment, I promised Max that he and I would vacation in Ohio during his next school break. Why Ohio? Because Cleveland is the home of the Rock 'n' Roll Hall of Fame, a place Max has pined to see ever since he became obsessed with rock music. I figured a Midwest vacation was the least I could give my son. After all, my job had almost gotten him killed.

And Todd and I pledged to find some way to work time for each other into our hectic schedules, to see if our relationship might have a future.

We might actually make it, too, at least until the next serial arsonist shows up to demand my undivided attention.

✦　✦　✦

Greg Wutke

About the Author

Nancy Baker Jacobs is the award-winning author of eleven crime novels, including the Devon MacDonald private eye series, plus six nonfiction books under another name. She has worked as a private detective, a college professor, and a journalist. A resident of the Central California coast, Jacobs now writes full time. She can be reached at PGAuthor@pacbell.net.

MORE MYSTERIES

🂠 FROM PERSEVERANCE PRESS 🂠
For the New Golden Age

Available now—

Another Fine Mess, A Bridget Montrose Mystery
by Lora Roberts
ISBN 1-880284-54-5
Bridget Montrose wrote a surprise bestseller, but now her publisher wants another one. A writers' retreat seems the perfect opportunity to work in the rarefied company of other authors...except that one of them has a different ending in mind.

Open Season on Lawyers, A Novel of Suspense
by Taffy Cannon
ISBN 1-880284-51-0
Somebody is killing the sleazy attorneys of Los Angeles. LAPD Detective Joanna Davis matches wits with a killer who tailors each murder to a specific abuse of legal practice. They call him The Atterminator—and he likes it.

Too Dead To Swing, A Katy Green Mystery
by Hal Glatzer
ISBN 1-880284-53-7
It's 1940, and musician Katy Green joins an all-female swing band touring California by train—but she soon discovers that somebody's out for blood. First book publication of the award-winning audio-play. Cast of characters, illustrations, and map included.

The Tumbleweed Murders, A Claire Sharples Botanical Mystery
by Rebecca Rothenberg, completed by Taffy Cannon
ISBN 1-880284-43-X
Microbiologist Sharples explores the musical, geological, and agricultural history of California's Central Valley, as she links a mysterious disappearance a generation earlier to a newly discovered skeleton and a recent death.

Keepers, A Port Silva Mystery
by Janet LaPierre
ISBN 1-880284-44-8
Shamus Award Nominee, *Best Paperback Original 2001.*
Patience and Verity Mackellar, a Port Silva mother-and-daughter private investigative team, unravel a baffling missing-persons case and find a reclusive religious community hidden on northern California's Lost Coast.

Blind Side, A Connor Westphal Mystery
by Penny Warner
ISBN 1-880284-42-1
The deaf journalist's new Gold Country case involves the celebrated Calaveras County Jumping Frog Jubilee. Connor and a blind friend must make their disabilities work for them to figure out why frogs—and people—are dying.

The Kidnapping of Rosie Dawn, A Joe Barley Mystery
by Eric Wright
Barry Award, *Best Paperback Original 2000.* Edgar, Ellis, and Anthony Award nominee
ISBN 1-880284-40-5

Guns and Roses, An Irish Eyes Travel Mystery
by Taffy Cannon
Agatha and Macavity Award nominee, *Best Novel 2000*
ISBN 1-880284-34-0

Royal Flush, A Jake Samson & Rosie Vicente Mystery
by Shelley Singer
ISBN 1-880284-33-2

Baby Mine, A Port Silva Mystery
by Janet LaPierre
ISBN 1-880284-32-4

Forthcoming—

Death, Bones, and Stately Homes
by Valerie Malmont
Finding a tuxedo-clad skeleton, Tori Miracle fears it could halt Lickin Creek's annual house tour. While dealing with disappearing and reappearing bodies, a stalker, and an escaped convict, Tori unravels the secrets of the Bride's House and Morgan Manor, which the townsfolk wish to hide.

Slippery Slopes and Other Deadly Things
by Nancy Tesler
Biofeedback practitioner/single mom/amateur sleuth Carrie Carlin is up to her neck in snow, sex, and strangulation when her stress management convention is interrupted by murder on the slopes of a Vermont ski resort.

NONFICTION
Funhouse & Roller Coaster:
Creating the Reader's Experience in Mystery and Suspense Fiction
by Carolyn Wheat
The highly regarded author of the Cass Jameson legal mysteries explains the difference between mysteries (the art of the whodunit) and novels of suspense (the flight from danger) and offers tips and inspiration for writing in either genre. Wheat shows how to make your book work, from the first word to the final revision.